The Kahiki

SCRAPBOOK

Relics of Ohio's Lost Tiki Palace

David Meyers, Elise Meyers Walker,
Jeff Chenault & Doug Motz

AMERICAN PALATE

Published by American Palate
A Division of The History Press
Charleston, SC
www.historypress.com

First published 2023

Manufactured in the United States

ISBN 9781467152846

Library of Congress Control Number: 2022948087

Notice: The information in this book is true and complete to the best of our
knowledge. It is offered without guarantee on the part of the author or The
History Press. The author and The History Press disclaim all liability in
connection with the use of this book.

In memory of
William "Bill" Sapp and Leland "Lee" Henry—
the men who made it all possible.

Contents

CONTENTS

Preface

It doesn't look like any one thing from Polynesia. It's a mix of features from that culture…all brought together. It's a period that's long gone. And they're not building restaurants like that anymore.

—*Patrick W. Andrus, preservationist*

The Kahiki is dead. Long live the Kahiki.

More than twenty years ago, the legendary Kahiki Supper Club fell to the wrecking ball. It was indisputably the greatest tiki palace ever built—the epitome of a fad that started at the end of Prohibition and continues to this day, battered and bowed, but unbroken. Well, maybe a little. Tiki bars have become a beverage industry mainstay with their message of fun, fantasy and flight from the everyday. It is hardly a coincidence, then, that a tiki revival began during the recession of 2008 and has flourished throughout the era of COVID-19—when liquor stores were declared an essential business and many tiki bars survived by packaging cocktails to go. Suddenly, everyone felt like they were marooned on their own island and had to make the best of it.

In our earlier book *Kahiki Supper Club: A Polynesian Paradise in Columbus*, my coauthors and I endeavored to write the definitive history of the legendary tiki palace more than a dozen years after its demise. But it was a salvage operation, really. Even as we were researching that book, we were keenly aware that large chunks of the story were being discarded, misplaced,

destroyed or forgotten. And the hope—make that dream—of one day reconstructing the Kahiki was already doomed. We were working against time, more so than we realized.

Fortunately, we had the assistance and support of the two men who made the Kahiki possible—F. William "Bill" Sapp (1928–2021) and Leland W. "Lee" Henry (1930–2015). They were the ones who first conceived the idea of building the supper club, assembled the design team, arranged the financing, planned the menu and ran the operation for seventeen years. Men—and women—of such vision are rare. Those who can realize them are even rarer. Like the Kahiki, both Lee and Bill are gone, but their place in restaurant history is assured. They set a standard that few can equal.

In addition to Lee and Bill, many other people who played a part in making the Kahiki such an unforgettable experience have also passed away and their stories with them. For example, I did not learn of Joyce Ann (Saunders) Darcangelo until her niece Angie Wood contacted me about a collection of photographs some six months after her aunt died. So instead of being able to interview Joyce about her involvement with the Kahiki, I had to reconstruct it from interviews with her husband, Terry, as well as various other sources. And then, Terry passed away not long after that. Both of their deaths underscored the need to redouble our efforts to identify and interview others who might be able to contribute to the Kahiki story.

Many thousands of people patronized the Kahiki or worked there during its thirty-nine years of existence, and every one of them has a story to tell. It was just a matter of tracking them down and getting them to share their memories with us. In the process, there have been such serendipitous finds as the discovery of a set of blueprints for a proposed "MiniHiki" franchise and another for a Kahiki museum addition. Meanwhile, each of us had begun to acquire additional flotsam and jetsam pertaining to the Kahiki through happenstance or interactions with other tiki enthusiasts.

As it turned out, Kahiki Foods—a separate but related offshoot of the restaurant—housed a collection of Kahiki memorabilia that we were allowed to view and photograph just a few days before the marketing department departed for California. While Kahiki Foods continues to manufacture frozen Asian foods in the Columbus suburb of Gahanna, the company is now owned by a South Korean conglomerate.

When the Kahiki Supper Club was razed, a lot of finger-pointing took place, much of it directed at the last owner, Michael Tsao. Yet in retrospect, it was inevitable. The Mai-Kai in Fort Lauderdale, Florida—an inspiration for the Kahiki—has survived because of its location in a tourist destination

by the ocean. Whitehall, the Columbus suburb that was the home to the Kahiki, is neither. Residents of east Columbus will never enjoy a warm sea breeze even when the polar ice caps melt. But even the venerable Mai-Kai's future hung in the balance after it sustained extensive water damage and was forced to close for more than a year and a half.

The Kahiki was born during the period depicted in the television series *Mad Men*. Some of the issues explored in *Mad Men* are alcoholism, sexism and racism. In many respects, the Kahiki was a reflection of the times. In others, it seemed to have existed outside of them. Although many of the women were clearly sexualized, they were also able to advance within the organization and play key roles. And there were likely few places in Columbus that actively developed such a diverse workforce.

While Polynesia is not part of Asia, most people don't know the difference. Certainly, there have been relatively few if any Polynesians associated with the Kahiki, but many Asians, particularly Chinese, Japanese, Korean, and Vietnamese. At a time when many Asians have come under attack simply because of their ethnicity, we feel a need to point out as President Charles A. Arthur attempted to do when he vetoed the first Chinese Exclusion Act in 1882: "No one can say that the country has not profited by their work.… Enterprises profitable alike to the capitalist and to the laborer of Caucasian origin would have lain dormant but for them."[1]

In an earlier work, *Ohio's Black Hand Syndicate*, my daughter, Elise, and I discussed the treatment of Italian immigrants to America. In another, *Historic Black Settlements of Ohio*, the focus was on those of African heritage. And in *The Kahiki Scrapbook*, the emphasis is on the Asian experience. As many of our books have illustrated, the stories of various racial and ethnic groups are both surprisingly similar and unique. It behooves us to learn what we can from each of them.

We would not have undertaken a second Kahiki book if we didn't feel there was an audience for it. Certainly, it fills a gap in our personal libraries. However, we know from the response to our first book that many of our readers have an unquenchable thirst for all things tiki. We are also encouraged by the success of Jeff's *Ohio Tiki* book and Doug's two books: *Lost Restaurants of Columbus, Ohio* and *Lost Restaurants of Columbus & Central Ohio*. Apparently, we aren't the only ones who are interested in such things.

Just before the Kahiki closed, *Food & Wine Magazine* proclaimed it one of the "five coolest bars in the world."[2] The other four were in Berlin, Mexico City, New York and London—a distinguished group of cities in which Columbus is unaccustomed to finding itself. Yet it captured the top

spot on the strength of "live parrots and a wall of fish."[3] You really had to have been there.

Nearly a decade ago, the four of us began our own Oz-like journey down the Yellow Brick Road that culminated in the publication of *Kahiki Supper Club: A Polynesian Paradise in Columbus*. Little did we realize at the time that the story wasn't over or that so many readers hungered to know more. The book you hold in your hands is not a rehash of our first book. It is a stand-alone companion, chock-full of new stories, new pictures and new revelations. It is a further exploration of what was, what could have been and what is—the ongoing legacy of the Kahiki Supper Club, the greatest Polynesian palace of them all.

David Meyers

Acknowledgements

Many thanks to the following people who helped us in various and sundry ways to write this book: Marsh Padilla, Henry "Hank" Burch, Gerline "Geri" Lude, Angie Wood, Terry Darcangelo, Diane Hopkins, Wendy Tyson, Kay Oliver, Mike Renz, Autumn Shah, Rod Metz, Linda (Sapp) Long, John Fraim, Doral Chenoweth, Susan Weyrick, Don Beck, Linda Dachtyl, John "TikiSkip" Holt, Doug Horne, Dave Hansen, Josh Agle, Ruth Pearl, Patricia Wilson, Todd Popp, Deb Chenault, Aja Miyamoto, Doug Winship, Rikki Santer, Franco Conti, Sam Walker, Ford Walker, Beverly Meyers, Olivia Woods (Ohio State University Archives), Abigail Fleming and John Rodrigue.

1
Setting the Table

Kahiki.
To islanders, the word means "sail to Tahiti." To residents of the Columbus area, Kahiki means an adventure in delicious Polynesian cuisine served in an exotic atmosphere.
The Kahiki, which has prompted as much curiosity as the mysterious islands it represents, didn't come into being as the whimsy of someone's wild imagination. In 1957, Lee Henry and Bill Sapp, after operating The Top Steak House for three years, felt that Columbus was a good restaurant town, able to support another supper club.
To make the new restaurant something different and unusual, the two men traveled extensively around the country gleaning ideas. After several trips and thousands of photographs, they realized the trend was to Polynesian restaurants. They investigated more closely.
The first Polynesian restaurant, "Don the Beachcomber's" was built in 1938 in Los Angeles. He later opened two more in Chicago and Palm Springs. Others followed: Trader Vic, the Luau, the Islander, the Mai Kai, the Kon Tiki, Ports of Call, and many others.[4]

—From an early advertisement for the Kahiki

Nowadays, Columbus has something of a reputation as a mecca for foodies. But that wasn't always the case. Ohio's capital city spent much of the twentieth century adrift in the culinary doldrums— with several notable exceptions. The opening of the Kahiki Supper Club

may have been the turning point, although it took another three or four decades for it to finally shake its image as the fried food capital of the Midwest. Up until then, exotic cuisine meant Oriental, and Oriental was synonymous with Chinese.[5]

During the last half of the nineteenth century, most Chinese immigrants to Ohio settled in northeast corner of the state, although their numbers were small. Cleveland, with the largest concentration, had fewer than one hundred Chinese nationals. But they were starting to turn up in smaller towns as well. They had fled China for the same reasons most people leave their native countries—war, disease, famine, poverty, persecution and natural disaster. The United States offered them the hope—if not the promise—of a better tomorrow. And Columbus was a reasonably happening place.

Between 1860 and 1900, Columbus's population increased nearly sevenfold from 18,500 to more than 125,500. It was getting to be a big city— the twenty-eighth largest in the nation. Ben Hope (or Hop) Lee was the first Chinese national to make his home in Columbus. He soon opened a laundry on West Long Street, a few steps from North High. As early as May 1876, Ben began running ads in the *Columbus Dispatch*. They included his name and his likeness. Only Ben Hope Lee wasn't his real name. It was actually Won Koon, and he had been living in Franklin County since at least 1872. He changed his name because Americans teased him about it.[6]

Woh Hing, another laundryman, became the "first Chinaman who ever cast a vote in Central Ohio" and probably in the state on October 14, 1879.[7] Ben attempted to vote, too, but he was turned away when it was discovered that he had not followed through on his stated intention to become a citizen. Nevertheless, he was becoming a prominent member of the community. For example, he was on the official reception committee when former president Ulysses S. Grant came to town later in the year.[8]

According to the U.S. Census, there were eight Chinese men and no women living in Columbus in 1880. Two were tea merchants and the remainder laundrymen. Most Chinese who came to the United States after the California gold rush (1848–55) and the completion of the Transcontinental Railroad (1862–69) found jobs in laundries because that's where the work was. They would soon flood the market.

Doing his best to fit in, Ben, age twenty-nine, was living quietly in a building at the northeast corner of Broad and High Streets in the heart of the city's nascent Chinese community. But when he married Laura Cleary, age eighteen, on June 27, 1881, it made national news. Many single Chinese men would take American wives for the simple fact that few Chinese women

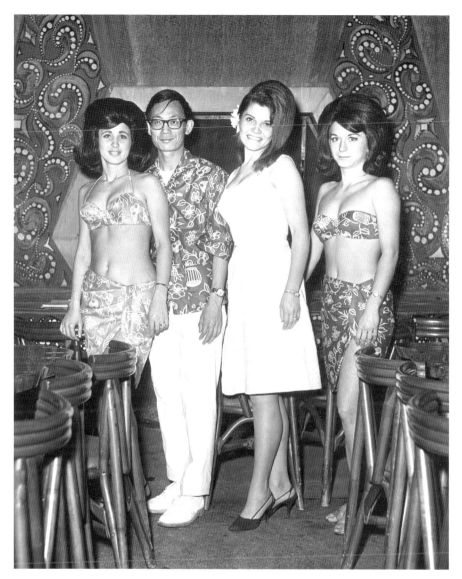

Joyce Saunders, who worked briefly at the Kahiki, poses with other staff members. *Courtesy of Terry Darcangelo.*

had come to the United States. For one thing, the trip was considered too grueling, and for another, immigration officials suspected many would become prostitutes.

Ben and Laura's wedding was held at Wesley Chapel in a Methodist ceremony. Afterward, the newlyweds hosted a banquet at Schneider's

Restaurant for some fifty guests. They likely would have preferred to dine at a Chinese establishment, but there weren't any and wouldn't be for a while.

The very next year, the Chinese Exclusion Act was passed, suspending Chinese immigration for ten years and prohibiting them from becoming naturalized citizens. It had been reluctantly signed into law by President Chester A. Arthur, who had vetoed an earlier version that would have banned Chinese immigration for twenty years.

Although the 1900 census still listed just eight Chinese in Columbus, they were not the same ones. Many Chinese moved rather freely about central Ohio, stopping for a time in Delaware, Chillicothe, Circleville, Coshocton and other surrounding towns, where they often opened branches of their existing businesses. At the time, Ben and Laura were living fifty miles away in Mount Vernon.

In the early years of the twentieth century, the "chop suey craze" arrived in Columbus. A sort of Chinese stew, chop suey's true origins have been lost in the mists of time, but various myths have arisen to fill the void. They all derive from the fact that the Chinese were forced to substitute American vegetables for Chinese in their diets. And the seemingly overnight demand for chop suey—the first Chinese American dish—led them to open restaurants.

Although it may not have been first Chinese restaurant in the city, Kee Jan's at 50 East Long Street appears to have been the first mentioned in the local newspapers—and it wasn't favorable. On May 19, 1902, John Artis shot and killed Charles Henderson at Kee Jan's just after midnight in a dispute over women. The same year, Song Lee Chinese Restaurant at 146½ East Town Street appeared in the city directory. This would soon become Sun Joly's. Two other Oriental restaurants also made their first appearance: Lee Goon's at 429 East Long Street and Albert Aldon's at 11½ West Broad Street.

The first mention of "big headed Sun Joly" was in September 1903 when a member of the Empire Theatre Stock Company—likely Fay Courteney—suggested that they go to a Chinese restaurant following an evening performance.[9] The troupe's stage manager, Francis Powers, was also the author of *The First Born*, a well-known play about Chinese life in San Francisco. When it debuted, Francis and Fay were members of the original cast. Both spoke some Chinese, and Fay could handle a pair of chopsticks as well.

Sun Joly made special preparations for the theatre troupe. According to the reporter who accompanied them, "They were given a big room and a big table with free access to the big kitchen. Little blue tea cups, brown Chinese

nuts and white salted crackers were arranged on the table, and everybody was satisfied and everybody got into the atmosphere and everybody said 'great.'"[10] Fay even donned Chinese slippers for the occasion.

The bill of fare included: "Yoko man, chop suey, can lice, green pepper and tomato steak, guy awy main, oolong tea"—or at least that is what it sounded like to the newspaperman.[11] "Such a clean kitchen," he wrote. "Where is there another restaurant in town on the American plan or the European plan where one may enter the kitchen?"[12]

It was all great fun and gave the actors a chance to continue to play make believe off the stage, much as many Hollywood stars would do sixty years later at the Kahiki Supper Club. The following week, however, Sun Joly's Restaurant was raided by the police. Sun had been a little too eager to please his customers, violating both the midnight closing ordinance and selling beer without a license. When his day in court came, he pleaded guilty and was fined twenty dollars plus costs.

According to professor emeritus Dr. Yung-Chen Lu of Ohio State University, the foundation of the city's Asian American community was "a group of Chinese merchants who immigrated to Philadelphia in the 1880s."[13] After being treated poorly, they moved west to Pittsburgh. "They were treated badly there as well and decided to try Columbus," he explained. "They wrote to their friends and family in Toy San village in Canton province of China about how well they were doing and by 1903, many of them decided to come here as well."[14]

By 1905, the same year the city's first Chinese American baby was born, there were an estimated forty Chinese men living in Columbus, none of whom, it was noted, had ever asked for charity. They worked hard and were said to be thrifty with their money. An overzealous reporter referred to the tiny area in which they lived and worked as "Chinatown." The name did not stick.

The "King Yen Low high class Oriental Chinese Chop Suey Restaurant" held its grand opening on Monday evening, July 17, 1905.[15] King Yen was some mythological figure, and Low or Lo means "house." Located at 216½ South High Street at the corner of Rich, it was still at that site nine years later. Managed by Will C. "Willie" Yeng (or Yen), it was decorated with Oriental furnishings throughout and offered a private dining room for ladies with escorts.[16]

"The establishment is one of the finest of its kind in the United States," a reporter declared. "Beautiful decorations adorn the walls, fine painting and handwork on silk being displayed wonderfully. Numbers of carved

tables inlaid with pearl settings stood in the beautifully decorated room and everywhere was the feeling of cleanliness. The money expended in the place would have started a person in almost any business."[17]

A week later, the *Columbus Dispatch* published a review. "Willie Yen is King Yen Low's American name, meaning '$5 in money,'" the reporter wrote. "Willie being adopted from William, a slang name for a five-dollar bill, and Yen meaning, in Chinese, money."[18] A member of the Chinese Tong of Chow, Willie had invested several thousand dollars in outfitting his establishment.[19]

It took at least twelve and sometimes twenty-four hours to prepare a great Chinese meal. So for his Thursday night "blow out" banquet, Willie—a "descendant of the famous Pang Wang Yew, of cooking fame"— began cooking on Wednesday morning.[20] Featured dishes included bird nest soup and shark fins. The bird nest was actually a type of moss found only in China.

Competition among the chop suey houses was keen, especially between Sun Joly and Willie Yen. Sun had a penchant for setting off fireworks to celebrate Chinese New Year. Willie wanted to do so as well, but the city fathers wouldn't let him. Seems he hadn't learned how to curry political favor yet.

The 1910 city directory lists Foo Lee Chinese and Chop Suey Restaurants at 11½ West Broad Street. This was formerly Albert Aldon's place. The Oriental Restaurant at 30½ North High Street opened on December 19, 1917, on the second floor of the Kroger Grocery Store building.[21] It was started by P.C. "James" San, who already owned several other "high-class" restaurants elsewhere in the state. San Pon, an East High School student, was the manager. Serving both American and Chinese dishes, it attracted many customers from the educational and business communities, who used it for luncheon meetings. The Kahiki would also be a popular spot for office gatherings.

On September 18, 1918, the State Restaurant opened at 13½ East State Street. The proprietors were Louis Yee and You K. Yee. They offered "Superior Cuisine, Excellent Service, and Beautiful Music." The following year, Howard's Popular Players—an African American musical ensemble—performed there. Steubenville's Dean Martin was booked there when he was singing under the name Dino Martini. The State Restaurant would survive for decades.

"Prohibition was the catalyst for today's restaurant," according to reporter Jay Gibran, "Taverns quickly converted to the food business. Hotels, forced to become more competitive, opened the coffee shop, which

served a limited menu but offered quick service."[22] Whatever the impetus, Chinese restaurants began to proliferate in Columbus, and the competition for diners intensified.

From 1922 to at least 1925, Nankin, a restaurant at 1542 North High Street, offered Chinese and American food, including a chop suey dinner. The name Nankin referred to a type of Chinese porcelain with a blue design on a white background.

Then in June 1926, Alfred C. Ginn, a former Chinese student at Ohio State University, and Gin Han, a resident of Santa Barbara, California, leased the entire second floor at the 216 South High Street—the northeast corner of High and Rich—for a Chinese restaurant. They planned to spend more than $25,000 in remodeling and decorating the rooms, including a main dining room, an Oriental tearoom, a large dance floor, private dining rooms and kitchens designed to accommodate both Chinese and American foods. The dance floor would be the first for a Chinese restaurant in Columbus. A new entrance was planned for High Street with a marquee and marble stairway leading to the second floor. It was called Pearl Garden.

Earl Y. Sen leased the corner room in the Frances Hotel at 756 North High Street at Warren, where he opened the Pekin Restaurant in 1927. The following year, Yee San opened the Bamboo Inn in April at 1900 North High Street. According to the *Columbus Dispatch*, bands played

> under draperies which are unequaled in any Chinese restaurant hereabouts. One is of yellow satin, a temple hanging from a Buddhist temple in Canton, China. It is entirely of hand embroidery with small mirrors around the edge, and eat each side is the Phoenix, the Empress' special symbol. The back hanging is of brilliant red with a vivid green overhanging, with embroidered figures representing the "Eight Immortals."[23]

On December 28, 1930, Earl Sen opened the Shanghai Palace at 2352 East Main Street near Dawson Road. An article in the *Dispatch* noted, "The entrance of this establishment is perhaps the most unique in the city. An ornamental gate is set flush to the sidewalk and at least 30 feet in front of the door. The gate is cut in the Chinese style, all angles and upturned cornices, from heavy beams. Painted a bright scarlet and trimmed with gilded lamps and urns, it is strikingly ornamental."[24] The inside of the restaurant was elaborately decorated as well.

The Far East Restaurant debuted on Tuesday, December 2, 1930, at 2525 East Main Street in Bexley in a spot formerly occupied by the Kuehne

Restaurant. The proprietor was Walter Ming, formerly associated with the State Restaurant. He had come from China in 1915, setting first in San Francisco, where he learned to speak English. He then moved to Columbus in 1920, where he worked at the State for several years before relocating to New York, where he ran the kitchen at the Cotton Club, an uptown American Chinese restaurant.

In his new restaurant, Ming planned to create a Greenwich Village atmosphere, naming booths after famous artistic spots throughout the world. Just eight months later, Ming provided another Columbus suburb, Grandview, its first Chinese restaurant on Tuesday, July 14, 1931. He leased a storeroom at 1307 Grandview Avenue to cater to residents of Grandview and Upper Arlington. He called it the New Far East Restaurant.

No sooner did Ming have it up and running than he began manufacturing an egg noodle that was said to be identical with the Chinese American chow mein noodle. Walter sold them in airtight paper bags at one hundred different groceries around Columbus. He also started furnishing ready-to-serve chop suey for other food outlets. In effect, Ming had anticipated the direction the Kahiki would take a half century later.

On Tuesday, January 17, 1939, Walter Ming opened the Olentangy Village Tavern in Clintonville. Located in the Olentangy Village, it matched the early Colonial architectural scheme that pervaded the apartment development.[25] It served both American and Chinese fare. The décor was knotty pine. Writing in 1962, columnist Johnny Jones asserted, "This restaurant is known for its strange drinks."[26] But by then, the Kahiki was being recognized for its strange drinks, too.[27]

Chan Lem and Wu You leased a double storeroom at 33–35 East Town Street for a Chinese restaurant in 1947. For twenty-four years, they had operated the Oriental Restaurant at 82 North High Street. This new dining spot was called Lem's and would be the only Chinese restaurant in downtown Columbus, although it would also serve American food. In 1960, Lem's became Hoy Toy. It continues at 11 West State Street.

Wing Chin and his wife, Dong Shee Chin, of Mansfield moved into the Columbus market on January 10, 1950.[28] Calling their new establishment Jong Mea, they opened at 747 East Broad Street, former site of Yee San's Golden Lotus Restaurant, which dated to 1930 if not before. All menu items were being prepared by chefs who had worked in New York's Chinatown. Their ads would soon feature a quote from nationally known pianist Joe Bushkin, who was appearing at the Grandview Inn. "After trying every Chinese restaurant in sight from New York to Frisco to the Far East," Bushkin proclaimed, "Jong Mea hits the jackpot for me."

In March 1957, Ohio-born Broadway columnist Earl Wilson recalled, "The first time I went to a Chinese restaurant, about 25 years ago in Columbus, I was trying to show off to my date. Picking out just anything at all, I ordered egg foo-yong. It was excellent and for 15 years I always played it safe and ate egg foo-yong. Then my wife became an expert."[29]

Clifford Yee took an old gasoline station on West Broad Street, painted it white, built a kitchen and opened Ding Ho's Chinese Restaurant at 3715 West Broad Street as early as September 1956. Ding Ho means "very good." In 1962, he built a new one with his partner Frank Yee and celebrated by setting off six thousand firecrackers—just like Sun Joly did a half century earlier. It later replaced the Ground Round at 120 Phillipi Road.

From an Oriental restaurant perspective—nobody called them Asian back then—this was the situation when Lee Henry and Bill Sapp took the plunge into the Polynesian bar/restaurant business. Nearly all the ingredients were in place—all except the rum, the pineapple and the pizazz. But it would take someone with imagination, determination and daring to

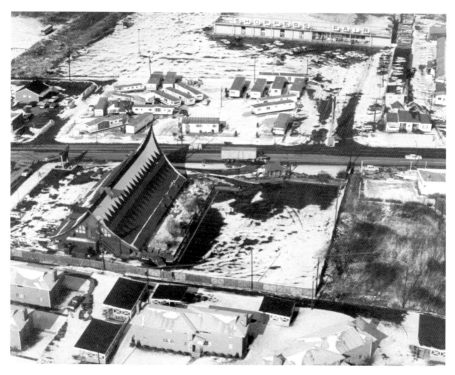

The Kahiki was built across the street from Shoppers Fair. *Courtesy of Kahiki Foods.*

21

put them together. While Polynesia is not part of Asia, the Polynesians are believed to be descended from Southeast Asians, and they had become gastronomically intertwined.

Leland W. Henry Jr. was born on May 9, 1930, in Dayton, Ohio, to Helen (Anderson) and Leland W. Henry Sr. Less than a year later, Lee's father died in Arizona, where he had gone for his health. He was just thirty-six. Lee's mother subsequently married Loren Murphy Berry (1888–1980), a widower with four children of his own. By all accounts, Lee was warmly welcomed into his new family.

Longtime WTVN radio personality John Fraim (1926–2016) was Lee Henry's nephew. According to John, Loren was a major influence on Lee. A Dayton businessman, he had originated the concept of the "Yellow Pages" phone directory in 1910. His motto was "It CAN be done!" A true Horatio Alger character, Loren became extremely wealthy, and his spirit of entrepreneurism clearly rubbed off on Lee. He would also become an investor in Lee's various projects.

After graduating from Oakwood High School, Lee visited "his eccentric aunt Gertrude Embry" and her husband, Higsby, in Los Angeles during the summer of 1949.[30] The Embrys lived in the Las Felix neighborhood, next door to former movie star Adolphe Menjou and down the hill from the Griffith Park Observatory. The couple owned a seventy-five-foot yacht called the *Rainbow* on which they entertained guests while cruising the Catalina Islands. They also liked to dine out, especially at more exotic venues. On several occasions, they took Lee to Don the Beachcomber's, a Polynesian-themed restaurant. Founded by Ernest Gantt, it was the grandfather of all things tiki.

When he entered Ohio State University that fall, Lee didn't know what he wanted to do with his life. He still didn't when he left four years later. Upon graduating in 1954, he took a job at the Union Department Store in Columbus as a salesman in menswear department. It didn't take him long to realize whatever he wanted to do, working in the retail industry wasn't it.

One evening, Lee was commiserating with a college buddy, Francis William "Bill" Sapp, who was still in school studying law. In his own way, Bill's father was as colorful as Lee's and likely exerted an influence on him, too. According to Mark Sapp, Bill's son, Francis William Sapp Sr. (1903–1965)—or "Squire"—was a resourceful individual. For example, during Prohibition, Squire worked at the Deshler Hotel in Columbus as a bellman. Through a connection in Cleveland, he would buy "top-shelf

bottles of booze" and stash them atop the elevator cage.[31] He then sold them to wealthy patrons of the hotel, secretly delivering the bottles to their rooms at a premium price.

A resident of the west side, Squire was good friends with his neighbor, a Jewish immigrant. Once when they were out together, they returned home to find a cross burning in the Jewish man's lawn. Squire kicked it over and quickly extinguished it. However, this purportedly angered the Ku Klux Klan members who were responsible. Believing their lives were in danger, Squire packed everyone in his car, including the neighbor, and drove to Cleveland to wait for the threat to pass. Linda Sapp Long, Bill's daughter, suspects this incident was the catalyst for Squire's decision to relocate. Having saved his money from his liquor sales, he was able to pay cash for a cottage at Buckeye Lake just before the 1929 stock market crash. The cottage would remain in the family until Squire's wife passed away.

Bill mentioned to Lee that he had briefly worked in the restaurant business in Florida and felt it would be a great field to go into. Pooling their resources—and likely with assistance from Loren Berry—they purchased a run-down bar called the Top and turned it into the Top Steak House in 1955. It was an immediate success and remains a popular chophouse to this day.

Squire put up some of the money for the Top as well. He also ensured they received quality meat and produce. And every Sunday morning, he did the books. Linda has fond memories of accompanying her grandfather to the Top, where he provided her with banana Laffy Taffy and packages of Lance peanuts from the snack display. When he passed away in 1965 at the age of sixty-two, he was treasurer of both the Kahiki and the Top Steak House.

"While he enjoyed running the Top," John recalled, "Lee could not forget the exotic Polynesian restaurant in LA he had visited with Gertrude and Higsby."[32] So he made additional trips to visit Gertrude, while also taking in some of the other Polynesian-themed restaurants that were popping up, such as the Trader Vic's that opened in Los Angeles in 1955, the Zamboanga South Seas Club and the Pirate's Den. The LA scene benefited not only from a large immigrant population but also a surfeit "of out-of-work movie set-designers who found new employment in making restaurants into movie sets."[33] They put the "theme" in themed restaurants.

Then in 1957, Lee and Bill visited the Mai-Kai—the most lavish faux-Polynesian restaurant in the world up to that point—in Fort Lauderdale, Florida. Brothers Bob and Jack Thornton had opened it a year earlier, after luring away a number of key staff members from Don the Beachcomber's

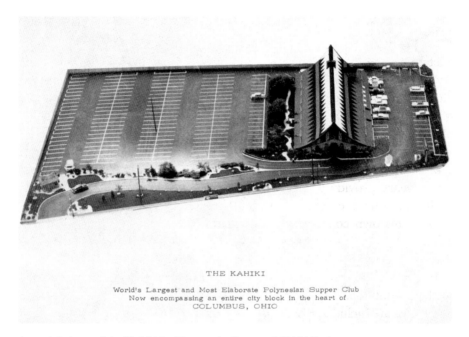

THE KAHIKI

World's Largest and Most Elaborate Polynesian Supper Club
Now encompassing an entire city block in the heart of
COLUMBUS, OHIO

An aerial photo of the Kahiki looking south. *Courtesy of Kahiki Foods*.

Chicago location. Upon their return to Columbus, the two partners opened the Grass Shack at 3583 East Broad Street—a sort of laboratory for testing drink recipes.

The Grass Shack was just a stone's throw from the venerable Desert Inn at 3540 East Broad Street. One of the city's few themed restaurants, it was owned by Joe Alexander and his sons, Albert and Guido. They had previously owned Palm Gardens, a nightclub at 1492 North High Street. When it was shuttered in 1953, the Alexanders opened the Desert Inn. They had since constructed five additions.

Although the Grass Shack was always viewed as just a stepping stone along the way, Bill and Lee did not intend for it to come to an end as quickly as it did. But on June 14, 1959—coincidentally, his birthday—Bill received a late-night call from Sandro Conti, their bar manager and chief mixologist, informing him that it had burned to the ground. This only caused them to redouble their efforts to get their grand Polynesian supper club built and the doors open. But they would need to put together the right team.

Kahiki Scorpion

Victor Bergeron, founder of Trader Vic's, purportedly discovered the Scorpion in Hawaii, where it was served with okolehao, a local distilled alcohol on the order of moonshine. His drink recipes provided the groundwork for many of the better-known tiki cocktails. The Kahiki, naturally, had its own version of the popular mixed drink.

Before becoming a professional bartender at Huli Huli Tiki Lounge in Powell, Ohio, Douglas Winship was a bar writer and blogger for almost fifteen years, providing "assorted ramblings on cocktail life." When he left Huli Huli after a couple of years, he moved to Florida, where he plans to open his own cocktail bar. We asked him to provide his expertise on a handful of differing Kahiki drink recipes, apparently representing two distinct eras—the Bill and Lee era and the Michael Tsao era.

It is quite possible that Sandro Conti's drink recipes were not included in the sale of the Kahiki or Michael preferred to use his own. Winship's comments are included below and in some of the following chapters.

> *The comparison between the early recipes from what I like to call the High tiki era and the later versions from the receding years of the original tiki wave is fascinating and instructive. Each recipe evolved in its own way, but there are some overarching themes that illustrate tiki's history. The later recipes are almost universally sweeter, less boozy and less complex. This reflects the overall course of change in drinking consumer tastes, as well as, I suspect, a general desire for better margins.*
>
> *During the 1970s, all genres of cocktails followed a similar evolutionary path, becoming sweeter and blander, as alcohol faded to an often supporting role for…other intoxicants.*
>
> *The Scorpion is a prime example of this evolution. The earlier recipe has almost twice as much booze as other ingredients. The later version's ratio is the reverse. And in addition to being much less strong tasting, the massive dose of orange juice is a dead giveaway that the Kahiki was going for a blander, softer flavor. The reason you seldom see orange used in modern craft cocktails is that it is like a belt sander to a flavor profile.*
>
> *I find two other interesting things about the evolution. While the later version would taste much less boozy, you would end up downing almost the same amount of alcohol if you finished the drink. And both new and old feature the signature garnish found pretty much everywhere for a Scorpion, a gardenia flower. The Kahiki always seems to have paid at least a fair amount of attention to the classic elements, regardless of the recipe evolutions.*

Kahiki Scorpion (Original)

½ ounce orgeat syrup
1½ ounces lemon juice
2 ounces light rum
1 ounce brandy

Blend and pour into Grapefruit
Supreme Glass. Add gardenia

Kahiki Scorpion (Revised)

3 ounces silver rum
3 ounces orange juice
¾ ounce orgeat syrup
2 ounces lemon juice
½ ounce brandy

Pour ingredients and ice in a
blender. Pulse until combined. Pour
into a glass. Garnish with a gardenia
or other edible flower.

Note: Orgeat is an almond syrup that resembles liquid marzipan.

• • •

2
The Kahiki Experience

IT SEEMED *the American public liked the informal atmosphere offered in Polynesian restaurants, and also liked the exotic food and drinks. Throughout their trips, Sapp and Henry failed to find one that wasn't successful. So The Kahiki was born. But not with a wave of the magic wand. From its inception until its opening in February 1961, thousands of hours of researching and planning went into its design and construction.*

FIRST OF ALL, *the right person had to be found to do the actual design. The requisites were a high sense of aesthetic beauty; a knowledge of the unusual materials that would be used in its construction; a willingness to put in the hours of research necessary to make the atmosphere authentic.*

To do this job, Henry and Sapp chose Coburn Morgan, a painter, designer, decorator, and sculptor, who has degrees in electrical engineering and architecture. He also spent several years in the South Pacific, and had the background needed for a job of this type. Architects were Ned Eller and Ralph Sounik of Design Associates.[34]

—From an early advertisement for the Kahiki

Polynesian was not a word in common parlance in the streets of Columbus during the late nineteenth century. If the man on the street knew anything at all about the Polynesian Islands, it was that they were about as far away as one could go. Certainly, they had never met anyone from there or who had even been there unless it was a well-traveled

sailor, and there were few of those knocking about land-locked Columbus. But in August 1872, the *Columbus Dispatch* reported,

> *A COLORED woman named Clark, at present confined in the city jail, refuses to eat anything unless is it is a white baby boiled alive. She claims to be Queen of some Polynesian Island, and has cannibalized since an infant. The Mayor* [James G. Bull] *is anxious to dispose of this baby eater and will probably have her sent to the Infirmary at an early day.*[35]

Obviously, the poor woman was not who she claimed to be. But what makes the story interesting is that the fantasy she had cobbled together about herself was drawn from the general public's impressions of what life was like in the South Sea isles. She had latched onto the most sensational aspects because that is what the newspapers and books of the era emphasized. But that would change during the next fifty years or so. Polynesia would come to be equated with paradise—and a Columbus native, Earl Schenck, helped paint that picture.

Earl Oscar Schenck (1889–1962) was an actor, adventurer, artist and author who played an important, but largely forgotten, role in awakening American interest in the Polynesia. Born in Columbus, he was the son of Charles Schenck, a wealthy liquor dealer. Following graduation from South High School, Earl attended Ohio State University, where he was active in Strollers, a campus theatrical group. As a freshman, he happened upon a "mass of tangled skeletons partly exhumed by the weather" in rural Fairfield County.[36] They proved to be of prehistoric Indians and led to a two-week-long dig by his archaeology class. He subsequently designed and built a diorama portraying this scene that was put on display at the Ohio Archaeological and Historical Museum.

But in 1911, after being recruited by the Stubbs-Wilson Players, a touring stock company, Earl left college to appear on the New York stage in *The Ghost Breaker*. This led to his being cast in many other productions as well, for which he received generally good notices. Then on July 11, 1913, Earl married Marion Carr Schenck (1873–1936), who had recently divorced his uncle Oscar A. Schenck, a bank cashier.[37]

According to the *Cincinnati Enquirer*, "The newest bridegroom is 16 years younger than his bride, and is an actor. The bride backed him in his efforts on the stage, and this is said to have been one of the real causes of the divorce."[38] The very same day, Uncle Oscar also remarried. After all, his ex-wife had left him with a nine-month-old daughter to raise, also named Marion.

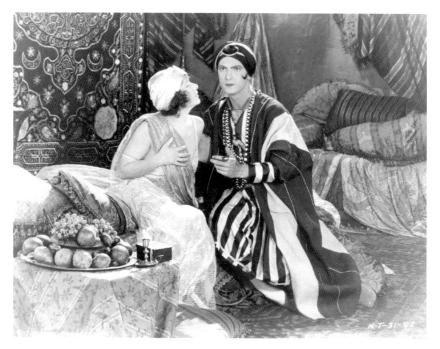

In 1923, Earl Schenck starred in *The Song of Love* with silent movie star Norma Talmadge. *Authors' collection*.

Disappointed in Earl's career choice, Charles Schenck had severed ties with his son. That's when Marion "came into the affair as an 'angel' for the lad."[39] The daughter of Dr. C.S. Carr, publisher of the *Columbus Medical Journal*, Marion was described as a talented magazine writer.[40] Learning that Earl "had written a melodrama and could not find anyone to finance it…Mrs. Schenck induced her husband to venture."[41] Although the play bombed, Earl's movie career would soon heat up. He went on to appear in more than forty motion pictures between 1916 and 1946.

However, after performing opposite such major stars "as Mae Murray, Mae Marsh, Norma Talmadge, Alla Nazimova, and Marion Davies," Earl developed "Klieg eye"—a serious inflammation of the eyes caused by the carbon arc lights used in moviemaking.[42] Taking a break from show business, Earl and Marion went to Hawaii for a vacation. The South Seas were a revelation to him, and he would remain there for the next fourteen years. Commissioned by the Bishop Museum in Honolulu, Earl spent his time traveling about the islands, sculpting detailed miniatures and gathering artifacts. He also wrote articles for *National Geographic* and other periodicals, such as the *Columbus Dispatch*.

Despite their age difference, Earl and Marion remained together until she passed away in 1936 at their home in Tahiti. When Earl finally returned to the United States, he was accompanied by his second wife, Agnes, whom he had met and married in the islands. She was the secretary to the governor of French Oceania. Earl soon launched a career as a lecturer on the South Seas.

In 1939, the year after Earl came home to Columbus, Lazarus Department Store staged a "Polynesian Hei-Tiki" Fashion Show.[43] But the fashions were Polynesian only in that they were somewhat abbreviated and incorporated what were described as "primitive Polynesian" designs. The following year, the Club Gloria booked the dance duo of Nessley and Norman, who treated the patrons to a "Polynesian Fantasy." And Tui "Sikuka" Tamalelam and his Royal Samoan Band performed at the Palace Theater as part of the seventy-person *Bali* musical revue.

When World War II broke out, Earl lent his expertise to the U.S. Navy, helping plot the locations of military bases in the islands. But in 1943, he resumed his career as a motion picture actor, as well as writer, for Metro-Goldwyn-Mayer. However, his health was beginning to fail, and after suffering several strokes, Earl returned to his beloved Tahiti, where he passed away at the age of seventy-two.

Earl's first book was *Come Unto These Yellow Sands*, published in 1940 by Bobbs-Merrill.[44] The title was taken from Ariel's song in Shakespeare's *The Tempest* and recounted Earl's experiences living in the islands. The book includes many of his sketches. He followed up with *Lean with the Wind* in 1945 and *Weeds of Violence* in 1949—both novels set in the South Seas. His books, articles and talks helped shape the public perception of Polynesia.

During the 1950s, America's love affair with the Polynesian islands blossomed. By 1956, Polynesian décor was being hailed by designers as the next decorative motif in homes, displacing Oriental designs because it mixed so well with mid-century modern. Three years later, home builder Ernest G. Fritsche introduced "The Polynesian" model in its Holly Hill development on the west side of Columbus.

Having recognized that a Polynesian wave was coming, Lee and Bill made preparations to ride it. According to Lee, "We researched madly, reading everything the explorers had written—in French and German as well as in English—about life as it once was in the South Seas."[45] Presumably, that included the works of Earl Schenck. In addition to dining in as many Polynesian restaurants as they could and interviewing the owners, they wrote "about 1,400 letters to places like Hawaii, Japan, Hong Kong, the Philippines, and the South Seas Islands."[46]

No doubt the partners were also familiar with the philosophy of management consultant Peter Drucker, who preached, "Because the purpose of a business is to create a customer, the business enterprise has two—and only two—basic functions: marketing and innovation."[47]

Although food sales are typically greater than alcohol sales, most successful restaurants are profitable because of their beverage sales. That's why Bill and Lee put some much emphasis on their cocktail offerings. Fortunately, they could draw on the pioneering work of Ernest "Donn Beach" Gantt, also known as Don the Beachcomber, and Victor Bergeron, founder of Trader Vic's. Both spent decades developing exotic drinks. But Bergeron didn't make it easy to follow in his footsteps. Over the years, he created some eighty different drinks, while doing his best to keep his recipes secret. His bartenders were instructed to mix so much from each of the bottles numbered one, two, three and so on without knowing exactly what was in each bottle.

Alejandro "Sandro" Conti (1927–2020), the ad hoc bartender Bill and Lee met at the Top Steak House one night when he came in and fixed himself a drink, was purportedly born in San Salvador, raised in Nicaragua and attended school in Italy.[48] He gained his knowledge of rums, however, from South America. Impressed with his knack for inventing cocktails, Bill and Lee hired him to be their official mixologist. Their next step was to open the Grass Shack in July 1958 as a venue for Sandro Conti's drinks. They would later claim Sandro spent three years working in a "special lab"—in other words, the Grass Shack—to come up with the recipes.

Columnist Johnny Jones (1899–1971) took note of this former barbecue rib joint in March 1960 when he wrote: "The Grass Shack and its atmosphere has been causing crowds to attend an unusual place. One concoction served is known as 'Smoking Eruption.' It does resemble a volcano. The waitress at this spot is Polynesian looking and beautiful. Maps and decorations remind one of the islands."[49]

The Smoking Eruption was one of Sandro's showy cocktails that helped create the Kahiki legend. In 1999, *Dispatch* columnist Mike Harden repeated the following anecdote:

A Columbus woman, who asked to remain anonymous, wrote that she once was having dinner at the Kahiki when she was asked whether she would like something to drink. The East Side, Polynesian-style restaurant features an array of exotically named libations, one of which is called the Smoking Eruption. The woman said she knew that was the drink she wanted to order, but instead blurted, "I want a fiery erection."[50]

As Sandro was occupied inventing new tiki drinks, Lee and Bill were busy brainstorming and barnstorming around the county with their new buddy, Coburn Morgan (1922–1993), a talented designer and artist. Next to the two of them, Coburn was the most important player in the creation of the Kahiki. Born in a two-room log cabin in Line Creek, Letcher County, Kentucky, Coburn entered the Marines in 1942, three years after graduating from Lexington High School. Leaving the corps in 1949 with a degree in electronics, he was later recalled and sent to Korea.

While hospitalized for five months with shrapnel wounds, Coburn occupied himself by redesigning the officers' and enlisted men's clubs. Although he earned a degree in architecture from the University of Kentucky in 1955, he never became a licensed architect. But everyone who knew him concedes he was an amazingly gifted designer.

Four years later, Coburn came to Columbus. When Lee and Bill met him, he was head of the design division of Newark, Ohio–based Tectum Corporation, manufacturer of high-impact wood fiber acoustical panels. The company was founded in 1950 by Murray D. Lincoln, president of the Farm Bureau Mutual Automobile Insurance Company, now known as Nationwide Insurance.[51] It soon found a market for its panels in school construction, where they were used to reduce noise in hallways, gymnasiums and indoor swimming pools. But Coburn, ever the artist, was also using it to make decorative wall panels. The three of them—Bill, Lee and Coburn—were becoming experts on Polynesian culture, both real and ersatz.

The site chosen by Lee and Bill for the Kahiki was a plot of land at the corner of East Broad Street and Napoleon Avenue. It had originally been a farm owned by a Greek couple, Dominic and Carmella Casabarro. The farm extended south to East Mound Street. Their daughter, Margaret, would later marry Constantine "Gus" Soteriades, who operated a succession of Gus's Fine Foods restaurants in Columbus, including one in Whitehall. When Bill and Lee bought the property, it had most recently been Cooper's Broad Tavern, a barbecue restaurant.

When it came to choosing an architectural firm for the proposed Polynesian supper club, Ned Eller and Ralph Sounik of Design Associates— later Sounik-Eller-Martin, or S.E.M.—had the inside track.[52] Lee and Marilyn (Mansfield) Henry had previously used Design Associates to design and oversee the construction of their new home in Rolling Ridge, northeast of Columbus near Blendon Woods. Eller stated that the "project's architectural design had nothing in common with that of The Kahiki, but

was nevertheless unique in its own way and helped to establish a years-long continuing personal and professional relationship with the Henrys."[53]

Ralph Sounik (1927–2012) was born in Cleveland, Ohio. After graduating from Maple Heights High School in 1946, he enlisted in the U.S. Air Force. While stationed at Lockbourne Air Force Base, he served as commander of the 121st Armament & Electronics Maintenance Squadron. He attained the rank of lieutenant colonel prior to retiring from the reserves. Ralph was also a graduate of the Ohio State University College of Architecture and practiced architecture for many years at Design Associates and, later, S.E.M. Partners with Ned Eller.

Ned B. Eller was born in New Jersey in 1932. His father was Ohio State University's first graduate in engineering physics and was employed by the Western Union Company in New York City, developing and implementing intercontinental fax lines through the newly installed trans-Atlantic cable. When Ned was nine, his family moved because had father was recruited by Bendix Aviation Corporation to work in the air defense industry in anticipation of the country's entry into World War II.

As one of his older brothers became a commercial artist and the other an engineer like his father, Ned feels that he "had a bit of both in his genes," since architecture is a mix of art and engineering. At S.E.M., they handled various projects, including "schools; colleges; churches; auto dealerships; medical facilities; single, group-home, and multifamily residential; office buildings; retail and other commercial facilities; historic renovation projects; various public facilities; and even some work in correctional facilities."[54]

"The history of The Kahiki's design," to quote Eller, "is a bit complicated."[55] The original concept was the brainchild of "architectural designer Bernie Altenbach and the exceptionally talented interior designer Coburn Morgan."[56] The participation of Bernard Gerald Altenbach (1927–1997) had a profound impact on the iconic look of the Kahiki, but there were limits to what he could actually do. The meetinghouse or "inverted war canoe" idea was his. The large fireplace and the two giant moai that stood outside were thought up by Bernie, Coburn and Bill. But despite his undeniable talents as a designer and a degree in engineering from Ohio State, Bernie was not a professionally registered architect. He was an "Architectural Consultant."

So Design Associates worked with Coburn and Bernie "to transform that original concept into the developed design, construction documents, and building construction services phases"—or what Eller likes to call "The

Kahiki Experience."[57] As he had been with Lee's house, Eller became the principal-in-charge of the project.

It has long been rumored that certain design elements developed by Design Associates for the Kahiki were subsequently incorporated into Covenant Presbyterian Church in Upper Arlington. As Dave Timmons, head of the congregation's building committee in 1959, recalled a master plan for the church was developed by the firm of Benham, Richards & Armstrong four years earlier. Tim Armstrong, the principal architect, had proposed "a neo-gothic vertical-walled brick sanctuary."[58]

However, by 1962, the building committee had decided to go in a different direction. According to Timmons, some members of the committee had become "intrigued with the new concepts which Sounik was executing at London Presbyterian and Westerville Methodist among others."[59] Both firms had been popularizing steep-pitched roofs, which gave a "big tent" effect. So they hired Design Associates for the church project.

Although the Kahiki had been completed a year earlier, Eller insists there was no architectural design relationship between the two buildings. "The roof design of [the Covenant Church] was intended as an inspirational expression of the denominational client's faith. The Kahiki's roof, on the other hand, was a structurally, aesthetically, and extremely complex form intended only to convey the impression of a Polynesian architectural theme."[60] On the other hand, "I would imagine that we mentioned our work on The Kahiki during an interview, so maybe it helped."[61]

While the Kahiki was the most unique of their restaurant designs, they had done other themed eateries. He cited Young Chow's in Beckley, West Virginia, as an example. Though "much smaller and more subtle in its design, [it is] nevertheless another recognizable architectural expression of a cultural identity."[62]

"There are only 80 such [tiki] restaurants in the United States," Bill Sapp told the *Columbus Dispatch* in August 1960, "and our crew has been in all of the important ones. In the building and designing of such a restaurant, it was definitely to our advantage to incorporate every other good idea as well as our own since The Kahiki will be the largest Polynesian restaurant in the world."[63] And it began by hauling in sixty tons of coral rock and a whole lot of bamboo.

To create the giant moai sculptures guarding the front door, the towering fireplace inside and the huge clamshell bathroom sinks, Bill and Lee turned to Philip E. Kientz (1924–2006). Born into a family of stonecutters, Phil grew up on South Fifth Street within walking distance of Schmidt's Sausage

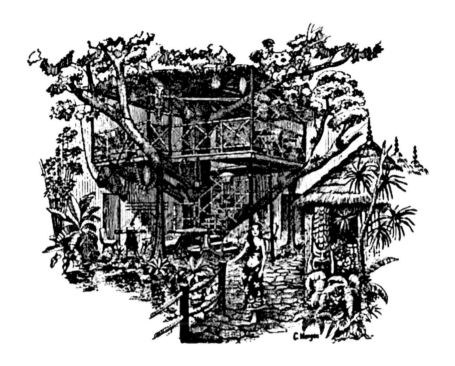

A Coburn Morgan sketch of the proposed treehouse. *Authors' collection.*

Haus in the heart of German Village. Following his graduation from South High School, eighteen-year-old Phil won a year's scholarship to Columbus Art School—now known as Columbus College of Art and Design. However, World War II intervened.

After serving in the U.S. Coast Guard, Phil enrolled at CCAD in 1945. Then, degree in hand, he went to work as an artist and stonemason, eventually opening Kientz Custom Studio. Along with George Wilson and Byron Kohn, Phil started the Village Art Colony, just across the street from the German Village Society office where Phil was a trustee. Phil taught free-hand drawing and sculpture, Wilson oils and tempera and Kohn watercolor. Although he was responsible for a large number of artworks around Columbus, Phil was proudest of his iconic creations for the Kahiki.

Initially, Burwell's Nursery and Garden Store, 4060 East Main, provided the plants used to enhance the architecture. Started by Walter Burwell in 1922, when he was a graduating horticulture student at Ohio State University, it had expanded immensely from the original small plot

The garden outside the Kahiki was as tropical as the climate would support. *Courtesy of Bill Sapp.*

of land. In 1924, he was joined by Bert Keinmaier, a fellow Ohio State student. The landscape department, with its four designers, was under the leadership of Jim Fornes.

Prior to taking on the Kahiki, Burwells had landscaped gardens for the Park Towers Apartments, Nationwide Inn, Olentangy Inn, Huntington National Bank branch offices and Riverside Methodist Hospital. Just the previous year, it won a national award for its work on the grounds surrounding the Buckeye Union Insurance building.

Then in May 1963, Bill and Lee had eighteen palm trees of various sizes trucked in from Florida and planted on the grounds surrounding the Kahiki. However, they did not thrive in Ohio's contrasting climate of hot summers and cold winters.

Creating the most magnificent Polynesian restaurant in the world was one thing. Running it would be quite another. While the Kahiki was still under construction, Harold M. "Hal" Noguchi (1922–2004) was hired as the first general manager. Born in Los Angeles, California, of Japanese parentage, he served in the U.S. Army during World War II. Afterward, he attended UCLA and graduated from Syracuse University with a master's degree in industrial psychology.

While living in Chicago, Hal worked for Cadillac Employment Agency, a pioneer in the field of finding employment for Nisei—people who were born in the United States or Canada but whose parents had emigrated from Japan. Under the pen name "Hal Noel," he wrote articles for the *Pacific Citizen* newspaper about the challenges Nisei faced obtaining jobs.

No doubt it was Hal's expertise in the employment field, as well as his training in psychology, that paved the way for him to enter the field of restaurant management. He was working at the Club Waikiki (previously Honolulu Harry's Waikiki) in Chicago when Bill and Lee lured him to Columbus to manage the Kahiki—a much, much larger operation. Later, he would manage various club hotels around the country and even teach school for a time before retiring in Columbus, Georgia, where he passed away at the age of eighty-one.

One of Hal's first hires was Freddy Eberlyn, a cook born in Dutch New Guinea (now part of Indonesia). A graduate of the University of Amsterdam, Freddy spoke six languages. Facility with languages was a valuable skill at the Kahiki. Someone was always translating for someone else. Although Freddy hailed from an island in the Pacific, it was not part of the Polynesian Triangle, which includes Hawaii, Samoa, Fiji, Tahiti, Tonga, Tuvalu, the Cook Islands, New Zealand and more than one thousand other islands. As

a group, they are often called the South Sea Islands, although the Hawaiian Islands are actually in the northern Pacific.

However, Hal Noguchi's tenure at the Kahiki was brief. A couple of months after the Kahiki opened in February 1961, Lee Henry and his new wife, Marilyn, visited Ithaca, New York—by chartered plane, no less.[64] The purpose of their trip was to interview students from the Cornell University School of Hotel Administration. It was famous for its program in hospitality management, and Lee felt that an operation the size of the Kahiki could benefit from hiring someone with this training.

Lee settled on Craig Moore, who would graduate in June. Although he had offers from Marriott, Pan American Airline and ARA, a food and beverage service company based at the Los Angeles Airport, Craig was intrigued by the Kahiki job. "I never planned to be a big Corporation person," he told John Fraim. "I planned to do my own entrepreneurial thing after 4 or 5 years of experience. I really liked the food and beverage part of the hotel business. I also knew that an F&B guy would make much more money running a hotel than just a hotel person."[65]

Accepting Lee's offer to manage the Kahiki, Craig moved to Columbus in June. As John observed, "Apart from being astounded when he first saw the restaurant, one of the first things [Craig] noticed was the food"—a hybrid of Chinese and Hawaiian.[66]

The Kahiki's first chef was Philip C.W. Chin (1920–1979), a graduate of Texas A&M in mechanical engineering.[67] Born in China, he left before the Communists took over. "While in college, he and a classmate started a restaurant to help see them through the financial burden of school," a Kahiki ad noted.[68] The classmate later became a structural engineer at North American–Rockwell.

One Kahiki ad detailed how Polynesian cuisine arose:[69]

It is the result of the gradual evolutionary process that came about paralleling the fusion of cultures and races in the islands since their discovery by the western world. Islanders ate nothing but fish, fruit, and a few vegetables prior to their contact with the explorers and navies of the world powers in the early 1800's. Then, then to staple diet, was added the various cooking techniques of the Portuguese, Spanish, English, and Dutch explorers and navies. These were followed by trading vessels that established regular commercial routes through area, and these crews added their tastes to Polynesian fare.[70]

Even the appointment of a Chinese man to the executive chef position was presented as being in keeping with tradition. When the Chinese and later the Japanese came to the Polynesian islands, they were hired to perform domestic chores, including cooking. Adapting their own techniques to their employers' tastes, they "created Polynesian cuisine, a mixture of ingredients from most of the countries of the world."[71] Consequently, the Kahiki ran help wanted ads in Chinese-language newspapers published in San Francisco.

Although the line cooks didn't particularly like Chef Chin, Craig still felt he was a good hire. In the days before hand calculators, Phil used an abacus to figure percentages on menu items, while Craig relied on a slide rule. Phil's old-school computations, Craig conceded, were generally quicker.

The kitchen equipment ranged from the most up-to-date radar range to ancient Chinese kettles. Because the kettles retained many times the temperature of any other cooking container, the Kahiki cooks could prepare any menu item in less than four minutes. As a result, no item needed to be precooked. Any dish that was not served within ten or twelve minutes was discarded.

Chef Chin would remain at the Kahiki until it was sold to Mitch Boich. Meanwhile, he had lent his name to Salvatore "Sully" Presutti, a third-generation restaurateur, and home builder Don C. Ettore in 1976 to form Presutti & Chin's, a small chain of restaurants that offered both Italian and Chinese food at two dine-in locations and two carry-out kiosks. The partners had leased twenty sites and hoped to sell franchises for the self-contained Fotomat-style booths at $70,000 each, but by 1982 it had folded.[72]

• • •

Kahiki's Fried Shrimp Polynesian

Shrimp was part of the Polynesian diet, but not always in ways that appealed to American tastes. Fafaru is a Polynesian dish that would be a hard sell in a midwestern restaurant. It consisted of "slices of tuna or parrot fishes that have been macerated in sea water with crushed heads of shrimps."[73] Earl Schenck wrote of dining on varos—or sea centipedes—which were like elongated lobsters but with a more "heavenly" flavor. They simply "sucked" the creatures out of their shells. If you are not a fan of shrimp, a mild fish such as cod, Alaskan pollock or tilapia can be substituted.

This recipe was published in the Columbus Dispatch *in 1973. Surprisingly, it doesn't include pineapple, coconut or garlic, as most popular "Polynesian" shrimp recipes do today.*

Batter Ingredients

1 cup all-purpose flour
1 cup cornstarch
1 teaspoon baking powder
Pinch salt
Pinch sugar
2 eggs, well beaten
Milk
Water

For batter, combine flour, cornstarch, baking powder, salt, sugar and eggs. Add equal amounts of milk and water and mix well to achieve a pancake batter consistency. Peel and devein shrimp and split body of shrimp. Use index finger, thumb and middle finger to separate shrimp into three prongs. Dip in batter and fry in deep fat at 350 degrees until golden brown. Serve with Kahiki Sauce (recipe follows).

Kahiki Sauce

1 cup catsup
1 cup chili sauce
1 tablespoon sugar
Juice of ½ lemon
1 teaspoon dry mustard
1 teaspoon horseradish
1 tablespoon Worcestershire sauce

Combine ingredients thoroughly.

• • •

3
Something Different

AFTER NINE months of actual construction, the Kahiki opened its door to the curious and eager public. From the beginning, it has been described as "something different."

Many like the Kahiki because it gives them a glimpse of the South Seas, a world some of them have never seen and may never see. Its authenticity sates just a little their curiosity about the islands and the people who live there, their goods, taboos, rituals, and environment.

Male meeting houses in New Guinea supplied the idea for the unusual structure of the Kahiki. The inverse curved roof, ranging from 40 to 60 feet high, contains the design found on many war canoes that purportedly repels evil spirits.[74]

—From an early advertisement for the Kahiki

Before a customer ever set foot inside the Kahiki, he or she had likely been seduced by the advertising campaign. For a project as unprecedented as the Kahiki Supper Club, Lee and Bill wanted someone who could think big and deliver bigger. Someone who was an expert in ballyhoo on an epic scale. Someone who knew what would pack the people in. Someone like Bob Slatzer.

Originally from Marion, Ohio, Robert F. "Bob" Slatzer (1927–2005) graduated from Ohio State University in 1947 and set off for Hollywood. He eventually landed a job—briefly—writing publicity for Twentieth Century Fox Studios. By 1949, however, he had returned to Ohio and would soon join the advertising staff of the *Columbus Dispatch*.

When the Kahiki opened its doors, the newly formed Slatzer Advertising Company was handling the account. It was likely Bob who arranged the tie-in with Kenley Players, the summer stock theater company that for many years brought the "stars" of television and movies to the Columbus stage—as well as those of Dayton, Akron and Warren. For example, in July 1961, Bob helped Zsa Zsa Gabor, who was appearing in *Blithe Spirit*, establish a scholarship fund for Hungarian refugees at Ohio State University. Naturally, she also dropped by the Kahiki, but she was not the first. Gordon and Sheila MacRae, who appeared in *Bells Are Ringing* a month earlier, held that distinction.

Then on October 12, 1961, a new Cinerama film, *South Seas Adventure*, opened at the RKO Grand Theater in Columbus. Unlike the previous four Cinerama offerings, it was not a straight documentary. It included some fictional stories. But it might as well have been a two-hour commercial for the Kahiki. No doubt Slatzer thought so and arranged another tie-in. For the pre-opening ceremonies, WTVN-TV's Gene Fullen served as emcee for a thirty-minute show that included hula dancers and the Beachcomber Trio from the supper club. As a backdrop, Coburn Morgan assembled a Polynesian hut, a few idols and even a water feature.

Just over a year later on November 5, 1962, WTVN-TV, Channel 6, broadcast a half-hour, behind-the-scenes look at the Kahiki on its weekly *Mann to Man* series, hosted by Dick Mann. Someone took note: the following year, Mann landed a programming position at CBS in New York City.

Turning his attention to other media, Bob founded Robert F. Slatzer Television Productions and in 1963 became host of *The Great Outdoors*, a weekly series on WLW-C, Channel 4.[75] But the story of his involvement with Lee doesn't end with the Kahiki. When Carl Ross struck oil on his Delaware County farm in April 1964, Lee just happened to own two shares of it. Unofficial estimates were that the "gusher"—the first in county history—would produce one thousand barrels a day. And Ross, who was developing land for a housing project, was already thinking about quitting his job. Then they struck oil again the next month. The wells were drilled by Slatzer Oil and Gas Company of Columbus, which was founded by Bob Slatzer in 1960. And Bob's television production company filmed a one-hour special on the oil boom.

But Bob wasn't quite finished with Hollywood and soon returned to the West Coast. In 1968, he was listed as the director and co-writer of a female motorcycle gang movie called *The Hellcats* released by Crown International Pictures. Another film, *Bigfoot*, followed two years later. He also served as

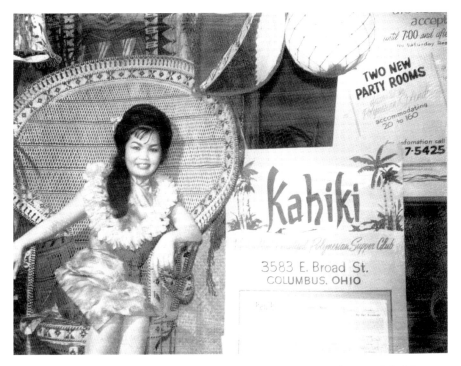

Mary Davis was the public face of the Kahiki at many trade events. *Courtesy of Aja Miyamoto.*

director of the National Academy of Television Arts and Sciences—or so he claimed. But there are many things on his résumé that are hard to verify. Hype, after all, was his first language.

During the summer of 1952, the *Dispatch* reported that Bob made a recent visit to Niagara Falls, Ontario, to visit Marilyn Monroe, who was on location filming the movie *Niagara*. He quoted her as saying, "My best picture to be released yet is 'We're Not Married.' In this story the studio lets me be myself…and I display all my talents to the best advantage."[76] Over two decades later, Bob published a bestselling—and highly controversial— biography, *The Life and Curious Death of Marilyn Monroe.* In it, he claimed he had been secretly married to the late movie star for five days in 1952 and called for a new inquiry into her death. Few believed his story, although gossip columnist Dorothy Kilgallen once mentioned Bob was wooing Marilyn by phone and mail.[77]

There were many people whose contributions to the Kahiki will never be recognized because there is no way of identifying who was responsible for what. Take the Kahiki billboards. There were two—one on the far east

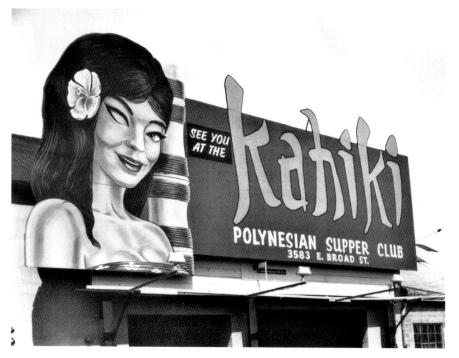

The fondly remembered "Winking Wahini" billboard—winking. *Courtesy of Bill Sapp.*

side and the other on the northwest. Those who saw one will never forget it. Those who didn't can't imagine the effect that it had at that particular time and place. The Winking Wahini billboard, more than any other advertising campaign, likely was the siren's call that lured thousands of customers to first set foot in the door of the Kahiki.

Presumably, Coburn Morgan would have done the original illustration. However, its execution was left to the artistry of Joachim Vincent "Vince" Segieth (1928–2018). Although Vince's name may not be well known, his work certainly was. A sign painter by trade and later art director at Columbus Outdoor Advertising, he was responsible for many well-remembered billboards, including the baby with the moving diaper wearing Rod's Western Palace boots. But it was the gigantic portrait of a Polynesian woman with a flower in her hair that remains his legacy over half a century later.

Born in Marienwerder, West Prussia (now Kwidzyn, Poland), Vince endured famine both during and after World War II. Then at the age of eighteen, he made a desperate decision to escape from behind the Iron Curtain by crossing through East Germany. Once in the West, he found work as a painter's apprentice, restoring cathedrals and other bomb-damaged buildings.

Under the sponsorship of Dr. Walter Meiden, a professor of romance languages at Ohio State, Vince came to Columbus in 1953.[78] His talent for painting was recognized by Thomas Kaplin, president of Columbus Outdoor Advertising, who hired him as a billboard artist. In an interview with the *Columbus Dispatch*, Vince explained how his artists worked in a 60-by-120-foot room with a 35-foot ceiling painting 14-by-48-foot billboards. The choice of a hand-painted billboard over one printed on paper was largely economic.

At the time, the cost for hand-painting a billboard ranged from $1,000 to $1,500 or more depending on how intricate it was. "A customer would have to have 500 boards around the country to break even on print," he said, assuming it was the largest size.[79] The cost of animating it was additional. Vince took pride in the fact that matte artist Mark Sullivan, one of the Columbus College of Art and Design students he sponsored, used his skills to paint some of the colossal backdrops for the *Star Wars* movies.

Of course, the Winking Wahini was just the tip of the iceberg. Perhaps no other restaurant in Columbus history made as substantial use of newspaper advertising as the Kahiki Supper Club. There was everything from thirty- to forty-word "ticklers" to full-color, multi-page inserts in the *Columbus Dispatch*, in addition to regular half-column ads in dozens of newspapers throughout Ohio.[80]

Loren Murphy Berry (1888–1980), Lee Henry's stepfather, had made a fortune in the advertising business. Known as "Mr. Yellow Pages," he had started from humble circumstances. Born in Wabash, Indiana, in 1888, he lost his father just four years later and had to grow up fast. At the age of eight, Loren was making and selling horseradish door to door while also peddling the *Saturday Evening Post* and operating a laundry route. During high school, he worked for the *Wabash Plain Dealer* as a reporter while serving as the business manager of the school paper and annual. It was during this period that he learned the basics of selling advertising space.

Following graduation, Loren started his own business—the Ohio Guide Company. He sold advertising space in the timetables published by the electric interurban rail lines which served nearly any town of consequence throughout the Midwest. This led to his being asked by the manager of the United Telephone Company in Marion, Indiana—purportedly his uncle—if he could sell advertising for the telephone directory.

Neither telephone directories nor advertising in them was a new idea. In fact, the phrase *Yellow Pages* has been traced back to 1883 when one such directory ran out of white paper and substituted yellow. However, they were

published irregularly, did not attract many ads and were regarded by the telephone companies as an expense, not a source of revenue.

Nevertheless, Loren took the job and just over a week a week later had sold $780 worth of ads. Not only did it cover his commission but entirely paid for the cost of printing the directory and earned United Telephone a profit as well. Loren then started selling ads for other directories in Indiana and Ohio and moved to Dayton, Ohio, in 1910. His big break came when he sold his services to the United States Independent Telephone Company of Columbus, which controlled twenty telephone companies statewide.

"A turning point in Berry's history came in 1921 when the U.S. government finally decided that local telephone competition caused more problems than it was worth, and legislation was passed to allow for natural monopolies and the consolidation of rival phone companies," according to a company history.[81] Although Loren lost some major customers, in the long run it worked to his benefit because advertisers knew they could reach everyone in the community by coming to him. Given that Lee Henry idolized his stepfather, it is likely he knew this story by heart and also had learned its lessons.

The "ticklers" were usually two or three sentences built on some pop culture reference, a play on words or a joke. They stood in stark contrast to the larger, text-heavy ads that explained in detail what the Kahiki was and what needs it fulfilled in the customer's life. The ticklers were sometimes tied to a particular month, and many of them were republished during the years that followed, generally with little or no revision.

It appears the ticklers were initially written by Mary Selleck (1923–2009), longtime publicist for Lombard's Furniture, who likely occupied a similar role for the Kahiki in its early years. This is suggested by a letter she wrote to columnist Johnny Jones on behalf of the Kahiki in response to his proposed match between the Jai Lai's fighting fish and the Kahiki's:

> So you want to the see Kahiki fish fight the Jail Lai fish? Our fighter is all ready [sic]. A Moray eel, just brought in from the airport, was popped into its tank and immediately jumped out of it into a tank eight feet away. Not content with that activity it ate four Blue Angels valued at $40 each!
>
> We also have another rare Lion fish a lovely thing that opens up like a flower. If, however, it should sting you, you're finished! There's not known antitoxin![82]

Although not nearly as long, the ticklers had a similar tone. They may well have been inspired by Elmer Wheeler's classic "Wheelerpoints."[83] The

head of Tested Selling Institute, Wheeler advised sellers how to win sales and influence customers. He was responsible for such marketing axioms as "Don't Sell the Steak—Sell the Sizzle!" and "Don't Ask If—Ask Which!" Over the course of ten years, he created 105,000 Tested Selling Sentences for 5,000 products. Nicknamed "Mr. Sizzle," Wheeler was considered America's greatest salesman up until his death in 1968.

What follows is a sampling of the many tickler ads that the Kahiki ran during the first ten years of its existence. The address and/or phone number have been omitted in most cases.

To Malihinis (new friends) and Kamaainas (oldtimers)… and announcement. Kahiki has TWO NEW CUSTOMER SERVICES. RESERVATIONS and PARTY ROOMS for your BANQUEST, LUAUS, and MEETINGS. The rooms were the Oahu and the Kilakila, which could accommodate 60 to 130 persons. Welakahao!

"Widow's Wail" and "Instant Urge" aren't names of TV psychiatry shows…they're two popular drinks on the KAHIKI menu. And you don't need an analyst to tell you that the KAHKI's south sea atmosphere is wonderful therapy. He probably goes there himself.

Did you know that the KAHIKI Supper Club is an authentic reproduction of a Male Meeting House in New Guinness… exact in every way with one exception…Ladies are invited! The males in New Guinea don't know what they're missing.

There's so much planning involved in a South Sea cruise. Tickets, reservations, shots, itineraries. Why not come to the Kahiki 3583 E. Broad St., instead? It's just as much fun, and you don't even have to pack a bag!

If all the pineapples used at 3583 East Broad Street were placed end to end they would stretch for miles. Over 1000 pineapples a month go into the making of the KAHIKI'S many delightful Polynesian drinks. What does this mean to you? Try one and see!

Ohio…Oceanless on all 4 sides. But that doesn't mean you can't pretend, especially when there's rate ocean fish to eat, giant shells, and ocean tortoise, and even sensual sea maidens only minutes from your home! Kahiki…Polynesia in Ohio.

GIVING UP SMOKING? Here's a relaxing pleasurable way to spy on others with the habit. See our flaming Tiki gods at the door. See how smoking has gone to their heads, and why the KAHIKI'S exotic atmosphere will go to your head. You'll forget reaching for the pack as you reach for real fun at the KAHIKI.

Children love the enchantments of Kahiki. Watch little eyes grow wondrous as they view the exotic tropical fish. See them delight in a refreshing Polynesian fruit drink, served in a giant pineapple they can take home. Kahiki makes everyone feel young.

Does this sound unreal? A trip to a Polynesian island. Does this sound exciting? Cascading waterfalls; romantic music, island enchantment. Does this sound exotic? Chunks of Filet Mignon, prepared and sautéed on a flaming sword. It's all yours…much more too.

Don't look at travel ads longingly. Don't despair when you see postcards of exotic islands…there's a paradise right here in Columbus, the Kahiki. Such and authentic Polynesian atmosphere you'll think you spent an evening in the South Seas. Send Kahiki postcards to your friends…they'll think so too!

It costs $6214.39 to charter a private plane to Tahiti. You and your friends could have a fine party there. Or, you can fly out to 3583 East Broad and have an even finer party in one of the three beautiful Kahiki party rooms…besides…we're terribly handy.

Englishmen have their pubs, Germans their Beer gardens, Frenchmen their sidewalk cafes. You can even travel to New Guinea and visit a Male Meeting House. Or you can drive out East Broad to the Kahiki and have the time of your life. The Kahiki is designed around a male meeting house, only better… New Guinea isn't air conditioned.

res'er va'tion (rez'er va'shun), n, 1. Act of reserving, esp, for oneself; as, the reservation of rights by the States; 2. A limiting condition; limitation; as, to yield without reservation. 3. Nice to have when you plan a visit to the Kahiki. Phone BE. 7-5425. 4. U.S. A tract of the public land reserved for special use, as for forests, for Indians, etc.

An ancient Chinese proverb says, "To know the road ahead ask those coming back." You probably won't have to ask your friends about their visit to the KAHIKI…they'll tell you.

Want to be the hostess with the mostest? Then have your party at the KAHIKI. Nothing beat the authentic Polynesian atmosphere of the KAHKI's three party rooms. Your guests can "go native" and dress luau style. It's in! For a colorful brochure to help you plan, call BE-7-5425.

Don't throw your hat in the door first. Take her a gift from our unusual gift shop, featuring items from all over the world. Sure, you lingered a little too long at the Outrigger Bar, but who doesn't? A present from the KAHIKI Gift Shop is the best way to say "Sorry I'm late!"

Chief Bonowana has never seen a wolverine, but he say, "You good fellow, Buckeyes chew them up. Then come to KAHIKI for one fine meal."

There are many ways to say "Merry Christmas To You And Yours," but we'd like to put it this way: MELE KALIKIMAKA. THE KAHIKI SUPPER CLUB.

HAUOULI MAKAHIKI or an endearing "Happy New Years to you and yours. We hope you may join us in welcoming it in at the KAHIKI SUPPER CLUB.

Celebrity sightings continued to be a frequent occurrence at the Kahiki and, in the early years, were part of the allure. But all "celebrity" has to be placed in context. Today's celebrity is seldom yesterday's or tomorrow's. Every generation has its own. But there used to be a time when a career lasted longer than fifteen minutes, when someone your mother had seen in the movies when she was a young girl was the same the person you discovered on TV—only a little older—when you were a child. Consider Sophie Tucker. She was one of the most popular entertainers in the first half of the twentieth century. She first appeared on stage in 1907 and continued to perform until she passed away at the age of eighty in 1966.

Five years before that, Sophie Tucker—"The Last of the Red Hot Mamas"—was performing at Danny Deeds's Maramor Night Club when she organized a group to go to the Kahiki one night after the show. There was a cover charge for her act at the Maramor but not at the Kahiki. Yet she undoubtedly entertained them there as well.

When TV game show host Merv Griffin came to Columbus in July 1963 to star in the Kenley Players' production of Neil Simon's *Come Blow Your Horn*, his co-stars were William Bendix, Mae Questel and Patricia "Pat" Wilson. Bendix was best known for his radio and television series, *The Life of Riley*, and Questel for providing the voices of the cartoon characters Betty Boop, Olive Oyl and occasionally Popeye himself. Wilson, however, was a local girl who had made it big on Broadway as Mayor LaGuardia's secretary Marie in the Pulitzer Prize–winning musical *Fiorello!*

Although *Come Blow Your Horn* wasn't a musical, the producer had interpolated a Patsy Montana song—"I Didn't Know the Gun Was Loaded"—into the show so Merv and Pat could sing a duet at the piano. Had he known, Simon probably would have sued. On July 6, the cast celebrated Merv's birthday. That may have been the night they went to the Kahiki. However, Pat didn't go along. As she noted it her autobiography, *Yesterday's Mashed Potatoes*, she was feeling fatigued and worried she was coming down with mononucleosis.[84] As it turned out, she was pregnant—and Merv was the first to guess.

The Kenley Players had their own table—number 51—which sat in the main dining room in front of the giant tiki fireplace. Stars would always make a visit to the famed Kahiki Supper Club. One evening in July 1961,

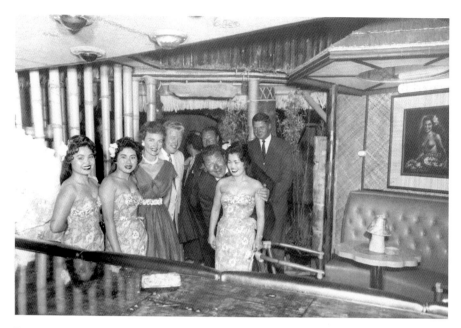

Betty White (*third from left*) and Jack Carson (*third from right*) were among the earliest celebrities to visit the Kahiki. *Courtesy of Aja Miyamoto.*

stars Jack Carson and Betty White showed up after playing in a musical comedy called *Take Me Along*. Hostess Hisako "Mary" Davis can be seen with the whole party right in front of Jack Carson.

By far the most popular celebrity to visit the Kahiki was Ohio's own Paul Lynde. Born in nearby Mount Vernon, the actor and comedian would sometimes dine with his sister, Grace, and her family during his nearly annual appearances in Kenley Players shows. However, Kenley finally ran out of steam in 1987 when the entire summer season was reduced to one show, an encore performance of *Do Black Patent Leather Shoes Really Reflect Up?* Starring Robby Benson, it had been the most popular production from the previous year. But celebrity sightings continued at the Kahiki.

When the Independent Theater Owners of Ohio held their 1966 convention in Columbus, the president's banquet was held at the Kahiki. The convention's theme was "Remodel, Rebuild or Retire." Actor Chad Everett, who was co-starring with Debbie Reynolds in *The Singing Nun*, was on hand to receive the "Young Star of the Year" award. He would later have his greatest success as a doctor in the television drama *Medical Center.*

Singer and actor Ed Ames, star of TV's *Daniel Boone*, visited the Kahiki in 1968 while performing at the Ohio State Fair. "I've been to Columbus

many times as you know," he told *Dispatch* writer John Huddy, "I never even knew this place existed."[85] Apparently, Ames had driven himself to the Kahiki because on his way back to his hotel, the man who had who had played Boone's Oxford-educated Indian companion, Mingo, somehow took a wrong turn off the freeway and got lost in Delaware County.

"Doc" Severinsen, musical director of Johnny Carson's *Tonight Show* flew by chartered jet to Columbus in October 1969 to play at a dance presented by the All-American Quarter Horse Congress at the Ohio State Fairgrounds. Afterward, Doc was wined and dined at the Kahiki. The trumpet virtuoso was a frequent visitor to Columbus but generally kept a low profile when he was in town.

In 1977, Arnold Schwarzenegger had just retired from bodybuilding. A documentary film about him, *Pumping Iron*, had its Ohio premiere at Cinema North in Columbus. Attorney James Lorimer, the mayor of Worthington, had become a friend and business partner with Arnold through his involvement in the Mr. Olympia weightlifting contests. Intent on a career in acting, Arnold held a press conference in a basement meeting room of the Kahiki. In addition to the local media, *60 Minutes* was also filming for a story they would be broadcasting later.

Looking back, this was the start of Arnold's transition from champion bodybuilder to Hollywood superstar and governor of California. His friendship with James Lorimer is the reason that Columbus is the home of the Arnold Sports Festival. It's also why a bronze statue of Arnold stands in front of the Columbus Convention Center, site of the Arnold Sports Festival.

Real estate developer Ron Pizzuti recalled that Andy Warhol used to visit the Kahiki during his trips to Columbus. "I don't know if he came… to see Eva [Glimcher] or go to The Kahiki, but that's where he went and we got invited to several dinners."[86] Eva was the mother of Arne Glimcher, owner of Pace Gallery in New York City. She managed a satellite gallery in Columbus. According to Pizzuti, the Kahiki was "very fancy, very authentic, very kitschy, and [Andy] loved it."[87]

One of the people Diane (Hsieh) Hopkins, a former Kahiki employee, met was "Jungle Jack" Hanna, the director of the Columbus Zoo. Jack came to Columbus in 1978 to take over the run-down facility and set about transforming it into one of the premiere and most high-profile zoos in the country. In the process, he became a celebrity himself, appearing frequently on ABC's *Good Morning America* news broadcasts and David Letterman's talk show. In Hanna's television appearances, he was always accompanied by an animal or two.

According to Diane, she never saw Jack eat or drink while he was at the Kahiki. Instead, his attention was focused on the animals, which he may have been hired to take care of. However, he also used the restaurant to host various events. For example, in 1982, he held a get-together there for the sixteen people who were scheduled to accompany him on a three-week tour of the Amazon. And there is a 1983 photo of him showing Sam the parrot to a ten-year-old boy who was one of two hundred youths with developmental disabilities treated to lunch by Kahiki owner Mitch Boich. Diane also saw Jack in the company of various members of the Ohio State football team.

The Hollywood movie *Teachers* was filmed almost entirely at the former Central High School (now COSI) from January to March 1984. While staying in Columbus, the stars and staff were provided with cars from Rent-A-Wreck so they could drive themselves around central Ohio. For example, producer Aaron Russo had a Cadillac and Nick Nolte an Olds Regency 98.

One of the male actors was notorious for his hard-drinking ways. He purportedly hit every watering hole convenient to his hotel and even farther afield. One night he arrived at the Kahiki accompanied by an attractive young woman. They took a back booth. In all likelihood it was table 41—known as Tiki 4—a two-top in a dimly lit section of the restaurant near and obscured by the large backs of the peacock chairs. During the course of the evening, she got mad at him for some reason, threw a cake in his face and stormed out. He remained there for another hour, continuing to drink and not bothering to wipe the cake off his face.

Columbus Monthly reader David Tuttle met musician Todd Rundgren at the Kahiki. David and his sister-in-law had gone to see Todd in concert, hoping he might sign a photo that was taken years earlier at the Ohio State Fair. But it was impossible to get near him. The following night, however, they were dining at the Kahiki when he and his band came in for dinner. As David recalled,

> *I ran out and grabbed the photo and Sharpie and approached him to sign it. I think he may have thought I was a stalker, thinking, "How long has this dude been following me with a photo to autograph?" He signed the photo and was willing to entertain some questions I had. The meal was great, and I got to meet one of my favorite musicians—a very fond memory![88]*

Neither was an uncommon experience for many Kahiki patrons.

54

Kahiki Lemon Chicken

Polynesians eat chicken and have for a long time. You will find chickens running wild in Hawaii, although they are not native to those islands. The best DNA evidence suggests that Polynesian chickens originated in the Philippines and spread throughout the Pacific islands.

Lemons, however, first appeared in northern India and were dispersed throughout the Mediterranean before Columbus brought them to Hispaniola. It is believed that some varieties of lemon arrived in Hawaii during the mid-1800s. Still, Hawaii produces few locally consumed lemons. The islands import nearly all of what they use. So the marriage of lemon and chicken in an entrée may have been an American development. After all, the Chinese favorite orange chicken was invented in 1987 by Andy Kao, executive chef for Panda Express. By the way, National Fried Chicken Day is July 6.

This recipe was contributed to the Columbus Dispatch *by the Kahiki Polynesian Supper Club.*

Sprinkle hot pepper sauce
Dash lemon juice
2 pieces boneless chicken breast
Salt and pepper
Butter
Flour
Lemon Sauce (recipe follows)

Sprinkle hot pepper sauce and lemon juice on each side of chicken breast. Season to taste with salt and pepper. Melt butter in a pan and heat to high. Dip chicken in flour and place in pan. Cook over low heat until golden brown. Serve Lemon Sauce on the side (recipe follows).

Kahiki Lemon Sauce

Lemon juice
Water
Sugar, salt and hot pepper sauce

Mix together equal portions of lemon juice and water. Season to taste with sugar, salt and hot pepper sauce. A dash of "egg" color can be added.

• • •

Kahiki Punch

The most famous "mocktail" (nonalcoholic cocktail) is the Shirley Temple, named after the child actress who spent so much time around adults during her movie career that they created an alcohol-free drink just for her. It includes grenadine, which is a sweet-tart syrup made from pomegranates.

Because the Kahiki also catered to youth—birthday parties, behind-the-scenes tours and the like—the Kahiki Punch was a necessity. Of course, like all punches, it can be spiked. The following recipe was contributed to the Columbus Dispatch *by the Kahiki.*

½ ounce grenadine
½ ounce lemon juice
½ ounce pineapple juice
½ ounce passion fruit juice
1 ounce orange juice
2 ounces soda water

Put ice cubes in a large glass and add the grenadine and juices. Add the soda water and garnish with fruit in season. Serves one. However, it was also served as a "smoky drink" for larger groups.

• • •

4

No Evil Spirits May Enter

A PELICAN, symbol of plentiful supply of food, perches on the apex of the roof, while fish, symbolic of good food, line the spine of the structure. The roof is supported on large piers designed after talles, a shield-like affair placed at the entrance of island homes to ward off evil spirits.

ON THE TALLES and above the door in front, authentic replicas of primitive art murals in gay colors greet the visitor. With these designs, no evil spirts may enter.

Crossing the moat to enter the hexagonal bronze doors with a tiki door-pull, one passes between two 20-feet-high Easter Island heads with flaming topknots. These are replicas of the mysterious statues found on Easter Island, their lips forever sealed on the secrets of Tahiti. Their topknots are gas-fed, as are the numerous luau torches that line the drive and illuminate the garden, and the flaming flowers in the moat.[89]

—From an early advertisement for the Kahiki

On a Monday evening in May 1962, twelve couples from First Community Church participated in a progressive dinner, and *Dispatch* columnist Johnny Jones rode along as an invited guest. But there was a twist. Not only would the focus be on international cuisine, but also each course would be served in a different Columbus restaurant. It was to be a gastronomic tour of seven "countries" in one evening.

After downing a Black Russian at exactly six o'clock in the evening, they all climbed into one of three station wagons supplied by local auto dealers. Their first stop was the Kahiki, where they were treated to Polynesian shrimp, cabbage roll, pork with sesame and meatballs. While they were dining, they also got to experience the sudden thunderstorm—Johnny called it "the hurricane"—in the Tropical Rainforest.[90]

From the Kahiki, they drove to Mike Joseph's New Sands French Restaurant and Supper Club at 3915 East Main Street, where they consumed French onion soup.[91] Next, they traveled to Presutti's Villa at 1692 West Fifth Avenue, where they dined upon fettuccine Alfredo—first served at Alfredo's in Rome, Italy—as Walter Knick played the organ.[92] The caravan then swung by Sandy's Hamburgers—an early McDonald's competitor—at Northwest Boulevard and Fifth Avenue.[93] Each vehicle was handed a sack of hamburgers, which the occupants ate while they were en route to the next stop.

Arriving at Casa Jose at 1972 East Main Street, they savored Mexican beef tacos beneath the murals of bull rings and dancing señoritas while serenaded by guitarist Richie Hilton. Columbus's first Mexican restaurant, it was opened on South High Street in 1959 by Pauline Wessa, a Californian, and her husband.[94] Then it was west to Plank's Bier Garten at Whittier and High Streets for German cheese, pickles, bologna and potato salad—hot, sweet and sour—washed down with pitchers of beer.[95]

At that point, they estimated they had driven close to fifty miles. They continued on to Vera's at 2083 North High Street, where they had a choice of strawberry torte, chocolate cherry torte, almost chocolate torte or hot strudel—all European delicacies.[96] The restaurant was opened by Vera Lampal and her sister, both Hungarian refugees.

By then it was ten-thirty in the evening, and the progressive dinner was at an end. Of all the dining places the party visited that evening, only Plank's Bier Garten, which opened in 1960, would survive into the next century.[97] Most were gone in less than a decade.

David N. Lewis, chief of Westinghouse Broadcasting in New York, never intended to visit the Kahiki. A graduate of the University of Pittsburgh and longtime resident of that city, he had always said that he never even wanted to see Columbus. Yet in January 1964, a chartered airplane flew Lewis and forty of his friends to Port Columbus for a surprise party arranged by his former boss, Jerome "Tad" Reeves, who had formerly worked at WBNS.[98] Although Reeves had taken a job in Pittsburgh as general manager of KDKA-TV, he remained a Columbus booster.

"The party's announced destination was a snow and ski weekend in the Pocono Mountains."[99] But when Lewis arrived at the airport, he was met by a small band of friends waving signs welcoming him. He and his wife were then escorted to a chartered bus that bore another sign, which read: "David N. Lewis, the man who so organized his department, they were able to get along without him."[100] Although Lewis passed at least three signs at the airport referring to Columbus, he somehow didn't realize where he was.

After attending a party at John W. Galbreath's Darby Dan Farm in Galloway on the far west side of Columbus, the party then headed to the Kahiki on the far east side for dinner.[101] About midnight, Lewis and company caught the plane back to Pittsburgh without having unpacked their skis. But would he ever return? That was the question whenever anyone visited the Kahiki.

Bill Sapp and Lee Henry knew it wouldn't be difficult to get many people to willingly come to the Kahiki at least once. But it would require repeat business if they were to succeed. Unlike Florida's Mai-Kai, the Kahiki couldn't count on the tourist trade because it was practically nonexistent in Columbus. And unlike the Mai-Kai, the Kahiki never had a floor show. Lee and Bill didn't think people would accept hula dancers in Ohio, assuming they could even find any. But the Kahiki offered live music nightly in the Music Bar.

From the beginning, the Kahiki featured the Beachcombers, an ever-evolving trio of talented musicians led by Marcel "Marsh" Padilla (1918–2010). A multi-instrumentalist (flute, guitar, piano, bass, percussion, sax, clarinet, congas), Marsh was joined over the years by Bob Chalfant (piano, claves), Henry Burch (vibraphone, conga, trumpet, flute, French horn), John Dragoo (vibraphone, drums, sax), Don Browne (drums, marimba, timbales), Rod Metz (bass/guitar), Don Hales (guitar), Leroy Plymale (guitar), Don Beck (guitar), Roger Wolfe (drums), Larry Paxton (drums) and others. Playing "the exotic sounds of the Islands"—that is until they got sick of them and switched to more standard fare—they were the house band from 1961 to 1978.

"Kay" Hsieh Oliver, who worked the bar for many years, came to know many of the musicians who performed there, beginning with Marsh. The ever-popular Bob Allen Trio, with Cornell Wiley (1929–2004) on bass and Rick Brunetto on drums, also played the Kahiki for a time. A virtuoso pianist, Robert "Bob" Prahin (1940–2015) had opened and closed the Christopher Inn—an amazing twenty-year run. Kay noted that Cornell spoke fluent Mandarin, a skill he apparently acquired while working in military intelligence.

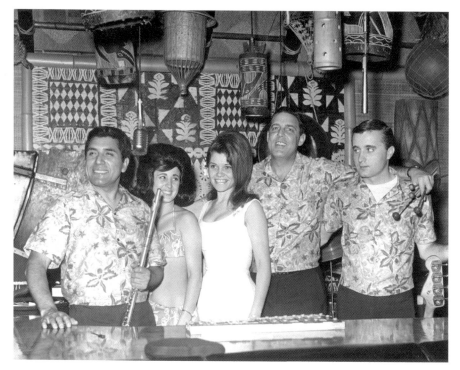

"Marsh" Padilla's Beachcomber Trio was the house band for seventeen years. *Courtesy of Terry Darcangelo.*

Carmen Cavallaro (1913–1989), "The Poet of the Piano," filled in for a time after he moved to Columbus, Kay recalled. Cavallaro, who recorded more than two dozen albums, was one of the most popular pianists of his generation and was awarded a star on the Hollywood Walk of Fame. After he married a Columbus woman and relocated here, he regularly performed in Japan, where he was still a huge attraction.

Then there was the Sonia Modes Trio. The daughter of camera shop owner Joe Modes, Sonia (Modes) Schottenstein has long been known as "The First Lady of Piano" in Columbus. A professional musician for more than seventy years, she played the Desert Inn for a decade, the Defense Construction Supply Center Officers Club for twenty years, the Neil House for eight and the Top Steak House off and on since the mid-1950s. Along the way, she led the Sonia Modes Trio at the Kahiki Supper Club for a couple of years. She seldom took a day off and can still be seen at the Top Steak House, where she has played almost continually since 1965.

Even the parking lot carried out the Polynesian theme. *Courtesy of Bill Sapp.*

Other groups such as Combustible Edison and Don Tiki, who headlined the farewell party, played one-offs over the years, but the last to hold a permanent gig was the Tropics Island Band, a quartet of Capital University students: Chad Loughridge (drums, percussion), Ian Howell (steel drums, guitar, percussion); Nate Anders (marimba, vibes, percussion) and Jim Cherwinskis (bass, percussion). They could be seen and heard at the Kahiki for a year or so just before it closed.

As was befitting a supper club, the Kahiki offered valet parking. Valet parking was first popularized in Columbus when the Jai Lai opened on Olentangy River in 1952 with a rooftop garage.[102] A decade later, patrons of the Kahiki would pull up to the twin moai at the front door, where, Doral Chenoweth recalled, "Two greeters wearing Polynesian shirts, loudly proclaiming another floral world, opened your car doors and pointed you across the bridged moat into a colorful saloon where pineapple drinks with little umbrellas prevailed."[103]

However, Bill Sapp later recalled with a smile, "One evening, three people, all dressed in those floral patterns, politely opened select car doors for patrons, handed each driver a ticket stub, and drove away to points unknown."[104] Michael Tsao finally did away with valet parking at the Kahiki in 1989, likely for insurance reasons. After that, patrons parked at their own risk.

If the Kahiki had an official game, it was backgammon. While the game dates back some five thousand years and backgammon boards were being sold in the United States as early as the 1820s, it really didn't start to catch on until the mid-1960s, when it started appearing on college campuses, at country clubs and in discothèques. This led to the formation of backgammon club and the first world championship tournament in 1967, held at Las Vegas. By 1973, backgammon lessons were being offered in Columbus, and two years later a "really plush and exclusive Backgammon Club" was being promoted in the city.

In June 1978, the Hilton Inn East opened Gammons Lounge and brought in Prince Alexis Obolensky to oversee free lessons. "Oby," as his friends called him, was a Russian aristocrat whose family had to flee the country during the revolution. He was only seven. Before coming to the United States in 1929, he had lived in Turkey, France and England. It was in Turkey that he learned to play the game, which he described as the national pastime in the Middle East.

Among Oby's pupils were Prince Grace of Monaco, Polly Bergen, Bill Cosby, Hugh Hefner, Jacqueline Onassis, George Hamilton, Valerie Perrine and Lucille Ball. "She'd rather play backgammon than eat," he said of Ball.

"I like her enthusiasm. And she's so thoughtful."[105] By then, the number of backgammon players in the United States was estimated to be two million. Bill's wife, Marceline "Marcie" (Morford) Sapp (1927–2018), was one of them and quickly became an expert player.[106]

During the 1970s, Marcie was hired "by the guy who wrote the book on backgammon," Bill related, to travel to shopping malls and teach people how to play the game. Michael "Mitch" Boich (1927–2000), one of their close friends, was "big into backgammon." He was the founder of Boich Companies, a group of businesses that engaged in construction, coal mining and related industries. He would come to buy the Kahiki and the Wine Cellar. There is even a rumor that he won the right to buy—or, alternately, that he lost and was forced to buy—the Kahiki in a high-stakes game of backgammon with Bill and Lee.

One evening, they were playing backgammon at the Sapp home with Mitch, Garth Guy and John Curry, an avid sportsman. Garth owned a small chain of Columbus-based restaurants call Guy's Restaurant. Starting in 1972, Garth opened restaurants in the French Market, the Patio on Morse Road, a former Borden Burger on Fifth Avenue and a fourth of Hamilton Road. Curry had bought an interest in the Sheraton Hotel along with Mitch.

At some point, Garth got into a heated argument with Mitch and John. Because he couldn't beat them, he thought they were cheating. As Bill recalled, "Johnny [Curry] could do math equations in his head and loved that Linda [Bill's daughter, who was thirteen] could do them, too." He told Garth that Linda's friends could beat Garth as well. Minutes later, fourteen-year-old Mark, Bill's son, was playing "Garth at $100 a point and beat him, although he was scared to death."

Beginning in 1977 or 1978, a backgammon club was organized in the basement of the Kahiki. Although Bill and Lee sold the restaurant to Mitch Boich in August 1978, backgammon continued. In 1979, the Kila Backgammon Lounge opened:

> *DISCO to The Kahiki's new mellow sound. You haven't discoed 'til you've discoed at the most intimate lounge in town. BACKGAMMON—Play on the most beautiful tables you've ever seen. WEDNESDAY—Big Band Night. FRIDAY—Ladies' Night. SUNDAY—Free Backgammon lessons. HAPPY HOURS—4:30 to 7:00. DANCING from 4:30 p.m.*

A year later, the Kahiki staged a backgammon tournament to raise funds for the Children's Mental Health Centers and the Columbus Jaycees. Both

disco dancing and backgammon were so popular that lessons were also being offered at many of the city's recreation centers. However, the Kahiki was engaged in a friendly rivalry with another local restaurant, the Water Works.

The Water Works was a restaurant-lounge-movie house started by Garry Morfit Jr., the twenty-seven-year-old son of television star Garry Moore. Interviewed by Eddie Fisher of the *Columbus Dispatch*, Morfit related that he had been working at a place called the Camel Back in Scottsdale, Arizona, when he decided he wanted to get into the restaurant business. So he enrolled in Cornell University's School of Hotel Administration—the same program Craig Moore, the second manager of the Kahiki, had attended.

"In 1966, while a sophomore" in Ithaca, New York, Garry recalled, he "set up and decorated his own living quarters in an abandoned railroad car. Then he acquired two more, and a few bars of track, and converted [his] home into a restaurant-bar. The title was a natural: The Box Car."[107] During the same period, he became friends with Ferg Jansen Jr., a graduate of Denison University in Granville, Ohio. They then spun off the Box Car into a second restaurant, the Warehouse.[108]

For their next venture, they settled on Columbus, leasing the four-story F.J. Quinn Building at 225 North Front Street. It had been built in 1894 as the E.E. Shedd Mercantile Company. After decorating it with anything related to water—claw-footed bathtubs converted to seats, fire hydrants, manhole covers, pipes, gauges, wooden barrels, large valves and blueprints of water treatment plants, as well as church pews, crocks, a giant spool of cable, a telephone switchboard, and a movie screen—they opened for business late in 1970.

Although not on a scale with the Kahiki, the Water Works was a popular themed restaurant that benefited from its downtown location. The partners also created a sports club within the restaurant where fans could watch their favorite teams. Presumably, this area also doubled as the backgammon room. However, early in 1987, the operation closed when Morfit and Jansen were unable to reach a deal for a new lease with the owners of the building.

Like most Americans, many Kahiki employees harbored dreams of making it big. According to Jim Rush, gambling was a popular avocation among the staff, especially playing the lottery. On one occasion, a waiter purchased a lottery ticket and then shared his numbers with a friend and co-worker. He was working the night when the numbers were selected. His friend immediately told him his numbers had won. Believing he has rich, the waiter quit his job and walked off, leaving others to cover his tables. The following day, he sheepishly returned, apologized for his behavior and was rehired.

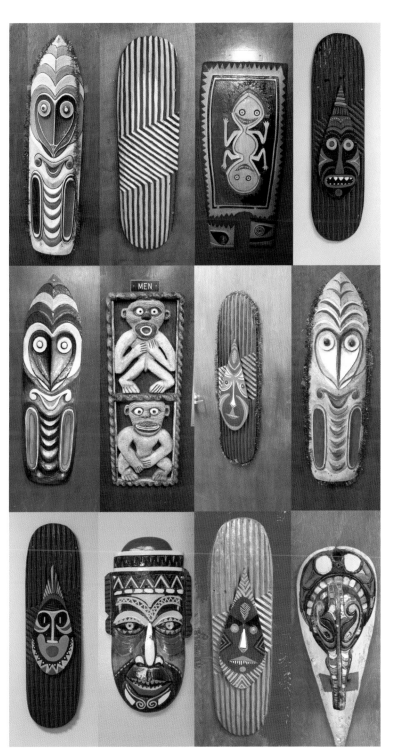

Some of the many shields and masks that once decorated the Kahiki. *Courtesy of Kahiki Foods.*

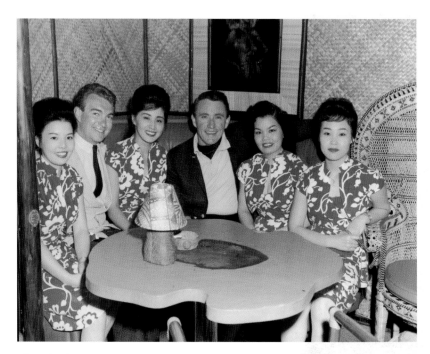

Merv Griffin was one of the many stage, screen and television stars who visited the Kahiki. *Courtesy of Aja Miyamoto.*

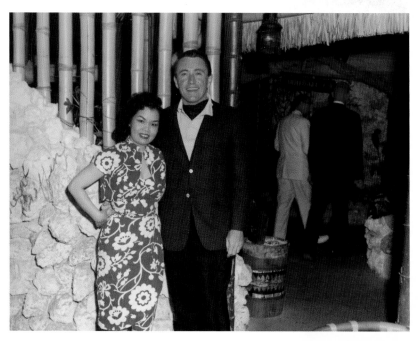

Merv Griffin poses with Mary Davis outside the Outrigger Bar. *Courtesy of Aja Miyamoto.*

Left: The Kahiki was featured in *American Restaurant* a year after it opened. *Courtesy of Kahiki Foods*.

Below: A "Minihiki" franchise was once under consideration. *Courtesy of Alex Stanek*.

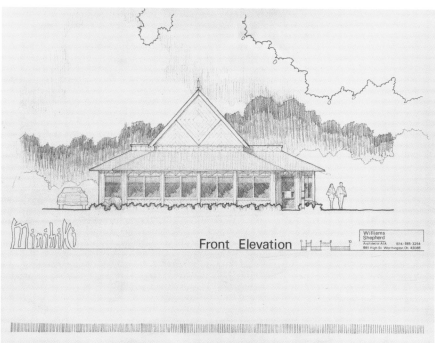

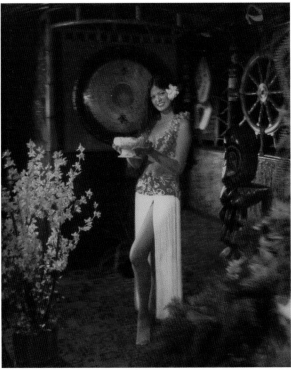

Top: The Kahiki was designed by a team that included Bill Sapp and Coburn Morgan (*second and third from left*) and Lee Henry (*far right*). *Courtesy of Bill Sapp*.

Bottom: "Wendy" Hsieh was the model for this 3D photo by Walter Neuron. *Courtesy of Kahiki Foods*.

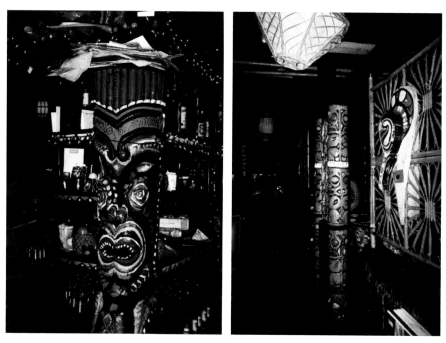

Left: Nearly every square inch of the Kahiki was decorated in some fashion. *Authors' collection.*

Right: Coburn Morgan was responsible for all of the interior design. *Authors' collection.*

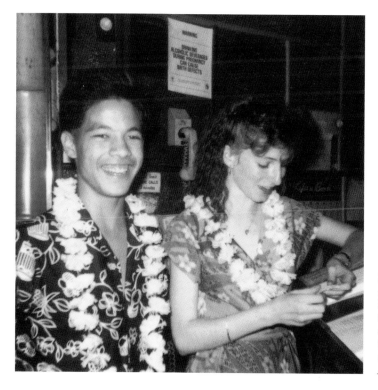

In her blog, Autumn Shah has written about her coworkers at the Kahiki. *Courtesy of Autumn Shah.*

Top: She was particularly impressed with Josephine's confidence. *Courtesy of Autumn Shah*.

Bottom: Autumn also enjoyed the friendship of Pam and Nai during the time she worked there. *Courtesy of Autumn Shah*.

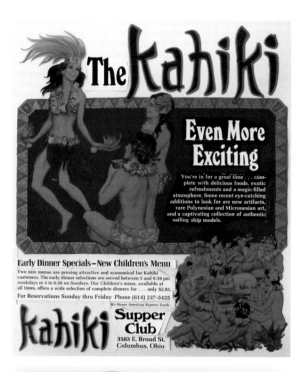

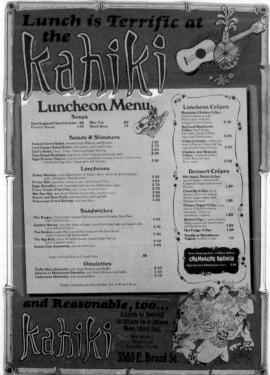

Top: The artwork for Kahiki ads always stressed the exotic. *Courtesy of Kahiki Foods.*

Bottom: Many of the ads were printed in color. *Courtesy of Kahiki Foods.*

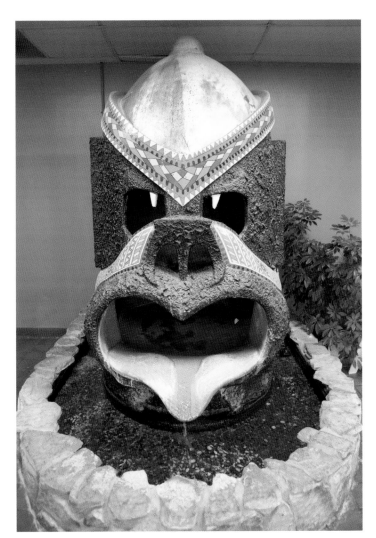

"Pete" or "George" has been moved three times since the Kahiki closed. *Courtesy of Steven Miller/Sam Howzit, Wikipedia Creative Commons.*

However, the outrigger canoe found a home in the lunchroom at Kahiki Foods. *Courtesy of Kahiki Foods.*

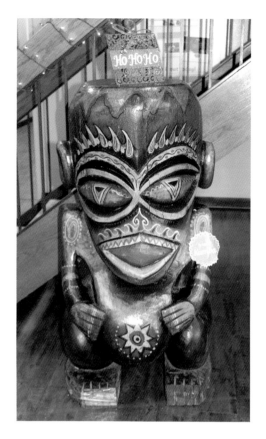

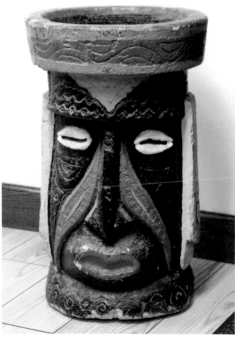

Top: Kumba, like most of the tikis on display at the Kahiki, was carved from wood. *Courtesy of Kahiki Foods*.

Bottom: A few the heads, however, were ceramic or stone such as this ashtray. *Courtesy of Kahiki Foods*.

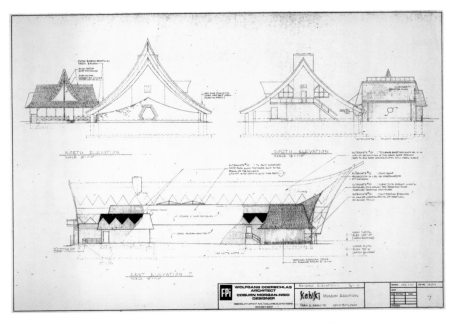

The plans for the museum addition are brittle and faded. *Authors' collection.*

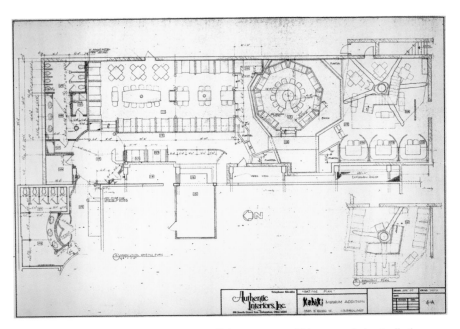

However, the integration of the treehouse dining area can still be seen. *Authors' collection.*

Top: Candid photos provide glimpses of the Kahiki's splendor… *Courtesy of Aja Miyamoto.*

Bottom: And also of its enormous expanse. *Courtesy of Aja Miyamoto.*

Top: The trade show booth hinted at what could be found at the Kahiki. *Courtesy of Aja Miyamoto.*

Bottom: The Kahiki gift shop once sold quality souvenirs to remind patrons of their visit. *Courtesy of Aja Miyamoto.*

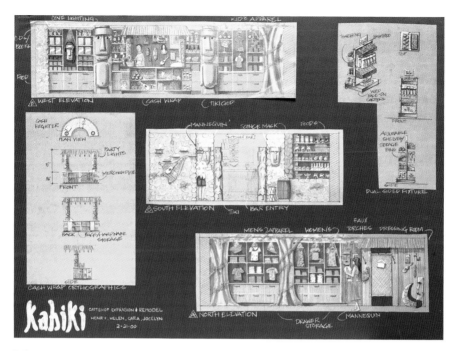

Michael Tsao considered expanding the gift shop to increase revenues. *Authors' collection.*

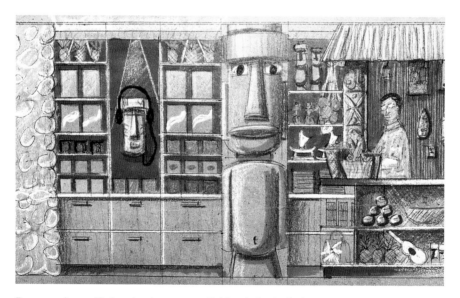

But operating a gift shop has its own set of risks. *Authors' collection.*

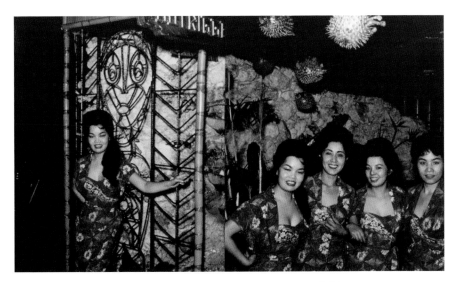

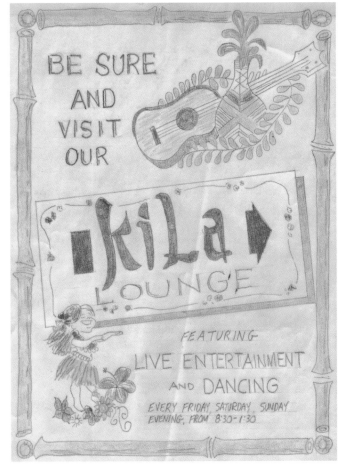

Above: In the end, the Kahiki's success was in having the right people… *Courtesy of Aja Miyamoto*.

Left: And ensuring the customers got what they wanted. *Courtesy of Kahiki Foods*.

To honor its passing, the artist, Shag, created an iconic painting, *Last Days of Kahiki. Courtesy of Shag*.

Since the Kahiki was razed, this moai has been awaiting its return. *Courtesy of Ford Walker*.

A sampling of the many beverage containers that were specially made for the Kahiki.
Authors' collection.

Jim recalled that many employees—including himself—hung around after hours to play poker and blackjack in the bar tended by Kay Oliver. At the time, he was married to one of Kay's daughters, Diane. When he didn't come home one night, he told her, "Don't worry. I was with your mother!"[109] Diane later married Mark Hopkins—Hugh Hefner's one-time personal valet. Originally from Whitehall, Mark remained at the Playboy Mansion for nine years before returning home to central Ohio and settling down.

All restaurant kitchens tend to be pressure cookers. Tensions often run high, and the Kahiki was no different. Occasional outbursts were expected. "We had a knifing one night," Craig Moore told John Fraim, "from a mistake I made in hiring a tough white ex-marine to supervise the dish washers who were all black."[110] By the time Craig reached the victim, he was writhing on the basement floor in a large pool of blood.[111] Craig, whose face was "as white as his suit," according to Lee Henry, went outside to direct the police and the ambulance in through the back kitchen entry and down the stairs in an effort to keep the customers unaware there was a problem.[112] "Music was probably my salvation with the group of 5 dishwashers," Craig observed, "because they could sing so well (harmonize) that I would stop sometimes and make a request."[113]

The Kahiki hired many Cuban refugees. In fact, Bill went down to Miami to recruit them. They later had two or three from New York who were experienced waiters with references but allegedly supported Fidel Castro. The FBI interviewed Craig to see what he could tell them about the Cubans who were said to be reporting back to Cuba on which ones were anti-Castro. Although the FBI agents asked Craig to keep the employees as long as possible, he wasn't comfortable doing so. Finally, a customer complained when the message in his fortune cookie read, "Tip the waiter 20% for good luck."[114] That gave Craig an excuse to get rid of him.

Craig recalled another fight that occurred one evening when he was at the maître d' stand. He was about eight or ten steps away from the Outrigger Bar when he heard a terrible commotion. As he rushed in, he saw "the head bartender shirtless and a guy about 8 feet tall bleeding profusely from his nose and cussing up a storm."[115] It turned out the "giant" was drunk, but since the bar was sunken, the bartenders and the patrons were eye-to-eye, though the bartenders were standing and the customers sitting. There had been a disagreement, and the customer reached across the bar and ripped the bartender's Hawaiian shirt off his body. The bartender responded by punching the patron in the nose, breaking it.

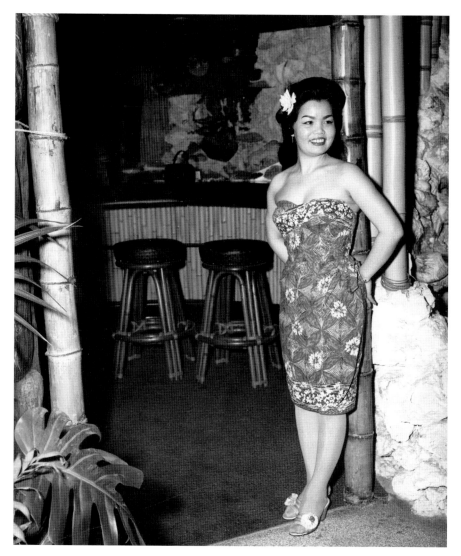

Mary Davis poses in the doorway of the Outrigger Bar. *Courtesy of Aja Miyamoto.*

On another occasion, Craig had taken an angry cook upstairs to the office try to reason with him. As anybody who has ever worked in a restaurant kitchen knows, they are hot and humid environments and tempers often flare. "Lee and Bill had a bathroom between their offices which was used by the off duty police officer we needed," Craig explained. "We had outside uniformed officers on Saturday night. There were stairs that climbed up from the outside (back of the building)."[116]

While Craig was talking to the cook, he became increasingly belligerent. Finally, the cook stood up and started to rush him. Craig jumped to his feet, and the cook chased him around the desk. At that moment, the back door opened, and a police officer walked in. Craig said something to the effect, "Help, this SOB wants to beat me."[117] The officer immediately swung his billy club, striking the cook across the bridge of his nose and dropping him to his knees. He then cuffed him and took him to jail. Although the cook sued the Kahiki, Craig said he didn't have to appear in court. The insurance company took care of it.

The word *legendary* is often attached to the name of Marek R. "Chills" Verne (1927–2015), who began his career in at the Kahiki in 1961. He would remain for fifteen years, most of it as general manager following on the heels of Craig Moore. However, Verne left after a controversial incident of alleged police brutality occurred at the restaurant in 1975. It involved two African American couples.[118] Verne was a key prosecution witness. He then worked as a consultant for several years before being named general manager of Mario's Internationale restaurant in June 1978. Mario's was located on the third floor of the BancOhio National Plaza in downtown Columbus. Chills was also in charge of the Galleria Tavern on the ground floor and the Galleria III cafeteria on the third floor.

All three restaurants were owned by Sanese Services, the city's largest food-vending operation. However, under Chills's guidance, the Galleria Tavern became a popular spot for lunch, as well as a popular watering hole for the statehouse crowd. The Galleria III cafeteria also did well with the lunch bunch, while Mario's Internationale acquired a reputation as one of the downtown's best restaurants.

One of the ways Chills endeavored to turn luncheon guests into dinner patrons was a card that customers could use at the restaurant in the Galleria to make dinner reservations. With his advance notice, Chills personalized the experience even down to printing up books of matches with the customer's name printed in gold letters. A veteran of the U.S. Army Air Corps, Chills had previously worked as general manager of the bar and restaurant at the Neil House Hotel and the Top Steak House before being hired at the Kahiki. In 1980, he was recognized by the General Assembly of Ohio for exceptional service in the industry to which he devoted nearly all his adult life.

Also involved in the 1975 "Kahiki Incident" was assistant manager John "Johnny" Yee Gim (1926–2007), one of the restaurant's best-loved employees. Born in Boston, Massachusetts, to Wong Yee Gim and Tang Fong "Louise" Gim, Johnny graduated from Withrow High School in

Cincinnati and then entered the U.S. Army. He was one of the first hires at the Kahiki in 1961 at the age of thirty-six, initially as head waiter and eventually rising to assistant manager.

Bar manager George Ono (1923–1990) was the son of Yasaku "George" Ono, a native of Japan. At the age of sixteen, George's father immigrated to the Hawaiian Islands and later made his way to San Francisco and, finally, Salt Lake City. He landed a job as a timekeeper and later a section foreman for the Union Pacific Railroad. "When a boatload of young Japanese women landed at Seattle, Ono went and selected his bride-to-be [Masa Kajiwara] and it was a happy marriage."[119] They had two sons, Joe, who became a dentist in Utah, and George, who eventually settled in central Ohio and took a job at the Kahiki.

After the bombing of Pearl Harbor, the Ono family had their home and many of their belongings confiscated by the U.S. government at the direction of President Franklin Delano Roosevelt, a Democrat, through Executive Order 9066. Along with 120,000 others of Japanese ancestry, most of whom were U.S. citizens, they were placed in internment camps out of fear that they might betray their adopted country.

Despite the mistreatment of their parents, both George and Joe enlisted in the U.S. Army, with George rising to the rank of staff sergeant. According to a newspaper account, "George was one of the few Japanese men who came out of the Battle of the Bulge."[120] George is best remembered for a Kahiki postcard in which he is standing behind a colorful display of cocktails. His son, also named George, recalled spending "a lot of time as a kid working on the weekends making drink Fruit Sticks!"[121] George remained at the Kahiki until at least 1974 if not later, passing away in 1990 at the age of sixty-six.

The Karsts were a restaurant family. The patriarch, John Henry Karst, founded the Broad-Nel Barbeque (later Grill and eventually Restaurant) about 1929, so-called because of its location at 18 North Nelson Road at the corner of East Broad Street. Although fondly remembered by many, the Broad-Nel was basically a "glorified burger joint" and "favorite watering hole for softball teams and families from the Bexley area," according to *Dispatch* writer Herb Grant.[122]

John passed the Broad-Nel on to his three sons—George, John Jr. and Robert W. (1931–2013)—who operated it for fourteen years following his death. A daughter, Virginia (Hunter), also worked there for many years as a waitress and a baker. The brothers finally sold the business to John Brennan and two others in 1984, and it quickly reopened as Brenner's Broad-Nel. It later burned down.

Robert grew up in the restaurant business, learning "the joy of hospitality" from working beside his father at the Broad-Nel. But while his wife, Mary (Starkey) Karst, was a waitress at the Top Steak House, Fisherman's Wharf on Morse Road and the Broad-Nel, Robert was a longtime employee of the Kahiki and the Wine Cellar. Perhaps his knowledge and experience were more important to Lee and Bill than to his own family's restaurant.

• • •

Kahiki's Sweet and Sour Pork

While March 7 is National Pork Day, October is National Pork Month. Bacon, ham, sausage and pork chops have their own days as well. When it comes to pork, hardly a month goes by without something to celebrate, unless you are a pig, of course.

Sweet and sour sauce had been a mainstay of Chinese cooking for a long time. However, the original sauce required more preparation and was not as strong as that to which Americans have become accustomed. It first appeared in the Chinatowns of San Francisco and New York, where ketchup was mixed with canned pineapple to make it sweet and acidic. According to Kristine Wen, "They replaced traditional, delicately-flavored rice vinegar with more pungent, but readily-available, white vinegar. These chefs had unlocked a shortcut to the complex flavor of Chinese cooking, and quickly repeated the profits."[123]

While sweet and sour sauce in many Chinese cuisines uses vinegar and sugar, the Americanized version often includes ketchup and soy sauce. This recipe was submitted to the Columbus Dispatch *by the Kahiki Polynesian Supper Club.*

2 pounds pork butt (Boston boneless butt)
2 eggs
1 cup water chestnut flour (or ½ cup all-purpose flour plus ½ cup cornstarch)
1 recipe Sweet and Sour Sauce (recipe follows)
1 can (No. 2) pineapple chunks (drained)
1 green pepper, diced into 1-inch cubes (squares)
1 tablespoon water chestnut flour (or all-purpose flour and cornstarch) for thickening

Trim all outside fat from pork. Cut pork into 1-inch squares. Mix meat squares thoroughly with the 2 eggs. Sprinkle 1 cup water chestnut flour or all-purpose flour and cornstarch over the meat; deep fry pieces until done (until they float on cooking oil).

Bring the Sweet and Sour Sauce (recipe below) to a boil; add meat, pineapple chunks and green pepper and return to boil. Add the tablespoon of water chestnut flour for thickening. Serve hot.

Kahiki's Sweet and Sour Sauce

1 cup vinegar
1 cup granulated sugar (or sugar substitute)
4 cups water
1½ cups catsup
1 clove garlic (fresh) or ½ teaspoon garlic powder
2 slices fresh ginger or ½ teaspoon ginger powder
1 orange (sliced, using rind and pulp)
Pineapple juice from 1 can (No. 2) pineapple chunks

Bring all ingredients to a boil. Simmer for 3 minutes. Drain and cool liquid. Keep refrigerated until ready to use.

This sauce is recommended for: Pineapple Chicken, Sweet and Sour Shrimp, Sweet and Sour Fish, Sweet and Sour Lamb and Sweet and Sour Pork.

• • •

5

Beyond Kahiki

PASSING THROUGH the bronze doors, one finds himself in the Hall of Waterfalls. Hundreds of gallons of water cascade hourly over these concrete cliffs. The only light in this grotto comes from the water itself, which has been chemically treated and activated with black light. At the rear of the grotto, another set of doors opens to the fabulous beauty of the South Pacific; its music, its food, its drinks, its flowers, and—in some cases—its people.

IN THE FOYER, one sees first a large tiki with glaring green eyes and a fierce red mouth. Bubbling water flows from the top of the head, down the face of the idol who jealously guarding the village, and into a pool of coral rock. Walls of the foyer are decorated with Tectum Pan-L-Art, which was specifically designed for the Kahiki. Authentic natives weapons of war are mounted on panels; an outrigger canoe hangs from the ceiling above the idol; a collection of many corals and shells from various islands, and large heads carved from cocoanut trees and mounted on the doors as door pulls, contribute to the motif begun in the foyer.[124]

—*From an early advertisement for the Kahiki*

Although the Jai Lai Restaurant, a one-time Columbus landmark, used to advertise, "In all the world, there's only one"—often paired with a photo of Ohio State football coach Woody Hayes—that was even truer of the Kahiki. Nothing before or since has come close to equaling it. However, as early as September 1961, Bill and Lee actually stated their intention to build other Kahikis in a two-page ad for the restaurant. In the last paragraph, they answered the question "What are the future plans for

The Kahiki?" with the following: "The management plan to make full use of the restaurant's potential. Its facilities will be conducted as a pilot operation and training ground to make policies and establish techniques for similar restaurants the management hopes to build in the next couple of years in various parts of the country."[125]

The fact is Lee liked building restaurants; Bill liked running them.[126] Bill was the yin to Lee's yang—complementary forces. That was the strength of their partnership. With the wild success of the Kahiki, it wasn't surprising that Lee began thinking of ways to expand their operation. They even went so far as to apply for a liquor license and identify a piece of land in Cincinnati to open a franchise—what they thought would be the first of many. Ultimately, they decided against it, however, out of concern that they would not be able to offer their patrons the same quality of experience they had come to expect.

The Cincinnati Kahiki apparently would have been smaller, judging by a drawing Alex Stanek posted online in 2019. Designed by the firm of Williams Shepherd, this "Minihiki" was intended to be the prototype for a possible Kahiki franchise.[127] The front elevation of the Minihiki suggests it would have been comparable in size to, say, a Bob Evans Restaurant. In all likelihood, Coburn Morgan, who had come up with the original Bob Evans farmhouse design, was involved.

When Doug Motz called on Williams Shepherd, they presented him with two sets of Kahiki-related blueprints. They likely obtained these as a reference when they were working on the Minihiki concept. The first set was dated 1960 and identified as "A Polynesian Restaurant." Apparently, Bill and Lee had not yet settled on the Kahiki name. The second set, however, was dated 1975 and titled, "Kahiki museum addition."[128] Evidently, after deciding against franchising, Lee and Bill had considered expanding the original Kahiki to include a museum and a faux treehouse in which patrons could dine. Reminiscent of Walt Disney's Swiss Family Robinson attraction, the plans for the treehouse and museum addition were the work of Coburn Morgan and his company, Authentic Interiors, Incorporated, and would have resulted in an even more amazing experience.

The personnel listed on the museum addition blueprints were: Functional Planning, Incorporated, Coburn Morgan, designer; Wolfgang Doerschlag, project architect; Metzger and Blackburn, consulting mechanical engineer; and PJ Ford & Company, consulting mechanical engineer. The addition is listed as 39 feet wide and 143 feet long and would have given the restaurant an additional 5,577 square feet of space to dazzle and transport diners. It

would have added twelve standard booths to the restaurant along with three expanded circular booths, fourteen tables and a dine-in treehouse with eight booths and twelve seats around what appears to be a treetop bar.

Access to the treehouse would be via a bridge as the base of the tree is surrounded by space listed as "pool" flanked by "planters." Additionally, one of the walls is labeled "Explosion Relief." Much like the main structure, the blueprints for the addition show rooflines for two main "huts" in the center of the space along with three smaller ones lining the walls in front of the "Explosion Relief" area. The new exterior roofline would echo the iconic black white and red "zig-zag" and would not be as tall in the front as the existing structure.

The Williams in Williams Shepherd was Frederick C. Williams (1932– 2012). Ohio born, Frederick was fascinated by airplanes as a small boy, announcing he would become a pilot. He attended Miami University on a full navy scholarship, graduating as a commissioned officer and a flyer in the Air Anti-Submarine Squadron. Following his naval service, he settled in Upper Arlington with his wife and began working as an architect. He was eventually licensed in a dozen states. After retiring from the firm of Williams Shepherd, Williams relocated to Beaufort, South Carolina, in 2005.

In 1960, architect Wolfgang Doerschlag settled in central Ohio, where he still lives, and became a U.S. citizen. Eight years later, he passed the architecture exam and soon started his own firm. In 1971, Wolfgang was listed as vice president of Funeral Home Industries, with offices at 739 South James Road. The company engaged in interior design and architectural work. By 1974, he was doing work for York Steak Houses, and in 1975 he merged his firm with the architectural firm of Tibbals-Crumley-Musson to form Doerschlag-Musson Architects.

Musson's firm had been in business since 1945 and designed the fourteen-story Ohio Bell Telephone building in downtown Columbus along with buildings at OSU and the hospital at Orient State Institute. By 1978, the firm was really growing with projects in twenty-eight states. During the 1990s, Doerschlag Architects was doing work for Wendy's, Bob Evans Restaurants and the Franklin County Commissioners. Following his retirement in 1998, Wolfgang's sons—Christopher and Martin—assumed leadership of the company. It has expanded globally, undertaking projects with McDonald's India, Johnny Rockets, Walmart, Whole Foods and Shake Shack among many others.

Regarding his father's involvement with the Kahiki, Chris recalled that Wolfgang was business partners with Coburn Morgan and had regaled

The large gong was used to announce the arrival of the Mystery Girl. *Courtesy of Terry Darcangelo.*

him with many colorful stories regarding Coburn's time as a student of Frank Lloyd Wright. "As a kid I remember the Kahiki well," Chris related. "Unusual for a child but it's where I developed a fond taste for escargot."[129]

Coburn Morgan remained Bill and Lee's comrade-in-arms long after his work on the Kahiki was finished. They enjoyed taking him along on their overseas jaunts and sharing in his artistic visions. A tour of Great Britain was

the inspiration for their next undertaking—the Wine Cellar—which would resemble an old English tavern above ground and a wine cellar housed in the catacombs of an old monastery below.

Also located in Columbus, the Wine Cellar opened in 1972 and would cost the partners another $1 million. It was also a way of accommodating Bill's ever-growing wine collection. In its own way, the Wine Cellar was as impressive as the Kahiki. Coburn Morgan and Frederick Williams had

> commissioned the London firms of Alexander Waugh and Associates and Bradford and Sons, Ltd. to help keep the Wine Cellar historically accurate. These unique English specialists searched out beautifully old and original structural beams, trusses, posts and ancient hardware from torn down pubs and buildings through the continent....Many of these romantic antiques date back as much as four and five centuries.[130]

A third architect involved in the Wine Cellar was Richard Henry Eiselt (1928–2017). A native of Columbus, he was the son of architect Henry Edward Eiselt. Following graduation from Ohio State in 1953, Richard joined his father's architectural practice, eventually becoming licensed in thirty-four states and the District of Columbus. A former president of the Columbus Chapter of the American Institute of Architects, he was also a charter member of the German Village Commission and served on Greater Columbus Arts Council. Richard wrote a series of articles on architecture for the *Columbus Dispatch* and was well known for his frequent letters to the editor. When the Wine Cellar was built, the three men all had their offices at 398 South Grant Avenue.

Although the Wine Cellar proved to be immensely popular, too, Bill and Lee found it hard to give sufficient attention to it and the Kahiki, not to mention the Top Steak House. Besides, they just didn't love it the way they did the other two. Meanwhile, Lee was losing interest in the restaurant business. They would sell both the Kahiki and the Wine Cellar. While Bill moved on to other restaurant ventures, Lee bought a condo in Aspen to indulge his passion for skiing. He also threw himself into flying, sailing, scuba diving, even bicycling, while buying a home in Ketchum, Idaho, to be closer to his daughter and grandson. And then, suddenly, on September 22, 2015, he died after being ill for a month or so.

Bill would retain ownership of the Top Steak House until 1999, when he sold it after forty-five years to attorney Steve Yoder and Ken Yee of the Wing's Restaurant family. The following year, Doral Chenoweth (1921–2019) "The

Joyce Saunders sitting on the hearth of the fireplace Moai. *Courtesy of Terry Darcangelo.*

Grumpy Gourmet," retired from writing restaurant reviews for the *Columbus Dispatch*. His first official review had been of the Top Steak House, and he had been a champion of Bill and Lee's restaurant ventures ever since.

The fourth major feather in Bill's cap as a restaurant owner—and his favorite—was the Café Martinique. Like the Wine Cellar, this classic French restaurant was an outgrowth of his love for wine. The acclaimed chef was

Travis D. Kawasaki (1963–2007), who had moved from Japan to Groveport when he was two. As local restaurants go, it was quite posh—gentlemen were required to wear jackets and ties—and a tad expensive for midwestern tastes. Serious customers could even lease wine lockers. As a result, it closed in 1992 after a five-year run. Bill would pass away on February 11, 2021.

While King Yen Low was, arguably, the first themed restaurant in Columbus, the Kahiki, which opened a half century later, would be the greatest and likely will retain that crown forever. No doubt, the owners of the Desert Inn felt some dread as they watched the peculiarly shaped structure being built nearly right across the street. Their own restaurant looked kind of dowdy by comparison.

Coburn Morgan's awe-inspiring work on the Kahiki Supper Club established his reputation as a major restaurant designer virtually overnight. The Polynesian palace had been open barely two months when the Alexanders announced that they would be adding yet a sixth addition to the Desert Inn. To show they were serious, they hired Jack Liberatore, the original building contractor on Kahiki, and Coburn Morgan.[131]

The Aztec Supper Club, as they called the new wing, would include a 250-seat dining room with a recessed bar, three party rooms and a cocktail lounge in an Old Mexico atmosphere. Music would be provided by La Plata Sextette. This brought the Desert Inn's total capacity to 1,500 diners spread throughout thirteen rooms, supported by three kitchens, three bars and six service bars. However, it would continue to lose ground to the Kahiki. In 1982, the Desert Inn was converted into a Playboy Club, and three years after that it closed.

Coburn then designed the Fontanelle Restaurant at Graceland Shopping Center for Bob Susi. Although the yellow brick building with the blue mansard roof, white shutters and fancy ironwork looked a little out of place in a strip mall, it was an immediate hit. And suddenly there didn't seem to be any project too big or too small for Coburn to tackle, from a barbershop to a shopping center.

Brookside County Club was one of several country clubs he was called on to refurbish. Completed in October 1963, Brookside featured a Tudor English motif with lots of oak—panels, tables, chairs and bar stools—set off by heraldic designs and copper and leather embellishments. Coburn even created an original coat of arms, which embellished the fireplace.

Simultaneously, Coburn was putting the finishing touches on the Diamond Room in Tommy Henrich's Steak House, 247 East Broad Street. Henrich was a former New York Yankee baseball player whose

only connection to Columbus was his business partner, Alex Clowson, who once was an assistant baseball coach at Ohio State. When Coburn was hired to design the Diamond Room, he turned the name into a pun. The "diamond" did not refer to Henrich's old stomping ground, but the diamond earrings that glittered from the various portraits hanging back of the bar. The one in the vestibule, for example, was painted by Columbus artist Joan Pusecker.

In the opinion of *Dispatch* columnist Johnny Jones, the Diamond Room was "one of the smartest Columbus has had since the old Ionian Room" in the Neil House Hotel. It called to mind "the Chez Paree of Sophie Tucker and the wonderful Beverly Hills of Newport, Ky. It's a reminder of the old Kaiserhof and the old Virginia and Chittenden dining room and the old roof garden of the Southern as well as Nick Albanese's Arabian Gardens."[132] In other words, it was swanky. When Rudy Vallee embarked on a nightclub tour in 1964, his first stop was the Diamond Room. The restaurant was later replaced by the first Wendy's Hamburgers in 1969.

Six months later, Coburn was hired to decorate the New Worthington Hills Club House, 7829 Olentangy River Road. The following year, William A. Wickes of Wickes Insurance Management, 870 Michigan Avenue, told Coburn to "use his own judgement" when redesigning his company's office suite. As Mardo Williams of the *Dispatch* observed, "The price was high and the results startling."[133] He suggested that it might be "the world's most distinctive office suite."[134] Coburn blended and contrasted reds, pinks, greens, blues and yellows in a variety of shades "in carpeting, wall covering and even in the built-in filing cabinets—to produce a pleasing effect."[135] The fabrics were made of woven grass from Korea, hand sprayed with color and a plastic cover. When others saw what he had done, Coburn was immediately offered five more decorating jobs.

In August 1965, the Thunderbird Restaurant opened in Lima. It was easily the city's finest and most exotic dining establishment. It reflected a southwestern motif in its design if not in its cuisine, which was steak, fish and fowl, fried or broiled. The Thunderbird was said to be revered among the Native Americans as "the Sacred Bearer of Happiness Unlimited."[136] Coburn carried out this theme in the hand-painted interior walls as well as the outside sunken gardens. Jack Bowman's Suburban Steak House, 1130 Dublin Road, also received the Coburn Morgan touch during this period.

In March 1967, the Sheraton Hotel in Columbus debuted the Compass Points restaurant. Designed by Coburn, it incorporated the ship's wheel and several port holes from a Venezuelan sailing vessel into the décor. The dining

room was also decked out with brass ship's lights, binnacle, telegraph, rope ladder and an ancient map—all in keeping with the nautical themes.

In 1962, Robert L "Bob" Evans opened a twelve-stool restaurant on his farm in Rio Grande, Ohio. He called it the Sausage Shop. As demand for his sausage grew, Evans built a production plant in Chillicothe. He then followed up by locating the first of a chain of Bob Evans Farm restaurants nearby at the intersection of Bridge and Water Streets in October 1968. Bob hired Coburn Morgan of Business Interiors to design the prototype. The next unit would open in Columbus a year later. For many years afterward, all of the restaurants were variations on Coburn's original red farmhouse.

About this time, the Neil House hotel engaged Coburn to create a new cocktail lounge in the venerable building. It was to be called the Archives Lounge.

In 1950, a new building went on the market at 1427 Oakland Park Avenue. It was a two-story brick structure with a living room and fireplace, two large bedrooms, a dining room and a kitchen above a 1,500-square-foot storeroom. The realtor suggested it could be used as a drugstore or a hardware store. It was purchased the following year by Reverend Robert W. McIntyre for Linden Wesleyan Methodist Church. When Joseph Asmo took title to the building in 1955, he converted it into Yolanda's Restaurant, naming it after his sister. Over the years, the little restaurant on the northeast side of Columbus developed a reputation as a good steakhouse.

Then in 1968, Coburn was hired to give it a new look. The formerly nondescript décor was transformed in Spanish Mediterranean style with hand-painted murals and lots of mirrors. That November, Yolanda's was highlighted by Columbus and Southern Ohio Electric Company as the restaurant of the month. As Doral Chenoweth observed on its closing in 1995, "By today's standards, it was tastefully ornate."[137] However, after thirty-nine years, business had dwindled to an unsustainable level.

When Parris Girves—son of founder Gus Girves—decided to open his first Girves Brown Derby restaurant in Columbus, he first acquired the former Betty Crocker Tree House restaurant at 1321 Morse Road, then hired Coburn to remodel it.[138] Girves already had thirty-four other Brown Derby units scattered around the country. This one was going to cost him about $2 million. The Tree House featured live trees growing up toward the skylights. But Girves gave Coburn a free hand to remodel it however he thought best. The dining room and the adjacent Luv Pub lounge were bedecked with Tiffany-style lamps and stained glass, bright colors and mirrors. It was a mix of Victorian and Art Nouveau. The stucco exterior

was covered with stained wood and brick, and a large canopy was added to the entrance.

Coburn retained the artificial birds in gilded cages but silenced their recorded songs. He also kept much of the foliage, trees and plants, including the hanging baskets. However, he installed a mirrored dance floor in the Luv Pub and a "conversation" bar with a double brass rail that replaced the usual bar stools. Nevertheless, the Brown Derby closed in 1994.

Other Coburn Morgan projects included George Bell's Tangier Restaurant & Cabaret in Akron, Bob and Nancy Steele's Restaurant in Circleville and Jim Adornetto's Old Market House Inn in Zanesville, which still stands. Formerly the Casino Restaurant, the Old Market House Inn was modeled after an English Public House, complete with an "English fireplace, wrought-iron chandeliers, oak timbers, buttressed chimneys and herringbone brick patterns."[139] And when pornographer Larry Flynt bought the mansion across the street from the Columbus School for Girls in Bexley, he hired Coburn to undertake the $1 million renovation of his residence.

Just five years after the Wine Cellar opened in 1972, Coburn was asked to create a 150-seat addition. Inspired by King William of Orange's enclosed garden of orange trees, built in 1520, Coburn reinterpreted the concept for Columbus. A faux rock cliff was fashioned out of concrete over metal lath mesh, while dining tables were installed in square gazebos. Trees included Japanese ficus, rubber, umbrellas, fiddle leaf fig and banana; moonlight filtered through a glass roof, supplemented by indirect light.

Then there was Emmanuelle, a state-of-the-art disco at 1921 Channingway Center Drive. In 1979, Coburn Morgan was brought in to convert an existing building into "an Oriental setting with a Thai flavor."[140] Owned and operated by Thomas G. Moore of Canal Winchester, it would feature a 1,980-square-foot sunken dance floor surrounded by carpeted steps that could double as a lounge. Reminiscent of the Kahiki, it had a thatched-roof bar area, Oriental conversation huts and large palm plants ringing the steps. In addition to various drinks, Polynesian-style finger foods would be available.

Designed to hold one thousand people, the club would give preference to those patrons who had purchased memberships. Lighting was being provided by Litelab, the company that supplied the fixtures for *Saturday Night Fever*. And the sound system was designed by the same group that had done Studio 54 in New York City—a club that Moore had once failed to get into. However, Emmanuelle never opened. It later became Screamin' Willie's East, a popular music venue.

The Kahiki had unexpected water features tucked away in various corners. *Courtesy of Terry Darcangelo.*

In 1982, the Dayton-based Ponderosa Steakhouse chain commissioned Coburn to convert some of its outlets to Mexican restaurants. They would be called Casa Lupita. No longer western themed, they were strictly Spanish Colonial with the tagline "South-of-the-Border." However, it takes more than a cute building to pack a restaurant.

As grandiose as some of these projects were, none compared to the Kahiki. They all lacked the incredible attention to detail that had been lavished on it. "Typical are two commonplace areas," Jerry Ransohoff of the *Cincinnati Enquirer* observed,

> *the telephone booths and the washrooms. The former are vertical, tapa-cloth-lined spirals. Although they are open on one end, they are absolutely silent. Standing in such a phone booth makes one feel something like living in a snail shell. The high point of the latter are the washbasins, made from huge clam shells that are fully two feet across. The handles for the hot and cold water are small, curled shells cemented to the valve stems.*[141]

Coburn would never again be provided with such a large canvas. However, north of Worthington, Ohio, on State Route 315 is a bit of eighteenth-century England called the Village of Kensborough. Modeled after Groombridge Place, a castle in Kent, England, it is a development of mini-mansions designed by architect John Reagan with interiors by Coburn Morgan. The first four were built in 1990. To ensure that the grounds are maintained, they are owned in common à la the condominium concept. A gardener cares for the "entertainment terraces" included with each home. This may prove to be Coburn's most enduring work.

When poet Rikki Santer and her husband purchased their current home, she became intrigued with the Kahiki—in large part because their house contains a large Polynesian-themed room created by Coburn Morgan. It is replete with lava rock, animal print–inspired upholstery and even tiki light fixtures. So Rikki started researching the restaurant. She also connected with architectural historian Nathalie Wright, who submitted the documentation to list the restaurant on the National Register. And she was even able to speak with both of the original owners, Bill Sapp and Lee Henry, before they passed away.

While many artists paid tribute to the Kahiki in home tiki bars and artwork, Rikki honored the Polynesian palace in poetry. Although she moved into her home after the Kahiki was torn down and was never able to visit it, she has still managed to evoke the romance and "Spirit of Aloha" that the restaurant was known for. When asked in a 2012 interview with *Columbus Dispatch* columnist Joe Blundo about what inspired her to pen poems dedicated to the Kahiki, Santer replied: "My motivation is just to get a memory book into people's hands. I was so shocked that this icon was torn down."[142]

Here is one of Rikki's poems from her collection *Kahiki Redux*:

LANDSCAPE

Plump clouds part and a great figure descends.
Follow its iridescence as it skims above the kingdom
of Eisenhower and Kennedy. Eggs release like wet stars
in slow motion, each nestling down to birth America's
Tiki Universe: The Mai Kai from Fort Lauderdale,
The Tonga Room of San Francisco, a nationwide necklace
of Trader Vic's. And here in the heartland of Ohio,
gas stations, pawn shops, and strip malls are sentinels lining
the path to the neighborhood Empress. Just look at her,
a behemoth of a Polynesian canoe with a crew from fifteen
countries. Sedans brim with locals, bus-loads of tourists
make the pilgrimage—moms in hairdo hats, dads in mad hatter
colors, and fidgety armies of fat fingered kids—all Kahiki subjects
longing to imbibe this post-WWII ritual, to lose themselves
inside this romantic cocoon that serves up foreign paradise
in pineapple carcasses and caricature tumblers,
or arrives on the butane tongues of fire.[143]

KAHIKI MAI TAI

Every tiki bar has to have a good Mai Tai—a Tahitian name that is said to mean "the best—out of this world." It's often the first cocktail a tiki enthusiast will order when he or she enters a new venue. Although Donn Beach pioneered many of the most famous Tiki drinks, Victor "Trader Vic" Bergeron is usually credited with developing the Mai Tai during the 1940s. His original recipe used L. Wray & Nephew rum from Jamaica, but when it wasn't available, he switched to blending rums.

Douglas Winship has this to say about the Kahiki's Mai Tais:

> *The two Mai Tai recipes are much more similar than they look. More importantly to a tiki purist, both are a genuine Mai Tai in the Trader Vic school: Strongly flavored rum, lime, orgeat, orange liqueur, crushed ice and mint garnish. Even in the later version, the Kahiki avoided such 'abominations' as dark rum floats, grenadine or (name your favorite sweet) juice. In the 1980s, you'd have been hard pressed to find a Mai Tai of this quality almost anywhere in the world.*

Kahiki Mai Tai (Original)

In Mai Tai glass ¾ full of crushed/shaved ice, add:

Juice of 1 fresh lime
Drop ½ shell of lime in glass
1 ounce Mai Tai Mix
1 ounce Jamaican/St. James rum
1 ounce 12/15-year-old special reserve rum
Shake it well in the same glass
Decorate with a fruit stick and mint

Mai Tai Mix

7 ounces Orzata Motta
12 ounces orange Curaçao (Bols)[144]

Kahiki Mai Rai (Revised)

2 shots "the finest dark Jamaican rum"
1 shot fresh lime
½ shot orgeat syrup
½ shot Cointreau (orange liqueur)
Mint (for garnish)
Lime wedge

To serve, add all ingredients (except the garnish) to a cocktail shaker, shake and strain into a rocks glass filled with crushed ice. Garnish with the mint and lime.

• • •

Kahiki Kapopo

*Kapopo comes from **ka** "to burn" and popo "pointed." It refers to the manner of cooking these meatballs on a skewer over a flame. It seems like a very Polynesian thing to do, except that traditionally they wouldn't have had pork shoulder available, save in Hawaii. Kapopo is also a class of priests.*

Of course, shish kebab (or sis kebap) is a Turkish dish that involves cooking mutton or lamb on a skewer over an open flame. Shish means "to skewer" and kebap means "roast meat." But it is likely that this cooking technique goes back to the beginning of man and was common everywhere there were sticks and fire. World Kebab Day is the second Friday of July.

Kahiki's Kapopo recipe was submitted by manager Marek-Ralph "Chills" Verne to the Columbus Dispatch:

5 pounds pork shoulder (grind twice with some fat)
2 pounds raw shrimp (grind with the pork)
1 teaspoon ginger powder
2 tablespoons seasoned oil
3 teaspoons monosodium glutamate
½ cup corn starch

1 cup flour
4 teaspoons soy sauce
2 medium onions (grind with pork)
1 cup water chestnuts (grind with onions and pork)

Mix ingredients well. (Beat, if possible, in a heavy-duty blender.) Shape into small balls. Steam for 30 to 4 minutes; allow to cool. Deep fry until done; drain.

When ready to serve, place each kapopo on skewer (bamboo, if available) and toast as a marshmallow just until heated through.

• • •

6

Paradise Lost—and Stolen

TO THE IMMEDIATE right of the foyer is the Beachcomber Gift Shop, displaying items from all corners of the globe. One can buy clothing from the Hawaiian Islands or Puerto Rico; tobacco from Cuba; jewelry from South America and France; objects d'art from the Philippines; rare herbs from India. ADJACENT TO the Gift Shop is the Outrigger Bar, housed in a large thatched-roof hut. The sunken bar features captain's chairs where the patrons my rest an arm on a luxurious padded railing. One may sip a delectable rum drink and marvel at the large outrigger canoe suspended about the bar.[145]

—From an early advertisement for the Kahiki

Early in their history, most Pacific Islands were totally lacking in meat animals except for bats and lizards, so the inhabitants consumed fish, shellfish and flightless birds. But they also ate a variety of fruits and vegetables, especially taro—the "Polynesian potato" and one of the earliest cultivated plants. Later, pigs, chickens and dogs were brought to the islands and added to the menu.

In the Cook Islands, a traditional meal was *ika mata*, or raw fish. "The fishermen would go out at night with bright lights for the fish to fly up out of the water and are captured in the nets in mid-flight."[146] They were fishing for *maroro*—flying fish. They would then gut it, clean it, scale it and remove the bones and gills. Next, they would "cut and score the flesh to expose the central part but leave skin and bones intact. Sprinkle or rub with salt and squeeze lemon or lime over, cover lightly and set aside for a couple of hours

to marinate."[147] Although some prefer to marinate it longer, they do so at the risk of toughening the flesh. The dish should then be served "with coconut cream and cooked root vegetable such as taro, kumara, breadfruit or boiled green bananas."[148]

Centuries of subsequent colonization by the Portuguese, Spanish, Dutch, French, British, Chinese and Americans, however, virtually eradicated traditional Polynesian cuisine. As a result, Trader Vic's and other pioneering tiki establishments began creating their own recipes by combining Cantonese dishes with pineapple, coconut and various French influences. Although they may not have been authentic, they were sufficiently exotic to appeal to their customers, especially when garnished with a tropical flower.

Few patrons of tiki establishment cared or were even aware that they weren't partaking of actual Polynesian fare. This is evidenced by the fact that in 1935, three years before Trader Vic's was born, Americans were happily consuming Hala-Kahiki Pie. San Francisco-based Speery Drifted Snow Flour—a subsidiary of General Mills— included a copy of Martha Meade's original recipe for this "Hawaiian pineapple dessert with a tang of the islands" in every sack of its product. Martha Meade, the recipe's "creator," was Speery's answer to the equally fictitious Betty Crocker.

• • •

Hala-Kahiki Pie

¾ cup sugar
3 tablespoons Drifted Snow "Home-Perfected" flour
¼ teaspoon salt
3 eggs
¾ cup top milk or thin cream
1½ teaspoons grated lemon rind
1½ cups grated pineapple, undrained
1½ tablespoons gelatine [sic], dissolved in
3 tablespoons cold milk
1½ tablespoons lemon juice
¼ cup butter

Topping

½ cup whipping cream
1 tablespoon sugar
2 tablespoons grated pineapple

Mix sugar, flour and salt together. Separate eggs, add slightly beaten yolks to milk and blend with flour mixture. Add pineapple and lemon rind. Cook over hot water 25 minutes stirring constantly until thick and smooth. Remove from stove and blend in butter, gelatine [*sic*] and lemon juice. When cold fold in stiffly beaten egg whites and pour into crust. Before serving cover with sweetened whip cream and decorate with well drained pineapple.

No doubt many housewives served Hala-Kahiki Pie in the belief that it actually was a popular dessert in the islands. But it was as phony as the grass skirts made of cellophane. Although the recipe was still being promoted more than a decade later, by then many servicemen were returning from the Pacific theater and had gathered their own impressions of island life—what they liked and what they didn't. Besides, nearly all food served in the United States is Americanized to some extent. Very few customers order not-on-the-menu items at the taco truck, for instance.

Michael Tsao's decision to close the Kahiki seems to have been a sudden one. Just six months prior to the bon voyage party, a conceptual drawing was created of a planned Beachcomber Gift Shop expansion. This architectural rendering by "Henry, Helen, Cara, Jocelyn" and dated "2-21-00" shows the north, south and west elevations, including a remodeled entrance to the Outrigger Bar. Much of the shop would have been given over to men's, women's and children's apparel. However, there were also shelves for packaged foods, mugs and other tiki-related items.

Likely, this was Michael's last-gasp idea to keep the Kahiki afloat. But it was also a recognition of the importance of themed merchandise in the whole tiki bar phenomenon. Perhaps, more than any other food and beverage establishments, tiki bars seem to attract patrons who desire mementos of their visits. And therein lies a problem. Petty theft—and occasionally, not so petty theft—seems to have been and still is a common complaint among bar owners. One Los Angeles restaurant lost about $2,000 worth of "tiki glasses and eclectic cups"—at $26 apiece—in less than eighteen months.[149] And in 2021, a Florida man went so far as to steal a floating tiki bar.

The Kahiki lost more than its share of ceramic mugs, plates, salt and pepper shakers, linen napkin, and other "souvenirs." It eventually began selling ceramic items in the gift shop, but there were not the original hand-thrown ones such as the Mystery Drink bowls, nearly all of which were

broken or walked out the door. As Linda Sapp Long observed, what wound up in the hands of collectors was originally stolen merchandise.

One present-day tiki bar has acknowledged that it loses about five items a week to customers seeking souvenirs—enough to jeopardize its continued existence in a business with low profit margins. Bartender Demi Natolia at Kreepy Tiki Bar & Lounge in Fort Lauderdale told writer Tae Yoon, "The staff and I keep count of how many mugs we have out at a time.…When a customer sits at the bar, I'll usually end up having a conversation with them so that also helps me keep an eye out."[150]

According to Jeff "BeachBum" Berry, owner of Latitude 29 in New Orleans, the expense of producing a custom mug "could end up costing a business more than $30 per mug. We definitely want custom mugs that are distinctive and cool-looking, but if we're paying $30 per mug and order 20 of them to have people steal 10, that still is an enormous amount of money lost."[151]

However, when interviewing people who actually stole items from a tiki bar, Yoon found that they felt little or no remorse. As a result, some tiki bars are requiring a $5 deposit (or more) for drinks that come in tiki mugs and glassware. If the customer declines, the drink is served in a regular pint glass. But some weren't satisfied with stealing a mug or a spoon. In one instance, someone got away with a Fiji war club that was bolted to the wall.

Judy Petticord had her first legal drink at the Kahiki in 1969. "It was probably some sort of a fruity drink, probably with rum," she recalled over thirty years later.[152] A native of Greenfield, Ohio, she was on a visit to the big city and decided to engage in a little pilfering. "There were loose palm leaves on the table for some reason, and I took them with me when we left. I also stole a cloth napkin, which I still have. I was so scared about stealing the napkin that I bolted for the door, dropping the palm leaves behind me all the way," she admitted.[153] Ironically, she later returned to the scene of the crime—sort of—when she became a resident of Whitehall.

When god—or a tiki god, anyway—was stolen from the Kahiki in 1968, it wasn't exactly front-page news. In fact, the initial report poked a little fun at it in the lede, "The great god Tiki may be omnipotent in Polynesia, but in Columbus Friday evening, he apparently was unable to defend himself against abductors."[154] But it was right down his alley for *Dispatch* writer Johnny Jones, who wrote about it his column.

Described as a "God of Tiki," the mahogany statue disappeared from the doorway of the Kahiki Supper Club on March 29. It stood four feet tall and weighed more than seventy-five pounds. A replica of the type of idol found in the Polynesia islands, it guarded the entrance to the restaurant's party

rooms. However, no one, apparently, was guarding it. When and how it was stolen, no one knew.

The statue was described as having "glaring green eyes and a fierce red mouth"—which should have made him easy to identify.[155] But more than four months passed with no clues as to its whereabouts. Apparently, the tiki wasn't being held for ransom.

Then on the Fourth of July, the statue reappeared as mysteriously as it had vanished. Chills Verne, manager of the Kahiki, observed, "The natives are no longer restless and the other gods are serene at The Kahiki since their wandering Tiki has returned."[156] Could he have simply gone on vacation? In August, the tickler ad read: "All's restful at the KAHIKI. Our wandering Tiki God returned on July 4…after a 3-month absence. You'll find him back guarding the party rooms…content but subdued."[157]

However, there was a more high-profile theft from The Kahiki—the abduction of a bird named Sam. One of the most popular attractions at the Kahiki, Sam was a blue and gold macaw. And his "friend" and caretaker was Jim Rush, known to most as "The Birdman." A photo of the two of them was published in *Kahiki Supper Club*, but Jim was misidentified as "Tillie." There was a Tillie who worked at the Kahiki, and he was also a birdman in his day. But Tillie and Jim never met.

Attilio "Tillie" Millrenee (1890–1976) was born in Cardonia, Italy. After serving in World War I, he became the head greenkeeper at the Columbus Country Club from 1919 to 1937. He then opened his own business, Tillie Sunburst Gardens Company. Tillie designed and maintained the landscaping—one of the most overlooked features—at both the Desert Inn and the Kahiki for many years.

A year after he passed away, two boys—Michael Yoli, age eleven, and James Pashovich, twelve—were walking along the Penn Central Railroad tracks near their home when they found a small headstone engraved with the name "Wee Gee Wee, born Dec. 25, 1932; died July 8, 1933."[158] Not knowing whose grave marker it was, the boys' parents were uncertain what to do with it.

The next day, the mystery was solved when Tillie's widow identified it as the headstone for a monkey in her late husband's pet cemetery. When he built his home on a four-acre lot at 87 Maplewood Avenue in Whitehall, he also constructed a Japanese garden. It included a pond stocked with goldfish and a menagerie of animals, including canaries, monkeys, rabbits and dogs. Furthermore, he cared for the birds at the Kahiki years before Jim took over.

It is likely that Tillie learned about birds from Edward Gabbart. A bird breeder, Edward resided with Tillie and his wife. After his left leg was amputated in 1950, fifty-six-year-old Edward lost his will to live. But following an article in the *Dispatch*, he was besieged by readers with questions about how to care for their birds.[159] Apparently, this helped him realize he still had something to contribute.

In 1980, Jim Rush was married to Diane Hsieh, daughter of Kay Oliver, the head bartender at the Kahiki. For about a year and a half, he tended bar, too. At the time, a Chinese woman was caring for the fish tanks and the birds, although she had no training for the job. According to Jim, she treated the birds "like chickens."[160] Consequently, he was hired as a subcontractor to care for the supper club's menagerie, including fourteen tanks of fish and the birds in the rain forest. He also maintained the plants at the Wine Cellar, the Kahiki's sister restaurant.

Because many of the Kahiki staff were not native English speakers, they simply referred to him as "Birdman." And Sam was the most famous of the birds. He took up residence at the Kahiki about 1982. The previous owner thought Sam was a female—he had named her Samantha—and tried to breed "her," but she fought with the other males. So that's how Sam came to live at the Kahiki. One day while Jim was training Sam to sit on his arm, the bird suddenly flew up into the palm trees. For the next two hours, Jim tried to recapture it, but no one was willing to help him. Finally, Sam wore out before he did. Grabbing a pair of scissors, Jim clipped his wings. After that, Jim and Sam were fast friends.

Sam's cage was built in the wall of the Outrigger Bar. Jim would access it from the gift shop. When people walked up on the bar side and began talking to Sam, he wouldn't respond. But as soon as they turned away, Jim would say, "Hello," and they would think it was the bird. "A kid would say, 'Mama, that bird talked to me,'"[161] Jim recalled, but he would not say anything more until they were about to leave. Then Jim would say, "Bye-bye, Johnny"—having picked up the kid's name from his conversation with his mother. The kid would leave the Kahiki wondering, "How does the bird know my name?"

On occasion, an intoxicated person would stick a finger in Sam's cage, despite Jim's warnings. Once, Sam bit a man's finger down to the bone. Although Jim urged him to go to the hospital, the man refused. Finally, Jim wrapped the man's hand in a bar towel, put him in a taxi and sent him home.

Owing to some coaching by late-night bartenders, Sam picked up a few bits of profanity to go with his repertoire of some ten phrases. "What, no tip?" was one of his nicer expressions. A bartender had also trained Sam to say

Jim Rush, the Birdman of the Kahiki, with Sam the macaw. *Courtesy of Bill Sapp.*

"F—— you."[162] The bird responded to a certain voice timbre. On one occasion, Jim took Sam to a veterinarian. While he was in the entry area, Sam began cursing the customers.

The Kahiki was a popular place for high school graduations and proms. At such times, Jim would walk around the restaurant with Sam on his arm and pose for photos with the students. He believed the experience made people feel better. As a result, Sam became something of a mascot and ambassador for the Kahiki. Jim recalled that he once took Sam to a television station for a live interview. Although Sam was talkative while they were setting up, as soon as the studio lights were turned on, he grew silent. There was nothing Jim could do to coax him to talk.

Possibly inspired by a recent spree of bird thefts from local pet stores, one disgruntled former employee who was looking for "easy money" decided to kidnap Sam. She had already been caught skimming money by collecting cash from a customer, keeping it for herself, then flushing the "tab" down the toilet so there was no record of the transaction. However, when the toilet became so clogged that it overflowed, she was caught and fired.

Returning to the Kahiki one day, the ex-employee hid in the cloak room until the restaurant was closed for the night. She then slipped a bag over Sam's head, snatched him from his cage and ran out the back door, setting off the alarms. As soon as Jim got the call that Sam had been stolen, Diane, his wife, immediately began calling all of the pet shops in the Columbus area. One employee from a shop on the northeast side of Columbus called back and reported that her boss had bought Sam—valued at about $2,000—with a bad check for $100. She said he wasn't going to contact them because he had knowingly purchased stolen merchandise. However, when Jim and a police officer went to the store, Sam began calling to Jim and trying to move closer to him. After that, a microchip was implanted in Sam's chest just in case someone else decided to birdnap him.

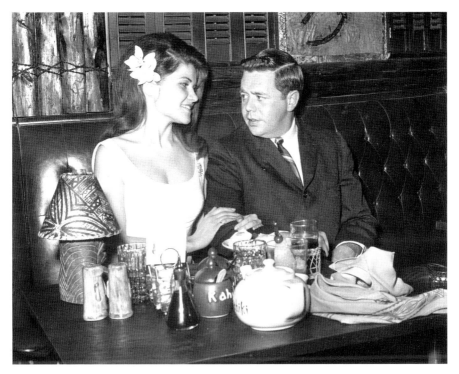

All of the items shown on the table are now highly prized by collectors. *Courtesy of Terry Darcangelo.*

Sam wasn't the only bird in the restaurant. Jim recalled that they had a pair of Quaker parrots in the rain forest. The rain forest had some sixteen to twenty wooden arches that were wrapped in concrete and covered with concrete. Somehow, the Quaker parrots drilled into the arches, made a nest and laid their eggs. Jim didn't realize they were there until they had done about $100,000 worth of damage.

Whenever they fumigated the restaurant, Jim would take Sam home with him. He became quite comfortable there and even tolerated Jim's wife, Beth. However, Sam's loyalty was to Jim. When the Kahiki closed, Sam went home with Jim and lived with him for the next seventeen years. The bird adapted quickly to the new living arrangements. He soon learned how to get out of his cage and take a stroll around the house. In order to climb up on counters and desks, he would pull at the drawers and use them as steps. Once Jim, a real estate appraiser by trade, left an eighty-page blueprint lying atop his desk. When Jim walked into his office, he found Sam had shredded the center of the document to make a nest.

Jim fixed up a baby stroller with a perch for Sam to sit on, a cup for water and other necessities, then would take him to festivals. Sadly, Sam came down with a cold, which is a serious illness for a parrot. Faced with subjecting the bird to chest surgery, of which he had only a 30 percent chance of surviving, Jim made the difficult decision to have him put down.

At one time, the Kahiki had a monkey. In the end, this was a short-lived experiment because the animal was fond of flinging its feces. According to Jim, the rainforest menagerie never included any mynah birds for the same reason. However, it apparently included two snakes named Orson and Welles.

Although Michael Tsao asked Jim to stock the aquariums—sixteen 80-gallon tanks and two 250-gallon ones—with saltwater fish and lobsters, Jim talked him out of it, explaining that the salt would cause all of the metal in the restaurant to corrode. Nevertheless, Jim tried to provide some variety, such as when he procured an electric eel. When he put the creature in its tank, he was careful to ensure the lid was on tight because the eel preferred dark, murky water and would leap out of the tank to find it.

Tables by the wall of aquaria were always popular. *Courtesy of Terry Darcangelo.*

What Jim hadn't counted on was that some of the waiters would use the eel to play a trick on a new employee, a young Vietnamese man. Taking a five-dollar bill, they attached it to a weight and dropped it in the eel tank. They then told him he could have it if he just reached down into the aquarium and took it. The new employee immediately plunged his hand down into the water and grabbed the bill but got "shocked to hell" Jim recalled. What's more, the waiters forgot to secure the top on the tank. When Jim arrived on the scene, the eel was missing. It was later found dead in a narrow space behind the fish tanks that was almost impossible to reach.

Jim also had some piranha in one of the tanks. Although the customers loved watching them eat goldfish, they drew the line at sitting by the tanks while the fish were dining. The attempt to keep large koi goldfish in the pond under the outdoor bridge failed because the water was too shallow, and the birds devoured them all. However, other fish breeding efforts were so successful that the Kahiki sometimes bred particular species for the Columbus Zoo and vice versa.

With the closing of the Kahiki, Jim Rush took pains to notify all the school districts in Franklin County that the aquariums and all related supplies and equipment were free for the asking. However, only one—Westerville City Schools—responded. Westerville took all but two of the tanks. These Jim later placed at two other schools.

Some losses at the Kahiki were even harder to accept. The 1990 murder of Yung Mo Yang, whose body was found behind the restaurant, devastated his coworkers.[163] He was shot to death. According to Kay Oliver, "Uncle" Yung was a wonderful person and a highly respected member of the restaurant staff. He had started at the Kahiki sixteen years earlier, working his way up from busboy to head waiter. Several of his family members worked there as well, including a sister, Bong "Betty" Im. Yung's killer has never been identified.

However, another mystery was solved—eventually. She was called the "Kahiki woman," although her only known connection to the restaurant was that she was found lying on the ground outside of it on November 11, 1999. The temperature was in the mid-fifties much of the day, and there was no precipitation. The unidentified woman died a few hours later at a local hospital of natural causes. She was 5'7" tall, 140 pounds and had reddish-brown hair, blue eyes, pierced ears and small scars on her nose and left cheek. Some referred to her as a "cowgirl" because she was wearing a straw hat, blue coat, overalls, blue socks, sunglasses and gray metal earrings.

Nearly twenty years after this particular "Jane Doe" was found, she remained unidentified. So a forensic artist created a portrait of her that was published in the media. Incredibly, someone recognized the mystery woman, and her identity was confirmed by her family, as well as through fingerprints and DNA. She turned out to be fifty-two-year-old Karen Kaye Frank. Originally from California, she had traveled widely throughout the country and at the time of her death had just moved to Columbus.

When Richard Earl Wern of Columbus passed away at 6:02 p.m. on Sunday, March 9, 2014, his obituary read: "He left in time to keep a 7 p.m. Heavenly dinner reservation at The Kahiki with his loving wife Ann who passed away in 2010."[164] Richard, who was ninety-five, had retired from John Deere after forty-one years. Dancing and music—he was a piano player for the Golden Clefs and the Kensingtones—were his life. Ann and the Kahiki also featured prominently, but they had preceded him.

KAHIKI BARBECUED SPARERIBS

The history of barbecue ribs can be traced back to "Porkopolis"—Cincinnati, Ohio—the largest pork-producing city in the world during the early 1800s. The city's slaughterhouses killed and butchered 2,600 hogs a day, which equated to between 200 and 500 barrels of pork and 200 kegs of lard. However, spareribs didn't fit in the barrels. "It is said that during the hog-killing season in Cincinnati," the *New Orleans Times-Picayune* reported in 1844, "any keeper of a boarding-house, by sending a basket to the butcher's, can have it filled with the finest and most delicious spare ribs, and 'free gratis for nothing' at that."[165]

However, the supply exceeded the demand, and cart loads of spareribs were disposed of in the Ohio River. It wasn't until the twentieth century that informal barbecue stands started to pop up. The American Barbecue Stand in Phoenix, Arizona, advertised barbecue and Mexican chili as early as 1916. Soon, thousands of them had spread across the county, and by the end of World War II, they had begun to turn up on menus in some fancy restaurants. They have become so popular that National Barbecued Spareribs Day is observed on July 4. So why not Polynesian spareribs?

The Hawaiian Islands are overrun with feral hogs. Until recently, they were believed to be descended from the original pigs that were brought to the islands around 1778 by famed explorer James Cook. However, DNA

testing has shown they date back hundreds of year earlier than that, possibly to the arrival of the Polynesians who inhabited Hawaii.

Joyce Katz contributed this recipe on behalf of Executive Chef Philip C.W. Chin to the *Columbus Dispatch*:

2 pounds slab-pork back ribs

Sauce

1 (14-ounce) bottle catsup
2 cloves garlic, chopped fine
1 tablespoon salt
2 tablespoons honey
2 tablespoons sugar
2 tablespoons bean sauce, A-1 sauce or Heinz 57 sauce
½ cup soy sauce or Worcestershire sauce

Combine sauce ingredients. Cut slab of ribs into 1-pound pieces. Marinate ribs in sauce at least 3 hours or overnight in refrigerator. Heat oven to 400 degrees. Put large rib section in oven for 10 minutes; then put smaller section in and cook both for 10 minutes longer. Turn over down to 300 degrees and turn ribs over every 15 minutes until done, about 1 hour.

• • •

KAHIKI ZOMBIE

Here are two versions of Donn Beach's famous Zombie recipe, which could transform the imbiber into "the walking dead" through its potent mix of various rums. The first was from the Lee-Sapp era, the second, presumably, from Michael Tsao's.

Historically, there is no zombie tradition in Polynesian folklore. But there was in Haiti. *The Magic Island* by journalist W.B. Seabrook was the first popular account of the "walking dead" to reach the United States. Since Haiti also produced rum from the pure sugarcane juice with the assistance of the zombies toiling in the cane fields, it was only natural to name a cocktail after them.

Here is Douglas Winship's take on the Zombie recipes:

The Kahiki's Zombie recipe was always a pale imitation of the classic original and got still weaker over time. The tart grapefruit and lime juices of most classic Zombies are replaced with the much sweeter lemon, pineapple and the dreaded belt sander, orange juice again. More problematic, there is no cinnamon or other spice element in either recipe, leaving only a dash of Pernod to carry the "what the heck is THAT?" element, and that can be found only in the early version.

Finally, both versions, while strong, are no more boozy, either in absolute quantity or (I suspect) in flavor than pretty much any of the other offerings we are looking at. A zombie should punch you in the snoot a little.

Kahiki Zombie (Original)

Mix in blender:

1 scoop cracked ice
1 ounce lemon juice
2 ounces orange juice
1 ounce pineapple juice
½ ounce grenadine
Dash Pernod (a strong anise liqueur)
½ ounce Jamaica rum
1–1½ ounces Puerto Rican rum
½ ounce Demerara 151 proof
(from Guyana)
1 ounce orange Curaçao

Pour unstrained into a Collins or Zombie glass. Decorate with fruit stick and mint.

Kahiki Zombie (Revised)

½ shot lime
½ shot lemon
1½ shots orange juice
1½ shots passion fruit puree
¼ shot grenadine
1 shot Curaçao
1 shot dark rum
1 shot light rum
Float of high-proof rum

Shake together with crushed ice and pour into your favorite skull mug. Float some high-proof rum on top. You can drink with a straw and a sprig of mint. Add a lemon and lime wedge.

• • •

Women of the Kahiki

The Maui Bar, named for one of the most beautiful of the Hawaiian Islands, is to the left of the foyer. Passing by a statue of the Hawaiian war god of the same name, Maui, one sees first the paintings by La Visse on black velvet, the numerous Blow-Fish whose soft light is supplemented by the chemically-treated water of yet another waterfall.

Flanking the walls are seats, each grouping in its own hut. The ceiling of these huts is composed of shells, stones, sea fern, and other items placed in a transparent sheet through which light is filtered.

THE RESTROOMS are also found to the left of the foyer. Faucets are armadillo shells, and water gushes from a spigot placed in the mouth of a tiki into a basin firmed by a giant polished Tridacara clam shell.[166]

—From an early advertisement for the Kahiki

There is an old business adage: marketing is everyone's job. Whether consciously or not, Bill and Lee seemed to have practiced this principle, because the Kahiki's best advertisement was always its people. The women of the Kahiki, in particular, were a major attraction. Dressed in faux Polynesian costume, they were expected to be "visually pleasing," as former hostess Autumn Shah observed. "That was kind of the point."[167] This was underscored by a number of black velvet paintings hanging on the walls, most of which featured provocative and semi-clad island women.

But many of the Kahiki women were intelligent as well—beauty and brains. Take Carol Kay Stanfield. A resident of Sebring, Ohio, Carol noted

she arrived at Ohio State "with a small high school education."[168] However, through a combination of hard work (five hours of study a night), physical discipline (thirty minutes a day on a trampoline) and an IQ of 157, she caught up with and surpassed her classmates. Not only did she graduate summa cum laude in 1965, but she was also named one of the top twelve chemistry students in the nation.[169]

Three years later, Carol's résumé would include: "a student of judo; an honor student in chemistry; a graduate student in chemical physics; a part time professional model; a waitress in a Polynesian night club; a student of gourmet recipes; a designer of her own clothes; a sky-diver."[170] The "vivacious" (to quote the *Dispatch*), dark-eyed brunette with waist-length hair was made up fit the image of a Polynesian islander in a Hollywood sort of way.

Another Kahiki employee, Christine N. Hada, grew up in Kipu-Huleia, a small sugar plantation in Lihue, Hawaii. It was composed of three generations of workers "from China, Japan, Korea, the Philippines and several European countries."[171] During that period, roughly 1910 to 1957, the plantation was transformed "from an immigrant society to a typical American society, all in a melting pot of many nationalities of the Asian-Pacific and European origin, in a uniquely Hawaiian setting."[172]

Although the Hadas were Japanese by heritage, Christine and her family were Hawaiian by benefit of their long residence there. As a senior at Kauai High School, she won a cash prize for her essay "Made in Japan." She then attended Ohio State University in 1964, earning a degree in education in just three years. While living in Columbus, Christine obtained a job as a hostess at the Kahiki Supper Club. Maybe it reminded her a little bit of home.

During World War II, female waitresses began to replace the male waiters who had been called to military service. But once they entered the dining room, women stayed there—for the most part. By 1966, the Kahiki was one of just two restaurants in Columbus that still used male waiters exclusively. Johnny Gim, as captain of the waiters, was responsible for training them in the proper way of serving their customers. Women were either hostesses or cocktail waitresses.

An unnamed "official"—likely Johnny—told *Dispatch* writer Jay Gibran, "We have employees from 11 countries, speaking six different languages or dialects. In fact," he continued, "we won't hire a waiter…unless he speaks a foreign language, has an accent or can fake one."[173] Johnny often represented the Kahiki at public forums, preparing such dishes as beef teriyaki and Caesar salad. Restaurant reviewer Doral "Grumpy Gourmet"

Chenoweth once proclaimed Johnny "this city's finest maître d'."[174] Johnny would later join Chills Verne at Mario's Internationale before retiring from Sanese Services.

In 1972, Johnny married "Anne" Earnhardt (1928–1999), another longtime employee at the Kahiki. She was born Maskao Hamada, the daughter of Kotaro and Matsu Hamada. Originally from Nagoya, Japan, she was previously married to Andrew J. Earhardt, who had served in the U.S. Air Force in Korea and Vietnam. Anne had two children by Andrew, whom she brought to her marriage to Johnny.

The story of Hisako "Mary" Miyamoto Davis (1927–2011) may never have been told had it not been for her granddaughter Aja Miyamoto. Six years after Mary passed away, Aja discovered her grandmother's personal scrapbooks hidden in a box at her home in Marysville, Ohio. They were filled with pictures and clippings from her life growing up in America and working at the Kahiki Supper Club.

Born in 1927 to a father who was a mason and a mother who was a seamstress, Mary grew up in Yamanashi, Japan, to the southwest of Tokyo on the island of Honshu. Both her grandfather and his father had been of the Samurai class. Mary's parents worked hard, and the family lived modestly.

Following World War II, Japan was left devastated and occupied by American military forces. Mary was fortunate to find work at a nearby military base in the PX (post exchange). While there, she met Phillip Earl Davis, an American soldier. The couple fell in love, married and had two children: Lawrence Earl Davis and Toshika Shirley Jane Davis. When her brother decided to become a teacher, Mary and Phillip moved to the United States so she could send money back home for her brother's education. Arriving in the state of Washington, they lived in Mountlake Terrace, a suburb of Seattle. After moving around a bit, they eventually settled in Columbus. Choosing "Mary" as her American name, she became a U.S. citizen in 1957.

For Mary, one of the Kahiki's earliest hires, the opening days were filled with many wonderful memories of working in a grand Polynesian palace. Plus, with all the immigrants and wives of the servicemen who lived in the city, she felt like she was part of a close-knit community—a family. The young women became known as the Kahiki Girls. It was the coming together of so many people from so many backgrounds, all working together, that made the Kahiki such an extraordinary place—a place they could call home.

Mary adapted quickly to her new working environment and was soon promoted to head waitress. She would oversee the scheduling of the girls and

While working at the Kahiki, Mary Davis supplemented her income by modeling. *Courtesy of Aja Miyamoto.*

made sure they received proper training. Over time, she did everything from tending bar and waitressing to administrative work in the office. Working at the Kahiki also opened up other opportunities for her. Coming from a modeling background, she willingly became a model for the Kahiki photo contest.

During the 1960–1970s, Mary was supporting her two children while Phillip was stationed in Germany. On occasion, Aja's father and aunt would help out at the Kahiki, too. Unbeknownst to her employers, however, Mary also worked for the competition. "There was a restaurant across the street from the Kahiki that was a big competitor, and they were called the Desert Inn," Aja noted. "And it was almost like the Kahiki and the Desert Inn were always competing over getting people in and running specials and going

between being, like, the place to go. She was kind of undercover. The nights she wasn't at the Kahiki, she was there."[175]

When her secret was finally revealed, the owners of the Kahiki and the Desert Inn—and the Christopher Inn as well—all vied for her services. The competition became so heated that she once quit the restaurants and went to work elsewhere because she couldn't handle the stress.

Mary's daughter, Toshika, worked for the Noni Modeling Agency in Columbus and picked up extra work as a Mystery Girl at the Kahiki. According to Aja, she visited her "Aunt Toshi" in Chicago quite often when she was growing up. "She was and is an idol to the person I am. She's enthusiastic, funny, graceful, and still to this day breathtakingly gorgeous. Her past is her story to share. Although, I'll say I can relate to the feeling of wanting to leave the past, family and pain behind in Columbus."[176]

Toshiko was once married to Ohio congressman Donald "Buz" Lukens (1931–2010).[177] She met him while she was working as a hostess at the Kahiki. He was fluent in Japanese, having learned it while serving in U.S. Army Intelligence during the early 1950s.

After the Kahiki opened, many people started building backyard tiki bars and adding a Polynesian flair to their basements as well. In Columbus, Polynesian décor and furnishings were advertised by the H.J. Nieman Company, which operated a store at 1289 East Main Street. Among the items it offered were spears, masks, tribal drums, tapa cloth, bamboo poles, roof thatch and other South Sea décor. Mary was hired to be the hostess for one of the company's displays.

Aja said that the discovery of her grandmother's scrapbooks "almost gave me a map for where part of me came from. Questions of my past and where I came from now made a bit more sense."[178] As she pored over them, they became an obsession that led her to drop out of college.

"I started asking questions about The Kahiki—how in the hell did something like this exist in Columbus and I knew so little about it? Why did something like that go away? Why is there not something like it now?"[179] She decided it was her mission to somehow, someway, reopen the Kahiki. Toward that end, she worked in the service industry for several years to start learning the ropes. But that was when reality set in. "I saw the great challenges, late nights, alcoholism, drugs, angry people and low profits of restaurant life. That's how I understood why my Obachan [Japanese for "grandmother"] didn't want to introduce me to the Kahiki."[180]

Now, Aja suspects that her grandmother omitted any mention of the Kahiki from their conversations because she was embarrassed by it. Certainly,

Mary Davis was hired by H.J. Nieman Company to promote their line of Polynesian décor and furnishings. *Courtesy of Aja Miyamoto.*

not all were comfortable with the skimpy outfits they were required to wear. "During the time period, it was frowned upon for women to be working at the Kahiki," she said. "They were very scandalous. She didn't like the idea of me working at a restaurant at all because she wanted me to be in school. She wanted me to get an education. And I think that has a lot to do with why she never told me about it, like, she didn't want to glamorize something that almost wasn't very glamorous."[181]

Realizing that her family would want her to finish college, Aja decided to return to Ohio State and major in something she always loved: "writing, specifically, journalism."[182] However, her affection for the Kahiki remains. "I still quite regularly have people reaching out to me about it. Souvenirs shared from people. The Kahiki is something I carry passion for what it was. Knowing that, something at that scale, with that much love, passion and detail could never be the same today and still make money."[183]

"My grandmother was the best friend I've ever had. There are a handful of people in life that love you completely for all that you are—and she was one of those people."[184] The scrapbook helps Aja keep her grandmother's memory

alive and cope with the regret she feels that her Obachan passed away before she had the chance to ask her some of the questions that still linger.

"I mean this in a good way," Aja said, "but Hisako was one of the vainest women I have ever met. Always caring about the way she looked. Spending hours in the mirror getting ready for a simple trip to the store. Her appearance meant a lot to her—and I think that's one of the things people liked most about her."[185] That and her desire for others in her family to follow their dreams.

Mike Renz has no idea what her name really was, but everybody called her "Frankie." And she came into their lives in 1961 when he was four years old. At the time, the Renz family lived on Grassmere Avenue, a cul-de-sac off Oakland Park Avenue. Mike was playing on the floor one day when someone began urgently knocking on their door. His father, Jim, answered it.

When he opened the door, Jim found a dark-skinned woman with long black hair standing there. She was in obvious distress, crying and talking fast. To Mike's ears, she sounded strange. But he realized she had been mistreated and, likely, beaten. His father, a police officer, immediately summoned his wife, Betty, to console the stranger.

"Moments later a man began beating on our door," Mike recalled. "My dad opened it and was unusually polite—almost submissive. The guy was scary to me. He was yelling and gesturing wildly."[186] Then without warning, Jim picked the man up and body slammed him on the wooden floor. Pinning him down with his knee, he reached under his shirt, pulled out a pistol he always carried when he was off duty, and held the muzzle against the stranger's temple.

Mike doesn't know what his father said to the man—the words came out like a growl—but they reduced the stranger to tears. Jim then "jerked the guy to his feet and frog marched him to the door and threw him down the three concrete steps."[187] They would later learn that he was a sailor who married a Polynesian woman. Once he had her isolated in Columbus, he felt comfortable abusing her.

"Frankie"—they couldn't pronounce her real name—lived with the Renz family until she could get back on her feet. Mike's mother helped her learn to read and speak English, while his father taught her how to drive. He also helped her obtain a "peace bond" to keep her husband at a distance while seeking a divorce.

"Being a cop, my father knew a lot of people," Mike noted, "and The Kahiki had just opened. He took Frankie to The Kahiki and she was one of their first hires. We of course had dinner there to visit her."[188] And for

a young woman far from home, the Kahiki community was something of a refuge.

"Frankie became like an aunt to my brother and I," Mike related. "She knit us both massive Christmas stockings—I still hang mine to this day."[189] Sadly, Frankie died of lung cancer when she was still quite young. "I have no idea what her last name was or what her real first name was. What I recall most vividly was her kindness and beauty. The Kahiki holds a special meaning for me because I associate it with her."[190]

Mon-Mei "Kay" Hsieh Oliver is the matriarch of the Hsieh family. Originally from Taiwan, Kay married a serviceman—Lewis Parker Oliver—who was stationed at Lockbourne (now Rickenbacker) Air Force Base. The mother of six children, all still in grade school, she took a job as the bartender at Lockbourne's NCO (noncommissioned officers') Club to help support her family. Then in 1970, she visited the Kahiki with her husband. When the manager of the supper club spotted her, he immediately offered her a job. She suspects that the fact she had very long hair at the time was a factor.

Kay's husband originally taught her bartending, and she had previous food service experience acquired in Japan. Despite her disdain for the uniform she would be required to wear, she finally agreed because it paid better than her job at the NCO Club. She also worked at the restaurant's oyster bar for a time, shucking oysters and making shrimp mimosas. Although she started out as a cocktail waitress, Kay eventually replaced George Ono as the bar manager.

Among Kay's other duties was sewing the uniforms worn by the staff—the men's shirts, the cocktail waitresses' two-piece and the Mystery Girl's skirt. She even grew the fresh mint that was served in drinks. Kay particularly valued the circle of friends she developed at the Kahiki—many of whom were Japanese women. Ironically, she had been forced to learn Japanese during World War II when Taiwan was occupied by Japan and spoke it so well that she was sometimes mistaken for being Japanese. In addition to speaking "broken English"—the unofficial language of the Kahiki—Kay also was conversant in Cantonese and Mandarin.

Although the Mai Tai was far and away the most popular drink at the Kahiki, Kay's personal favorite was the Bahia—a pina colada–type cocktail. Her least favorite was the Kahiki Pearl, because it was too strong. However, the worst to make was the Pina Passion because it involved coring the pineapple in which the drink was served. "It was," Kay recalls, "unpleasant."[191]

These Asian women became such good friends that they socialized outside of work and sometimes went on trips together, such as one to Canada.

The group included Masako "Anne" Gim, longtime employee and wife of "Johnny" Gim; Hisako "Mary" Davis (cocktail waitress); Diana Tanaka (gift shop); and Kay. They would often get together at Diana's apartment on Napoleon. Then there was Toshika "Toshi" Davis, daughter of Mary Davis. She later became head of police security in Chicago.

Although Kay treasures her memories of working at the Kahiki, there was one incident that still rankles her. A regular customer ordered a round of drinks for the whole house. However, when it came time to settle up his bill, he refused to pay. Apparently, he didn't remember having ordered the drinks. That meant Kay would have had to pay for them. She admits she was ready to fight him, but an assistant manager held her back.

Another regular customer was a Roman Catholic nun. She would arrive at noon each day, dressed in full habit, and drink her lunch. She was always alone. Bill Block of Block's Bagels also stopped in on a regular basis. However, Kay's best customer was a friend of Mitch Boich's who always tipped extremely well.

Not surprisingly, several of Kay's children also worked at the Kahiki, although briefly.[192] Her daughter Wendy (Hsieh) Tyson went to work there in 1979 as the Mystery Girl. She recalled that the Smothers Brothers—Dick and Tom—ordered a couple of the Mystery Drinks when they were in town appearing in the Kenley Players production of *I Love My Wife*. As she went to place the flower lei around Tommy's neck, he sneaked a kiss. Of course, that was strictly forbidden but totally in keeping with the ornery character he portrayed. Bill Daily, who played Major Roger Healey in the *I Dream of Jeannie* television series, also stopped by the Kahiki with his wife, Vivina Sanchez, but he behaved himself. However, Bill wasn't appearing at Kenley. He was starring in *Lover's Leap* at the Country Dinner Playhouse.

The trick to serving the Mystery Drink was to figure out who was paying for it and place the four straws before him (or possibly her) so he could decide who got to partake of it. When Jim Bracken of the *Ohio State Lantern* reviewed the Kahiki in 1986, the Mystery Girl ceremony involved the "scantily clad waitress" scurrying "through the dining room with the drink above her head. Followed by two waiters with gongs and tom toms, she kneels briefly before the tiki god, presents the drink, and brings it to your table. The humorous scene ends when the waitress hangs a lei around the woman's neck and kisses the man's cheek."[193]

Wendy's husband, Jeff, worked just down the street in an accounting office, so it wasn't unusual for him to bring his clients to the Kahiki, especially those who were from out of town. Wendy also worked briefly as a

cocktail waitress in the backgammon room in the basement. This was also the location of the dancefloor. However, in late 1980, Holly Dobrovich, the manager of the waitresses, was hired by the Hyatt Regency Hotel and took Wendy along. Wendy has remained with Hyatt ever since.

Diane (Hsieh) Hopkins was hired at the Kahiki after her sister. During her tenure, Diane was asked to appear in an advertisement for use in hotels. All she had to do was stand at the door and welcome people. When asked what she would like in payment, she said she could use a single bed for one of her children. So that's what she got. Wendy, on the other hand, never received anything for the use of her 3D photo in the advertisements at the airport. In fact, the first time she saw it was when she was returning from a trip.

When Michael Tsao decided to manufacture frozen egg rolls, Kay recalls that all of the "old ladies" sitting in the basement rolling them spoke Cantonese because they were from Hong Kong. Not everyone who worked at the Kahiki was Asian, however. Kay says there were many Greeks as well and even Italians.

In 1968, an ad began running in the *Columbus Dispatch* featuring the silhouette of a barefoot girl in a grass skirt, holding a bowl with two straws. The headline read: "Everyone Admires a Kahiki Girl."

> *She's warm…friendly…and something special to look at in her Kahiki uniform.*
>
> *Kahiki customers are the finest. A pleasure to serve. You'll find Kahiki pay, associate benefits, the hours, the complete atmosphere so inviting. We ask you to compare them with any other food service operation, anywhere.*
>
> *Maybe you'd prefer to be a Kahiki Hostess? A Cocktail Waitress? There even opportunity to become a Kahiki Mystery Girl. May we tell you more about these choice food service positions?*

Bill Sapp estimated that he and Lee Henry hired about one hundred Mystery Girls altogether—about six each of the first few years. However, when Michael Tsao took over, he eventually cut back to just one and she worked only in the evenings. Of course, an operation the size of the Kahiki was constantly recruiting staff. In the food service industry, employee turnover is always high, even in the best-run restaurants. But at the Kahiki, preference was given to those candidates who were "something special to look at," especially for front-of-the-house positions. Ideally, they maybe/ might/could pass for Polynesian.

In 1989, Autumn Shah applied for a position at the Kahiki. She was just sixteen, too young to serve cocktails. Still, she was hired as a server and a hostess, depending on the day and time. It was her first job. She often went directly from school to the Kahiki because it was closer than stopping at home. While awaiting the start of her shift, she'd "pick an area that suited my fancy that day," Autumn recalled, "and do my homework or read before changing into my green floral polyester sarong and pink lei."[194]

"Once the shift started, I stood at attention waiting for Lisa [the manager] to give instructions on the general strategy for the evening. She was in the habit of wearing ruffled white blouses that accentuated her already-large breasts. She disguised the rest of her plumpness attractively beneath A-line skirts and tailored, flared jackets that made me feel under-dressed and overexposed in my V-neck sarong."[195]

One of Autumn's least favorite duties was wearing the grass skirt for the Sunday brunch:

> As self-conscious as I was, it still would not have deterred me. After all, I was working on breaking out of the mold I had put myself in, trying to figure out if I was the type who could wear a grass skirt and bikini top in front of people. The outfit was the same one that the Mystery Girl wore. I was too young to be mysterious and thankfully deemed too young to award a kiss and a lei. A server carried the smoking bowl while I gave a weak-armed thump on the gong with herculean effort—a much more anti-climactic ritual.[196]

Although the Mystery Girl was supposed to be passably Polynesian, Autumn was far from it. "No matter what I did, I looked like a pale, spindly, uncooked shrimp in the grass skirt outfit," she recalled. "My skin so white it was almost blue....I tried to cover as much skin as I could. I wore pantyhose underneath the grass skirt for warmth as well as to give some color to my legs....I piled on the leis to hide as much of my sunken chest as I could. I used a half-dozen pins to keep the multicolored floral bra on; it was made for someone much bustier than I was."[197]

Autumn's best friend at the Kahiki was Josephine. The most seasoned of the hostesses, she "was vivacious and as outspoken in English as she was in Tagalog. She had long, straight hair with severely cut bangs. She was petite and sassy and her hips swayed in the grass skirt that at least one of us was required to wear."[198] When Autumn started at the Kahiki, Lisa trained her on our duties, but Josephine guided her "on the ins and outs: which servers

During the Michael Tsao era, servers' meetings were often held in "Ship," as this area was called. *Courtesy of Terry Darcangelo.*

to seat lightly and which ones could handle anything, how to gauge their moods, and which cooks gave leftover cake after the buffet. She shooed the busboys away when they hung around me too long. She pinned a tight grass skirt and taught me how to say 'I love you' in her bird-like Tagalog—mahal kita—and 'I'm hungry'—nagugutom ako."[199]

Among Autumn's fondest memories are those of her encounters with Michael Tsao, the Kahiki's last owner. "He was bigger than life, just like the Tiki god itself, except that he wore a smile to light up the room and possessed a big belly laugh," she wrote in her blog. "Because he was such a comforting presence, it alarmed me to see him talking over papers in hushed, serious tones with Lisa or with men that none of us recognized. I realize now that the restaurant, even then, was in trouble."[200]

When Alice Tsao, Michael's widow, stepped down from the board of Kahiki Foods in 2015, it marked the end of her thirty-seven-year involvement with the company. In 2007, she sold her majority interest to ABARTA, a family-owned holding company based in Pittsburgh. The family sold its remaining stock to CJ CheilJedang, of Seoul, Korea, in 2018, ending their involvement in the company.

• • •

Kahiki Beef and Snow Peas

Pua toro is a traditional dish from French Polynesia that makes use of canned corned beef. This is because pork, lamb and beef had to be imported from elsewhere. They were not part of the traditional Polynesian diet of fish, fruit and vegetables. However, many islanders now consume large amounts of processed chicken and canned meats such as Spam.

Snow peas are known as Netherland beans in China and Chinese beans in the Netherlands. Nobody calls them Polynesian peas. The following recipe for Kahiki Beef and Snow Peas was contributed to the Columbus Dispatch *by the Kahiki.*

4 ounces sliced beef flank steak
½ tablespoon brandy
Dash pepper, grated ginger and cornstarch
4 ounces Chinese snow pea pods
3 tablespoons vegetable oil
2 ounces water chestnuts, sliced
3 tablespoons chicken stock
1 tablespoon oyster sauce
Dash salt, pepper and granulated sugar

Marinate sliced beef with brandy, pepper, ginger and cornstarch for ½ hour.

Remove both ends and the strings of snow peas. Add oil to wok and preheat.

Stir-fry marinated ingredients until partially done. Add pea pods and water chestnuts; stir-fry again. At this time add chicken stock, oyster sauce, salt, pepper and sugar to taste.

Do not overcook. Serve immediately. Serves 2.

• • •

Kahiki Chocolate Cherry Ice Cream Pie

Tim Kantz took his girlfriend Jennifer Walker to the Kahiki in May 1986. But when she bit into an egg roll, her teeth came into contact with something unexpected. It turned out to be a diamond ring. Kantz, who at the time was the chef at the Wine Cellar, had asked Ping Lee, chef at the Kahiki, to help him arrange the egg roll surprise. It was his way of asking Jennifer to marry him. Fortunately, she did not require any dental work.

Apparently, Kantz also was a chef at the Kahiki, likely after the Wine Cellar closed. Here is a recipe he submitted for the Chocolate Fantasy Fair, an annual event held for the benefit of the Central Ohio Breathing Association. Created from ready-made ingredients, the Kahiki Chocolate Cherry Ice Cream Pie is both easy to prepare and delicious.

1 quart vanilla ice cream, divided
9-inch chocolate crumb pie shell
1 (19-ounce) can cherry pie filling
1 cup shaved semisweet chocolate, divided, plus additional for garnish
Hot fudge sauce
Whipped cream
Maraschino cherries, stem on

Stir half of the ice cream until softened. Spread in pie shell. Freeze about 1 hour.

Spread pie filling on top and sprinkle with half of the shaved chocolate. Return to freezer until firm. Soften remaining ice cream and spread onto pie. Top with remaining chocolate shavings and return to freezer. When ready to serve, cut into portions and top with hot fudge sauce and whipped cream. Garnish with additional chocolate shavings and 1 maraschino cherry per slice.

• • •

Pretty as a Picture

Next, one passes into the main room of the interior. On the left is the Piano Bar with its beautifully hand painted bar top.
FORTY-FOOT palm trees line the main street of the village, which ends at the large sacrificial altar, flanked by the two main dining huts.
Low table-height walls break up the huts into small intimate dining areas. The roof coverings are native grasses, wide blade Philippine grass, palm fronds, and other imported thatching. Everything has been treated with a retardant material to resist fire, and an extensive sprinkling system is also incorporated throughout the building.
DRAMATICALLY-GRAINED monkey pod wood imported from the islands furnish table tops in these huts. Large peacock chairs, used for queens in native cultures, have been placed at the heads of some tables.

—From an early advertisement for the Kahiki

More than a restaurant or bar, the Kahiki was a work of art. Visual artists such as designer Coburn Morgan, ceramicists Marcie Sapp and Dick Hoffman, sculptor Philip Kientz and many others combined their talents to create a sumptuous feast for the eyes to complement the feast for the stomach served up in the restaurant. It stands to reason that successive generations of artists would continue to be inspired by the Kahiki. This includes those who were lucky enough to have actually visited it, as well as those who have only seen pictures and heard the stories.

Whitehall's Dick Hoffman provided much of the ceramic ware for the Kahiki. *Authors' collection.*

Beginning in 1962, the Kahiki sponsored an annual photo contest for both amateur and professional photographers. "Shoot in black and white or glorious color the beautiful authentic décor, the rain forest, the $50,000 'Windows in the Sea,' the numerous waterfalls, tiki heads, lovely Polynesian models in native costumes and more."[201] While the contest undoubtedly attracted a lot of shutterbugs, it was discontinued after a few years. But the Kahiki continued to be the backdrop for many thousands of photographs over its four decades of existence, most of which have likely been consigned to the dustbins of history.

Wilmer Briggs Ogletree Jr. (1918–2004) of Fairborn, Ohio, was the first-prize winner in the professional black-and-white category in the 1964 Kahiki photo contest. His subject was hostess Hisako "Mary" Davis striking a large gong. Originally from Alabama, Ogletree served in the army during World War II and was a staff sergeant employed at Wright-Patterson Air Force Base.

In September 1965, Congressman Walter H. Moeller of Ohio's Tenth Congressional District and John W. Black, director of the U.S. Travel Service, unveiled a new poster promoting tourism in the United States. It featured a straw-hatted young woman carrying a fishing pole and a stringer

Right: Briggs Ogletree took this prize-winning photo of Mary Davis in 1964. *Courtesy of Aja Miyamoto*.

Below: Wilbur Downing photographed Joyce Saunders for an Ohio travel poster. *Courtesy of Terry Darcangelo*.

Reisen Sie in eine Neue Welt besuchen Sie die USA

of fish, walking away from a covered bridge near Lithopolis, Ohio. More than twelve thousand copies of the poster would be distributed worldwide, bearing the slogan, "Travel to The New World. See The USA," translated into seven languages.

The picture was taken by Wilbur Downing, a photographer for the Ohio Department of Development. As a child, Wilbur lost his hearing. Enrolled at Indianola School for the Deaf, he learned to read lips and was later able to work his way back into a regular school program, graduating from North High School in 1958. He then went to work as a clerk the Ohio Industrial Commission.

A photography enthusiast for many years, Wilbur submitted freelance photographs to the *Columbus Dispatch* as early as March 1961. Over the next five years, his work was published intermittently in the newspaper's "Sunday Magazine." He contributed a handful of covers and several photo essays. The subjects ranged from a story about Franklin County sheriff's deputies who work third shift to the first woman police officer at Ohio State University. He seemed to be particularly fond of dogs.

No doubt Wilbur was assigned to create a photograph for the poster through his position with the Department of Development. But he had also had an eye for folksy images such as his "worm's eye view" of kids playing marbles, a dog drinking water from an old-fashioned pump or a boy in a straw hat eating a piece of watermelon—all cover shots for the *Dispatch Sunday Magazine*. However, it is not known how Joyce Ann Saunders (1941–2020) became his model for the travel poster, as well as a series of photos taken at the Kahiki.

Joyce had just returned from Memphis, where she and her twin sister, Janice, had gone to try to break into the recording industry. As teenagers, they sang together with Gladys Thomas in a trio called the Tiptoes because they had to stand on their tiptoes to reach the microphone. For a time, they were performers on the long-running *Gene Carroll Show*, broadcast over WEWS-TV in Cleveland. However, they set their sights higher, especially Joyce, who was the more extroverted of the two.

While in Memphis, Joyce and Janice met Bobby Wood, an up-and-coming singer and piano player, at a church event in 1963. They provided backing vocals on some of his recordings, including "I'm a Fool For Loving You." But the sister act broke up when Janice became engaged to Bobby. Then, just a couple of weeks before their wedding, Bobby was traveling in a car with J. Frank Wilson and the Cavaliers when they collided with a truck near Kenton, Ohio. Bobby and J. Frank were both seriously injured and their driver killed.

Both men were touring to promote their records. Ironically, J. Frank's "Last Kiss"—the tale of a tragic automobile crash—would reach number 2 on the charts in 1964, his one and only hit. Bobby lost an eye in the accident, underwent a series of agonizing surgeries and spent months recovering, effectively putting an end to his career as a solo artist. But Janice stuck by him. He later went onto become one of the Memphis Boys, a group of studio musicians who played on 122 hits between 1967 and 1971.

Joyce also met Elvis Presley when she "crashed" a private party he was holding at Dollywood, jumping aboard the last car of his roller coaster as it was departing. Admiring her pluck, Elvis invited her to visit him at Graceland. But now she was back in Ohio, seeking opportunities to advance her career—such a modeling for a poster. That certainly got her noticed. Maybe Wilbur suggested they follow up with some photos that could be included in a modeling portfolio.

Years later, Joyce told her husband that whenever they went out to eat, Wilbur would stroll around the restaurant, reading people's lips. When he returned to their table, he would invariably say, "Nobody's talking about anything interesting in this place."[202] Fortunately, the Kahiki photos survived, providing some of the highest-quality images that have come to light in the years since its demise. Joyce would go on to work at the supper club as both a hostess an occasional Mystery Girl.

Not long afterward, Joyce met Terry Darcangelo, a young man from Cleveland. They eventually married and moved to Gulf Breeze, Florida, where they opened one of the earliest Stanley Steemer carpet cleaning franchises. The company was founded by Jack Bates of Columbus in 1947 and began selling franchises in 1972. With Joyce running the office and Terry the trucks, they steadily built it into one of the largest franchises in the region. As a successful female entrepreneur, Joyce became a mentor for many other women.

Other local photographers were also drawn to the Kahiki. Already friends with commercial photographer Douglas Robert "D.R." Goff (1947–2013), Diane Hopkins modeled for some fashion photographs, including a full-page ad that appeared in *Columbus Monthly*. Through Goff, she met Walter Neuron (1915–2000), a ski instructor who had just purchased a lenticular 3D photography system. This was a process that employs a plastic lens, allowing the photo to be viewed from different angles. They were sometimes called "winkies" because the picture changed when you tilted it.

For his first photo, Walter asked Diane to pose as the Mystery Girl. However, Diane suggested that he use her sister, Wendy (Hseih) Ward,

since she actually was a Mystery Girl and she felt she was more photogenic. This was the photo that was subsequently used to advertise the Kahiki at Port Columbus Airport for many years. In 1961, the Municipal Airport Commission rejected a request by Lee and Bill to setup a Polynesian hut in the terminal, staffed by a hostess, to promote the restaurant. This was in keeping with the commission's policy not to clutter it up.

Born in Vienna, Austria, Walter was an accomplished mountain skier and a member of the German Alpine Club. But he was also Jewish. With Hitler on the rise, he knew that he had to leave. After escaping from Nazi Germany, Walter came to Columbus in 1941 and set up a photography studio. Two years later, however, he joined the Tenth Mountain Division and was sent back to Europe to carry out mountain warfare. When the war was over, he returned to Columbus and resumed his photography at Miracle Mile Studio.

Walter missed skiing, but there was none to be found in Ohio until 1961. Early that year, Bucky Wertz started Snow Trails and hired Walter as director of the first major ski school in the state. By 1976, Walter was running a thirty-five-man ski school and had given seventy-two thousand ski lessons. One surviving photo is of Walter posing with the 1966 Bikini Ski Team.[203] He later moved to Vail, Colorado, where he became director of a ski school.

Columbus native Kojo Kamau (1939–2016) was an award-winning photographer whose works are in the permanent collections of the Columbus Museum of Art, Central State University, Morehouse College and many other institutions. Educated at East High School and the Columbus Art School, Kojo exhibited his photos throughout the United States and abroad. As a Black man, he was especially known for documenting the local African American community, as well as the lives and cultures of many people of color throughout the world.

In 1979, Kojo produced at least two Kahiki photos—studies of the unique interior design work. One was published in *Kahiki Supper Club*; the second is included in this volume. The same year, Kojo, with the help of his wife, Dr. Mary Ann Williams, founded ACE—Art for Community Expression—a nonprofit art gallery. Originally located in downtown Columbus, it was moved to the Short North in 1986. Although ACE Gallery closed in 2002, it continues to serve as an inspiration for many local artists.

While pursuing a degree in art history at The Ohio State University, Deborah Williams Diez was employed as a server at the Kahiki. She loved working there and still misses the people and the food. Just before the supper club was scheduled to close, Michael Tsao recruited her to thoroughly document the building's interior in photographs and text. The intent was to

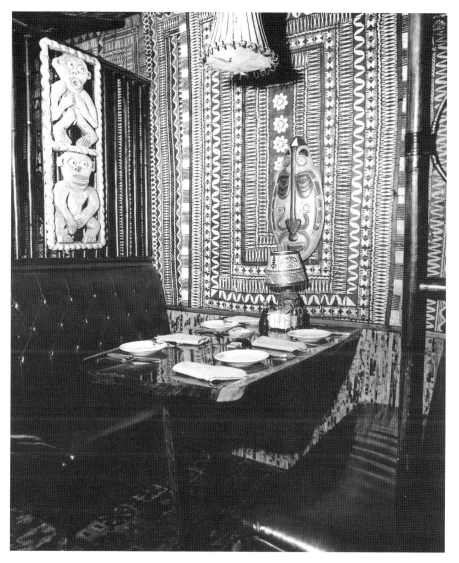

A richly detailed image titled *Kahiki #2* by Columbus photographer Kojo Kamau. *Authors' collection*.

use the book she created as a guide in order to put everything back the way it had been when Michael finally got around to rebuilding the Kahiki. Of course, he never did.

Deborah was provided with a digital camera and proceeded to document the entire restaurant, table by table, with special attention given to wall décor and ceiling fixtures. She was also given access to the computers and printers

at the Kahiki Foods distribution center to publish a few copies of her two-volume work. Although the camera was state-of-the-art for the times, digital technology has improved immensely since then. Unfortunately, Deborah did not keep a set for herself. "It's funny how one can get nostalgic over a restaurant," she said seventeen years later, "but I swear every time I see the logo, I can hear the dripping of the rainforest, the sound of rolling thunder and smell of the smoke machine."[204]

One of the best-known names in contemporary tiki art is Josh Agle, better known by his alias, Shag (joSH AGle). He describes tiki as "a very visual culture."[205] From his flagship gallery in Palm Springs and online, Shag sells framed prints, glassware and Hawaiian shirts. At Disneyland and Walt Disney World, in collaboration with the "House of Mouse," he sells purses and magnets and has even produced his own pair of designer Mickey Mouse ears celebrating the historic Enchanted Tiki Room attraction. He has released several books, including *SHAG: The Collected Works*; *SHAG A to Z*; *Shag: The Art of Josh Agle*; and a children's book, *Jojo and Lolo Throw a Birthday Party.*

A natural talent, combined with a need to make money for college, led Shag to a career in art. A couple of friends, and a shared pastime of visiting what they called "old man bars"—themed bars from the '50s and '60s that survived into the '80s—led him to Tiki. Their favorite "old man bars" were the tiki bars, not just for of the drinks but because for an extra five dollars they could take their mug home. These mugs became souvenirs of fun evenings together. Although there was not a lot of "art" in the classical sense in these bars, they had a lot of what Shag referred to as "décor." He recalls that wall space at one of his favorite haunts, Tiki Ti, was very limited. Instead of framed artwork, the bar showcased illuminated menus. Other places were covered in carvings, floats and fishing nets.

Shag's first visit to the Kahiki was also his, and everyone's, last. He had been hearing rumors that the behemoth might be on its last legs. These rumors led him to paint *Last Days of Kahiki*. The piece depicts a couple enjoying one (or more) last drink in front of the same famous fireplace that inspired so many artists. The gentleman wears a classic Kahiki moai necklace, once available at the gift shop. The waiter has his hands full, and one mug lies spilled on the floor. The end is near, but the party won't be stopped.

It was about a year and a half later when, in 2000, Shag and his wife, Glendele, made a special trip to visit the restaurant. The experience of flying across the country from California to visit a bar for one night made him feel like "a real jetsetter." Having seen only pictures, he knew he had to come

see the Kahiki in person before it was too late. In his own words, "It did not disappoint." Even though the restaurant was well past its prime, and some of the original pieces had already been removed, he still found it to be "pretty glorious." He said, "Of every tiki bar I've been to, that's the one that's most like a church or cathedral. It's like the 'Church of Tiki.'" He envisions the fireplace moai as an altar.

For those unable to attend the final party, Shag offers this remembrance:

The minute I stepped into The Kahiki people started buying me drinks. I probably had one of almost everything. Unfortunately, as the evening progresses it gets hazier and hazier for me, until I have no memories of the very end of the evening. I know because of my friendship with Sven (Kirsten) I got a private tour behind the scenes, so I got to see the kitchen, upstairs—the offices and everything like that. I also remember wading in the fountain at the entryway of the Kahiki.

His swimming instructor in the fountain that night would have been the moai most commonly known as George, sometimes called "The Pig."

Ruth Pearl and her daughter Hannah Tran also remember the Kahiki, although their actual experiences differ from Shag's. After completing a gouache painting for Tran's birthday, based on an old postcard of the Kahiki, Pearl captioned it with the words: "A long time ago, a young girl was taken by her family to The Kahiki restaurant in Columbus, Ohio. Sadly, this icon was torn down in 2002 but the girl's love of all things Tiki remains to this day."[206]

In 1990, Pearl's family came to the United States from South Africa. They originally settled in Gahanna before moving to Pataskala, Ohio. Money was tight, and eating out was a treat for the family. The Kahiki was absolutely out of their price range until one of her husband Ken's coworkers gave them a gift certificate for Christmas. The family of four, including big brother Ben, used the gift certificate to celebrate Tran's birthday in March. According to her mother, she "fell in love with it." As it was a luxury, the family made it back only once or twice more before leaving the Columbus area in 2002, just before the Kahiki was torn down.

Although many historians contextualize tiki as Americana, Ruth is originally from England and spent seven years in South Africa and three years in Kenya. She described the Kahiki as "magical," and likened it to something one would experience at Walt Disney World. This is a sentiment shared by Tran. Despite being eight at the time, she vividly recalled "just all of the décor, it was from the ceiling to the floor, so much going on. I

remember the building being so big, and it was packed,…I had never experienced anything as over-the-top."[207] She explicitly remembers ordering a meatball volcano appetizer served in a volcano-shaped porcelain bowl. She also had the "Smokey Drink," which included a dry ice effect and was de rigueur for any birthday girl or boy. The family sat in one of the hut-style booths, which provided both privacy from the other diners and an added sense of escape.

The visit was a foundational experience for Tran. She recalls creating a tiki head in art class. Although she was devastated to learn of the Kahiki's closing, the love of tiki it instilled continues into adulthood. In the past ten years, she's found community in tiki. She's joined tiki groups online and visited the Enchanted Tiki Room attraction at both American Disney parks. To her husband's consternation, several rooms in their home are tiki themed. She even had a tiki baby shower. Although she's been to as many tiki bars as she is able while traveling, she's met few peers who have actually been to the Kahiki.

Tran said, "I think it's just really beautiful. All of the textures. How when it's done right it's a full experience. It's not just the look, but it's the sights, it's the sounds, the smells, the tastes, everything pulled together that really allows you to be transported to another world."[208] Pearl's paintings can be seen on her website www.marulatoo.com and in galleries all over Georgia, while Tran is a freelance art director whose work can be seen on www.hannahelspeth.com.

Around the same time Pearl's family was enjoying the Kahiki, Doug Horne made a special pilgrimage with his then-wife to visit the restaurant in 1995 after reading about it in the *Tiki News*. He described first seeing the building as "Boom! It hits you like a punch in the face."[209] No doubt it was a pleasant "punch in the face." Horne has been creating art since grade school. This makes sense, as he is the child of parents who met in art school: an illustrator/graphic designer and fashion designer.

Raised in Phoenix, Arizona, Horne recalls that his family Christmas trees were often saguaro cactus arms they found on the ground in the desert. He found tiki in the 1980s through friends. When his roommate bought home some antique mid-century lamps, Horne sought out the secondhand store where he bought them—Doo Wah Diddy—and was taken by the design and style of everything there. He had an awareness of tiki and the ephemera that accompanied it, including napkins and mugs, thanks to the Islands, an already-shuttered Polynesian restaurant and bar in Phoenix, and the Kon Tiki Hotel, which he drove by on occasion, but unfortunately he did not visit either while they were open.

It wasn't until the 1990s that Horne began subscribing to *Tiki News* and collecting tiki mugs. He went to visit mug collector Brian Marsland, now owner of Exotica Tropicals flower nursery. "At the time, most people were collecting vintage because there weren't a lot of current-day manufacturers/production people doing mugs. Not like it is today," Horne recalled.[210] "I was blown away by how many different designs there were."[211] When he started to incorporate more tiki-themed designs into his work, he was able to use the brand-new website eBay to test the market.

Horne remembers seeing the Kahiki appear on the landscape of otherwise mundane buildings as they drove forward. He described it as a "monolith on the side of the road."[212] Although it was a small and quiet weekday lunchtime crowd that greeted them the first time they walked through the double doors, they were able to witness the Tiki Temple in full swing later that evening. This time, they were greeted by fire and lights. They sat by the rain forest window to the right of the fireplace and were waited on by a man Horne's former wife remembers as "Bob."

On hearing that the couple came from Phoenix to visit, the Kahiki staff treated them to a tour of the building that included the basement party room. One of his clearest memories is of a monkey lamp that sat on their table while they ate. Now that the Kahiki is closed, Horne facetiously says he regrets not stealing the fixture, although he acknowledges that would be wrong. He did lawfully pick up a few souvenirs in the gift shop, mostly some Coco Joe's statues and the like.

Horne says his experience at the Kahiki had a "huge influence on a lot of [his] art." This is nowhere more apparent than his painting *Kahiki Memories*, which features a romanticized version of the building's front entrance and two oversized flaming moai that guard the octagonal front doors. It is part of a series that features exteriors of iconic buildings, including (as of this writing still-standing) the Mai-Kai, and the Kona Lanes in Costa Mesa, California (the neon signage from which can now be found in Cincinnati at the American Sign Museum) and fictitious locales he dreamed up in his own head. He describes himself as taking a more relaxed view on tiki. As a creator, he does not want to merely recreate Polynesian art, instead combining traditional tiki elements with other aesthetics.

In interviews, Horne always makes a point to mention the Kahiki because his visit was what made him shift to become an almost full-time tiki artist. What he values most from the tiki community is the friends he has made. "For some people, it's about the drinking. For some people, it's about the music. There are so many aspects to it. It is kind of a lifestyle." He continued,

"The people [are] so friendly. It's really the 'Aloha spirit.'…I tried some car shows, that rockabilly thing, and it's like 'this is a totally different vibe.'"[213]

Not everyone was lucky enough to visit the Kahiki while it was still standing. Whether due to their ages, locations, financial situations or just plain ignorance, many fans just didn't make the trip in time. Although they never set foot in the Kahiki, artists Dave Hansen of Lake Tiki Woodcrafts, aka Lake Surfer; and Pete Klockau of the Black Lagoon Room were inspired by the legend to create pieces that directly reference the icon.

As a traveling artist, Hansen, who has carved pieces for Foundation, the Inferno Room, Smuggler's Cove, Ula Ula and Hele Pele, likes to tailor his work the local tiki history of the region he's visiting. It was the fond memories his Buckeye friends had for the Kahiki that led him to hand-carve reproduction Kahiki signage that has found a place in many home tiki bars in Ohio and beyond. He stated, "I really regret not being able to visit the Kahiki. It was really the whole package when it comes to tiki bars of that era. I love the photos of folks pulling up to it in the dead of winter. That's pure escapism right there; heading inside this A-frame building to seek a tropical getaway in your own city. Palm trees and bubbling fish tanks. Exotic foods and exotic drinks. Really something special."[214]

Klockau creates all manner of tiki art and products from mugs to apparel, swizzle sticks and a custom bitters blend. His Kahiki enamel pins stand out for their quality and clever detail. He also regrets he was never able to visit the Kahiki. Although he and his wife, Katie, planned a trip, they did not have a car at the time and had no way to get to Ohio from their home several states away. He does consider himself lucky that he got to experience some of the now-gone Chicago tiki outposts, including Trader Vic's at Palmer House, which toward the end of its time was known for not checking the IDs of potentially underage patrons.

There is an old platitude paraphrased by both modern American author Justin Cronin in his horror novel *The Twelve* and nineteenth-century English novelist George Eliot in her novel *Adam Bede* that states something to the effect that no one is really gone if there is someone who remembers them. If that's true, then the Kahiki is not gone, not by a long shot. It lives in the memories and hearts of everyone who recalls it fondly. It may even be given new life in the work of artists such as Shag, Ruth Pearl, Hannah Tran, Lake Surfer, Doug Horne, Pete Klockau and many, many others all over the country and the world.

Kahiki Mystery Drink

In 1978, a decade after the sexual revolution commenced, Evelyn Cochran was among hundreds of young women who auditioned for *Playboy* photographers in hopes of being chosen as the centerfold girl for the magazine's twenty-fifth anniversary issue. While most of the candidates were college coeds, Evelyn was not. She worked at the Kahiki as a Mystery Girl, serving the Mystery Drink.

According to reporter Martin F. Kohn: "The mystery drink is not just a drink. It's a production number in which Evelyn, in grass skirt and scant top, skitters out, bows to the tiki god, drapes leis around the necks of the customers who ordered the drink (it serves four) and, yes, serves the beverage."[215] On a typical Saturday night, Evelyn performed this ritual about twenty-six times. In between servings, she watched television and, perhaps, dreamed of stardom.

The concept for Mystery Drink likely was inspired by the Scorpion Bowl popularized by Trader Vic's. The Mai-Kai then combined the Mystery Drink with the Mystery Girl, who began serving it as early as 1958–59. In 1962, a year after the Kahiki opened, the Mai-Kai arranged for a Mystery Girl to serve a Mystery Drink to late night television host Johnny Carson—who was friends with the owners—live on *The Tonight Show*.

Although the Kahiki appropriated the idea from the Mai-Tai, the restaurant made the concept its own. It was on the menu from the beginning. When it was time to deliver the Mystery Drink to a table, a large brass gong was sounded, summoning the Mystery Girl. She would appear carrying a ceramic bowl with a smoking (dry ice) volcano in the middle. She would then kneel before the twenty-three-foot-tall fireplace god before dancing to the table and presenting the drink to the party along with orchid leis flown in from Hawaii.

Douglas Winship has this to say about the Mystery Drink:

> The Khaki Mystery Drink follows a similar trajectory. The original is essentially a Trader Vic classic, the Fog Cutter, minus the gin. The later incarnation was essentially a tiki version of a Long Island Iced Tea. The later recipe may have more ingredients but is likely to have had a bland overall flavor that betrays none of its ingredients.

Kahiki Mystery Drink (Original)

3 scoops cracked ice
6 ounces orange juice
4 ounces lemon juice
1½ ounces orgeat
6 ounces light rum
1 ounce brandy

Ice cubes to fill flaming ice
cone in center of bowl

Kahiki Mystery Drink (Revised)

1 shot light rum
1 shot dark rum
1 shot Bacardi 151
1 shot amaretto
1 shot vodka
1 shot tequila
1 shot Triple Sec
1 shot lime juice
8 ounces orange juice

Shake, strain into a shallow
bowl and serve

• • •

Larry Stone of Bradenton, Florida, once went to the Kahiki to celebrate his birthday. "We ordered the 'mystery drink,' which was normally served by a Hawaiian virgin," he told *Dispatch* columnist Joe Blundo. "Our drink, however, was served by an old man who stated, 'Here's your drink, the virgin went home!'"[216]

Everything New Is Old Again

To the right of the "Quiet Village" is the tropical rainforest. Lightning flashes and thunder booms periodically, while rain streams down the windows.
TO THE REAR of the "Quiet Village" is a staircase to the lounge area and offices on the second floor. The lounge, ornately decorated with tapa cloth, giant fish traps serving as overhead lights, a large tiki, a planter area, and a cozy seating arrangement, offers an intimate, relaxing atmosphere for small cocktail parties. The sculptured gardens are on the east side of the building. This area is often overlook[ed] by visitors to Kahiki, but it is one of the most beautiful garden spots in Central Ohio.[217]

—From an early advertisement for the Kahiki

All businesses have a lifecycle. They are born, enter a period of rapid growth (or not), reach maturity (peak) and begin to decline. Then they either die or are reborn. The rise and fall can vary dramatically from one business to another. The average lifespan of a restaurant is less than five years, which is actually a little better than most other business ventures. That is because the barriers to entry into the restaurant business—location, capital, attracting customers, economies of scale, regulations—are generally lower. Nevertheless, few restaurants survive twenty years without reinventing themselves repeatedly. Times and tastes change. They need to find some way to connect with each new generation. Perhaps one in a thousand restaurants survive as long as the Kahiki did.[218]

Twenty years after the Kahiki was born, the Polynesian restaurant fad had pretty much faded away. Nouvelle cuisine, Cajun cooking and artsy presentations were all the rage. By 1989, there were but three Don the Beachcomber's left out of a chain that once numbered sixteen. Trader Vic's, which once had as many as twenty-five locations around the world, also experienced a sharp decline beginning in the 1970s. However, by the late 1990s, it had begun to reverse the trend as all things tiki experienced a resurgence.

A look at what was going on in Columbus during the life of the Kahiki illustrates this point. There were several serious attempts to tap into the market as well as a dozen or so opportunistic ones. In 1963, Kalani's Polynesian Revue—a troupe of seven dancers, musicians and singers—were booked into the C'est Bon Room at Lincoln Village Lanes for four nights. Later the same year, Ben Waiwaiole's Hawaiian Holiday, featuring Prince Pokii and the Royal Polynesians, opened at the Deshler-Hilton's Top of the Isle. They invited audience members up to learn how to hula and even provided costumes. The following year, Kalani's Polynesians—now numbering eight—were back to host a luau at the Manor Motel on West Broad Street. They had recently been guests on the Arthur Godfrey, Ed Sullivan and Steve Allen television shows.

Most of these events seem to have been one-off affairs that weren't repeated. However, the Top of the Isle, which opened in the Columbus Deshler-Hilton Hotel on September 4, 1963, was a serious attempt at creating a Polynesian nightclub. Located in the former Sky Room, it was sixteen floors above High Street. Earlier, the same space had been occupied by the Ionian Room. Nationally syndicated columnist Earl Wilson gave the new restaurant a plug, noting, "The other evening we wandered in and out of the unusual and fascinating ways and by-ways of the gaily colored and wonderfully textured South Pacific setting of the newest entertainment spot in town."[219]

According to reporter William Fulwider, "The new look isn't overwhelming. Rather, the designers have imbued the room with a rich, red ceiling, and a modicum of trappings. There are moderate-sized fountains, the bar stools are carved Tiki Gods and a touch here and there of the South Seas results in a soft warm glow."[220] Although the waitresses, mostly brunettes, wore fireproof grass skirts, management soon switched to sarongs. The bar offered thirty-three exotic, mostly rum-based cocktails. It short, it was an obvious attempt to latch onto the Kahiki's coattails.

Glenn Wisecarver, who designed and decorated the restaurant, employed native stone imported from the islands, red cedar, palm trees and bamboo,

as well as grass-textured walls accentuated by carved idols. Multicolored lights emanated from thirty-two wicker basket lanterns. The bar was divided from the dining area by a curtain of wooden heads. The menu was standard Cantonese fare.

During its short tenure, the Top of the Isle booked various Hawaiian musical groups and featured a Polynesian dance revue. In addition to Ben Waiwaiole, it booked Johnny (Kaonohi) Pineapple and his South Pacific Revue. The men sang and played their instruments, while the Aloha Sweethearts danced the hula. But just two years after it opened, the Top of the Isle was no more.

The Waikiki Restaurant at 4101 West Broad Street, adjacent to the Imperial House West Motel, was incorporated in December 1972. It was the site of the former Nationwide Inn, which had advertised "Waikiki Weekend" packages in 1966. On Tuesday night, April 30, 1974, a fire swept through the building when a French fryer ignited, causing an estimated $200,000 in damages. Fortunately, there were no injuries, but the Waikiki Restaurant did not recover.

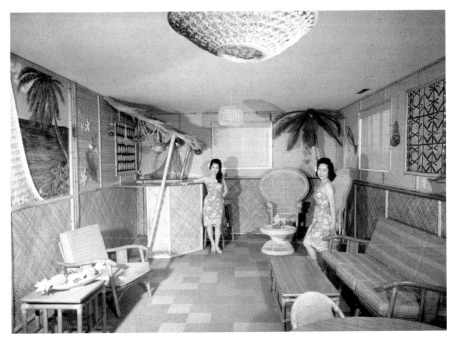

Many Asian women who worked at the Kahiki were married to local servicemen. *Courtesy of Aja Miyamoto.*

The Hu Ke Lau, 1939 Fountain Square Court, was incorporated in July 1977 and opened in December. It would feature Hawaiian entertainers as well. Josefa Mo'e, a Hawaiian artist, created a series of murals encompassing the history of Hawaii and the beauty of the islands. Originally hired to paint two walls, he eventually expanded to every nook and cranny in the restaurant.

"I am trying to create an atmosphere, a feeling of the island," Mo'e told writer Mary Bridgman. "I incorporate the customs of the ancient Hawaiians."[221] He worked with an airbrush, cutting down the time required by 75 percent. However, the half-hearted attempt at creating an island mood coupled with Lani Moe and the Lure of the Pacific—a singer, small combo and three Polynesian dancers—weren't exactly packing them in. So, during the first week of August 1978, the Hu Ke Lau booked Las Vegas hypnotist Sam Vine. Apparently, he couldn't hypnotize enough people into thinking they were having a good time, for by June 1980, the restaurant was gone.

In contrast to the Top of the Isle and the Hu Ke Lau, the Kahiki lived many lifetimes. They can be divided into two distinct eras: the Bill Sapp and Lee Henry start-up and rapid growth period and the Mitch Boich and Michael Tsao maturity and decline period. Lee and Bill opened the Kahiki in 1961. Seventeen years later in August 1978, they sold it to Michael M. "Mitch" Boich, founder of Boich Mining Company, and his son, Michel.

During business trips to Los Angeles, Mitch had taken a shine to Michael C. Tsao (1949–2005) at the Trader Vic's in Beverly Hills. At the age of twenty-three, Michael became the youngest general manager ever of a Trader Vic's franchise and turned it into one of the top ten restaurants in the Los Angeles area. So Mitch decided to buy a restaurant back home and use it to lure Michael to Columbus.

Mitch was born in Steubenville, Ohio, and died in Phoenix, Arizona, seventy-three-years later. Although he had lived in Phoenix since 1967, Boich Companies continued to be based in Columbus. Beginning in the late 1940s, he started a number of successful businesses, primarily in coal mining and construction. He was also a major contributor to the gubernatorial campaigns of George Voinovich, Richard Celeste and Lee Fisher. When he spoke, politicians listened. After serving in the army during World War II, Mitch attend Ohio State University, but what he knew wasn't something you learned in college.

When Michael became general manager of the Kahiki in November 1978, he was accompanied by his team from the Beverly Hills Trader

Vic's, including 1977 Los Angeles "Chef of the Year" award-winner Ping Lee. Michael was a true American success story. And obviously, he knew something about running a successful restaurant. However, to Bill and Lee, he would always be the guy who painted a moustache on the Mona Lisa. Immediately after selling the Kahiki to Mitch, they regretted it. And what they regretted were the changes Michael implemented—such as replacing their big gong for a tiny one and swapping out Hawaiian shirts for T-shirts.

Although Bill had believed "the new owners will keep things pretty much the way they are," they didn't.[222] They closed it for twelve days in November for "renovations." When the Kahiki officially reopened on November 18, a large ad appeared announcing the changes. The décor was the same, but the menu wasn't. The restaurant now offered "down-to-earth, everyday prices," a children's menu and a Polynesian Oyster Bar. The décor remained the same, except the large gong was gone.

By January 1979, the Kahiki had also started its own dining club, offering one "complimentary" dinner entrée with each dinner entrée purchased, making the food cheaper still. Dan Lee, assistant general manager, was quoted as saying he hoped the dining club cards would bring in new business. By 1981, there would be four competing dining clubs in the Columbus

An artist's sketch of a proposed Kahiki drink menu. *Courtesy of Kahiki Foods.*

area—Restaurant Owners' Dining Association, Entertainment, Prestige and Candlelight—and the Kahiki belonged to everyone. Clearly, the new owners felt the restaurant's success was dependent on changing its image from being an expensive indulgence—a perception shared by many Columbus residents—to affordable. And the coupons would continue as well.

Although backgammon had been introduced to the Kahiki during the Bill and Lee era, Mitch and Michael now began holding tournaments for charity. The entry fee was $20 per person with all participants receiving an Entertainment 79 Club membership (valued at $17.50) and a trophy.

There were certain changes that Michael wanted to make that others talked him out of. For example, Jim Rush, who looked after the plants and animals, recalled that he wanted to install saltwater tanks for fish and lobsters. However, Jim explained to him that all of the metal in the restaurant—the decorative brass, copper and iron—would eventually corrode because of the salt in the air.

Ten years after the creation of the Kahiki, Bill and Lee opened the Wine Cellar in 1971. The Wine Cellar had its inception during a trip they made to England with Coburn Morgan. In its own way, it was as heavily themed as the Kahiki, although less appreciated. However, Lee was tiring of the restaurant business, so Bill bought him out in 1980. After all, Bill was the real wine connoisseur in their partnership. But in 1985, he found himself in need of cash to cover some of his other investments.

Even though Bill and Lee still harbored some resentment over what had transpired with the Kahiki sale, they both liked Mitch Boich. Bill reached out to him to see if he would be interested in buying the Wine Cellar. He was. And then he turned around and leased it to Michael Tsao. Oddly, neither Lee nor Bill seemed to have the same emotional attachment to the Wine Cellar that they did to the Kahiki. Still, they were shocked when Mitch closed it early in 1989, less than five years later. But that's because they weren't privy to everything that was going on behind the scenes. A bulldozer finished it off in 1991 two years later.

In the arc of his career, Michael Tsao had gone from washing plates to spinning them. His was a true American success story of an individual who reached the top through sheer willpower (and the help of a rich friend). Four years after he took the reins at the Kahiki, Michael was made manager of the Sheraton Hotel in Columbus when it was purchased by the "Kahiki group."[223] Among the investors were Mitch Boich, Danny Lee, Ping Lee and Michael. However, their plans to renovate the aging hotel were almost immediately put on hold due to "tight money and internal problems."[224]

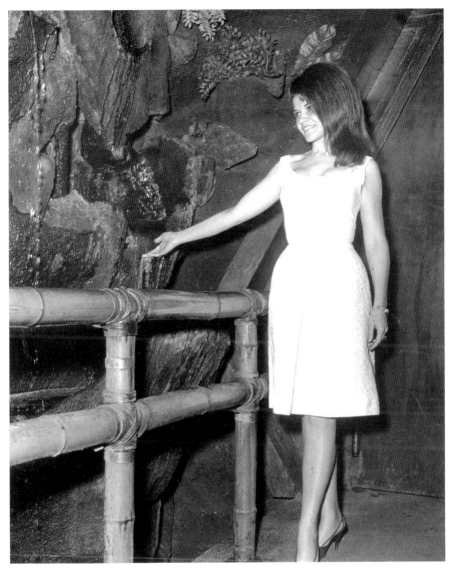

The waterfall in the entry way was always difficult to photograph. *Courtesy of Terry Darcangelo.*

Nevertheless, Michael set about doing what he could to revive business. In 1983, after nicknaming it "The Downtown Showplace," Tsao booked a variety show called the *Galaxy of Stars* with Morey Amsterdam, Gordon MacRae, Mamie Van Doren, Dorothy Lamour, Forrest Tucker, Gloria DeHaven and Patty Andrews. He wouldn't do that again. The same year,

he unknowingly booked the Ku Klux Klan in one meeting room and the mostly Black East Mount Olivet Baptist Church in another. He wouldn't do that again, either.

With occupancy running about 50 percent, the Sheraton began selling 207 of the 385 rooms as condominiums in 1986. Each would be sold "as-is" with existing furniture. There were few takers. A year later, it went bankrupt.

While struggling to keep the Sheraton solvent, Michael opened a new restaurant with a new concept in the New Market Mall in 1985. Called Oven One, this venue offered "California-type" cuisine and atmosphere built around a special oven that burned white or orange wood and employed wind drafts to cook meat at over 800 degrees. It "flamed out," as the Grumpy Gourmet put it, three years later.

In 1988, Michael finally bought out Mitch's share of the Kahiki and became sole owner. Still eager to expand his portfolio, Michael opened the China Express—a fast-food counter—in a Kroger store in Westerville in 1989. It quickly failed. As he later observed, "We tested the waters for fast food and decided that was not the way to go."[225]

Arguably, Michael may have been too distracted by these other ventures to look after the best interests of the Kahiki. Or maybe he took the Kahiki's success for granted. Although longtime customers could recognize that not all the changes that had occurred were for the better, it was getting more attention than ever and would continue to win prestigious awards right up until the end. However, it may also be that he recognized that if the Kahiki didn't grow, it would die.

Then in 1991, fate intervened. Out of the blue, Michael received a phone call that changed the Kahiki's course forever. According to writer Lorie Greenspan, "Frequent visitors to the supper, a group of Kroger executives, loving the Asian and Polynesian food, had an idea."[226] With consumer demand for premium ethnic foods increasing, they asked if he could supply all of their Columbus-area stores with frozen entrées and appetizers bearing the Kahiki brand. Michael decided to give it a try. It was possibly the best decision Michael ever made.

Then for six months in 1992, AmeriFlora—an international flower exposition—occupied Franklin Park in Columbus. During the run of the event, there was a major full-service restaurant serving festivalgoers. It was called Hawaii Kai, and to quote Doral Chenoweth: "It's big, flashy, pricey and has an interesting bill of fare. It's as close to Pacific Rim cuisine as we are going to get in Columbus."[227] He noted that much of the menu resembled the Kahiki—in the early days. However, the

structure was designed to be temporary, and the prep area was "small beyond comprehension."[228]

As far as beverages were concerned, the Hawaii Kai offered the usual rum-based cocktails that tiki bars were known for. What it offered that the Kahiki couldn't was the location—the middle of an international flower show—and didn't, a floor show featuring Filipino dancers doing the hula or Tahitian folk dancing.

Hawaii Kai was one of fourteen restaurants at AmeriFlora operated by Sebastian's, Incorporated. A Seattle-based company, it relocated its headquarters to Columbus to take advantage of the exposure it received. Lew Del Fierro, the director of Sebastian's, said it was a "family affair" with five Del Fierros in management, not including spouses and fiancés. They then transformed the former Otto's Deli into the Exchange Deli and the former Grandview Inn into Sebastian's Grandview Inn. A year later, however, they were heavily in debt.

Sebastian's was started by Antonio L. "Tony" Del Fierro, a nephew of a former president of the Philippines. As a young man, Tony moved to Seattle, where he built a successful career as a hotel and restaurant owner. He founded Sebastian's specifically to serve food at world expositions. AmeriFlora proved to be the last of fifteen such expositions over a thirty-year period.

Having already begun limited distribution of its products through Kroger, the Kahiki then signed a contract to provide egg rolls for Wendy's at the *Son of Heaven* art installation in Columbus. It was housed in the old Central High School downtown. But the restaurant's kitchen was not big enough to accommodate Michael's plans to increase the wholesale aspect of the food business.

Jim Rush recalled that Michael paid $50,000 for an egg roll making machine. However, sales took off so fast that he soon had to move it out of the basement of the restaurant. In order to obtain needed funding, Michael led an IPO that made the Kahiki a publicly traded company in early 1994. With the money raised, he took the big step of building a seven-thousand-square-foot frozen plant adjacent to the restaurant. But there was a problem. According to Jim, the facility did not meet food service standards, and the "drywall melted" because it was not properly sealed. As a result, Michael soon had to scramble to find another building to move his egg roll production line into.

Within a matter of months, Kahiki frozen foods had spread to half a dozen states, and sales topped $1 million. The operation had already turned a profit. Michael knew he was onto something—something that would keep the Kahiki alive, if in name only.

This prompted another change by Michael Tsao that horrified Lee and Bill. He installed a frozen food case in the entryway of the restaurant so he could sell his egg rolls. Of course, this destroyed the ambience they had worked so hard to create. However, Michael had become convinced that the only way forward was as a producer of frozen "high-end, gourmet-type Asian food products."[229] He had given up on the idea of opening a "satellite Kahiki" because of the expense.

Over the past thirty-three years, the area around the Kahiki had declined sharply. It had taken on a seedy appearance, and potential diners became concerned for their safety. During the 1960s, 1970s and into the 1980s, the far eastside was quite popular with diners and nightclub crawlers. Pat Zill, the former owner of the Boat House at East Main and Beechwood Road, lamented the passing of those days. Zill's bar became one of the stops "for salesmen with expense accounts, dating couples interested in seeing and being seen and other inhabitants of the entertainment scene."[230]

Among the other "popular retreats during that era of rare steaks, dry martinis and neon signs featuring the word 'cocktails'" were the Top Steak House, Kuenning's Suburban Restaurant, the Driftwood Steak House and the Sands Cocktail Lounge—all on the East Main Street strip. Meanwhile, the Desert Inn and the Kahiki had reigned supreme on East Broad. Now all that remained were the Top—still owned by Bill Sapp—and the Kahiki. And the lights were getting dim.

Michael continued to operate the Kahiki for six more years. On Valentine's Day 1998, the Kahiki served 1,068 customers for an average check of $25. Over 1,000 more were turned away. The most popular item was the Islander Fest, a $20 platter with a sampling of all the house specials. If only every day could be Valentine's Day. But the Kahiki of the 1990s wasn't the Kahiki of yore.

Blogger Alice Thomas Cervantes recalled that when she and her future husband went to the restaurant on one of their first dates, much of the magic had worn off. "Sitting at our table, I took in the spectacle as I calmed my new-boyfriend nerves and observed kitsch coming apart at the seams," she wrote.[231] "Fountains that were turned off; fish tanks only half-filled; and uninspired wait staff who couldn't feign enthusiasm. The bartender on duty seemed irked when we walked up to order a drink; he'd been talking to his girlfriend, who was keeping him company."[232]

The decline was also apparent to the staff. Hostess Autumn Shah noted in her blog: "I remember the physical signs: the shredding bamboo walls, the crackly static of thunder in the bathroom, the rain that sometimes

clogged in Rain [the rain forest], the threadbare carpet, the sputtering fountains. There were sections of the restaurant that we didn't use, or only for special occasions."[233]

Just two years later, Michael sold the property to Walgreens. After thirty-nine years, the Kahiki Supper Club closed forever on August 25, 2000. The historic building and the frozen food plant were soon razed and a not-so-historic drugstore erected in their place. But the frozen food operation was moved into a new twenty-two-thousand-square-foot plant at 3004 East Fourteenth Avenue in Columbus as demands for Kahiki products continued to grow dramatically.

Once the sale was complete, Michael immediately began talking about opening a Kahiki II on the downtown riverfront. Toward that end, he placed much of the interior décor in storage. And city officials were purportedly helping him search for a suitable location.

Jim Rush recalled that Michael had two distinct plans for rebuilding the Kahiki. The first was intended to be a restaurant on stilts in the Scioto River next to Veterans Memorial Auditorium with access by ramp. However, the city engineers purportedly rejected that idea because they didn't want anything encroaching on the river. Memories of the 1913 flood, perhaps. There was also a belief that it would detract from the *Santa Maria*, a replica of Christopher Columbus's flagship, which was moored on the opposite side.[234] And the directors of the Veterans' Memorial vetoed it for their own reasons.[235]

So Michael developed another plan—an even more ambitious one. The Columbus Health Department was scheduled to move out of its building south of the Center of Science and Industry (COSI) at 181 Washington Boulevard, fronting the Scioto River.[236] Michael's plan was to build three restaurants on the site in an L-shape: the Kahiki, a Mexican restaurant and one other. Across from them would be a theater with the river in the background. He thought of it as an "ethnic village" that would host a variety of festivals promoting the history of different cultures.

Michael's grandiose plan—more of a pipedream—also included four San Francisco–style trolleys operating on a circuit that would transport people to and from all the major downtown hotels and COSI. However, the powers that be in city government turned that one down as well. So in 2004, Michael decided to move some of the tiki décor out of the warehouse where it had been consigned since the Kahiki closed into the new frozen foods plant. That included paneling, artwork, statuary, the outrigger canoe and other items.

"It's our way of preserving The Kahiki," Michael said. "We've been in this town 40 years, and the memory is still alive. It's very much still in our hearts."[237] In one respect, this may have been his acknowledgement that his dream of building a Kahiki II was slipping further from his grasp. However, by doing so he probably kept even more artifacts from being sold off.

Before Michael passed away in 2005, Kahiki Frozen Foods were available throughout the United States and several foreign countries. Sales continued to skyrocket to $19 million, forcing the operation to move once again, this time into a new 119,000-square-foot building at 1100 Morrison Road in the Columbus suburb of Gahanna. By then, they had nearly 190 employees, most of whom were immigrants just like Michael and so many others associated with the Kahiki Supper Club had been.

Michael died on July 22 while on vacation in Vancouver, Canada, with his family. Four days earlier, spokesman Alan Hoover announced that Kahiki had opened an outlet in its manufacturing plant. It would carry not only Kahiki products but also specialty foods and sauces from other companies. It would also sell items from the original restaurant—these quickly sold out—and discontinued products. The inspiration was a Nestlé outlet store in Solon, Ohio. However, it was short-lived.

In 2021, there were nearly two hundred "Kahikians," as they call employees of Kahiki Frozen Foods, representing twenty-two different countries. The company is now owned by CJ CheilJedang of Seoul, South Korea. A global conglomerate dealing in food, pharmaceuticals and biotechnology, it has offices in China, the Philippines, Indonesia, Vietnam, Brazil, Australia, Japan, Russia, Singapore and Columbus, Ohio.

KAHIKI SUFFERING BASTARD

When writing about "Spook" Beckman's *Coffee Club*, a weekday morning show that originated on WLW-C, *Dispatch* television and radio editor Danny Flavin referred to an incident that occurred back when it was broadcast live: "Take the lavender-and-old lace type who said she liked to go to The Kahiki. 'I love those ——,' she said, citing a certain drink whose name comes on pretty strong when said aloud."[238] No doubt she was referring to the Suffering Bastard.

Since bourbon is "America's native spirit," a particular type of whiskey born below the Mason-Dixon line, it has nothing to do with Polynesia. Yet most tiki bars serve a bourbon cocktail known as the Suffering Bastard.

However, Sandro Conti's version dispenses with bourbon and substitutes his Mai Tai mix.

Again, Douglas Winship's comments:

The Suffering Bastard is the real outlier in this spread of recipes. The earlier version is…not a Suffering Bastard in any incarnation I've run across, but really just a second, less tasty, Mai Tai. Conversely, the later recipe is very much a classic Suffering Bastard, if a little less spicy due to the use of ginger ale, rather than ginger beer. But again, you probably could not have found ginger beer in the 1980s, and the customers would not have wanted it anyway.

Kahiki Suffering Bastard (Original)

Fill a 16-ounce double Old Fashioned glass ¾ full of cracked ice. Then pour:

1 ounce lime juice
1 ounce Mai Tai Mix
1 ounce golden rum
2 ounces St. James rum

Shake and garnish with:
Cucumber peel 1–1½ inch wide x
½-inch think
Orange slice
Red and green cherry

Kahiki Suffering Bastard (Revised)

1 shot bourbon
1 shot gin
1 shot lime
1 dash angostura bitters
4 shots ginger ale

Pour into an iced glass and top with ginger ale. Garnish with mint or an orange slice

• • •

A final theme to discuss that holds with virtually every drink on this list is the decline of garnish standards from the early versions to the late ones. The Mai Tai went from mint, a fruit stick and a lime husk to just mint. The Suffering Bastard went from a strip of cucumber peel, cherries and an orange slice, a very pretty and elaborate garnish, to "Eh! Just throw in a lime and lemon wedge." I'd very much like to know what exactly was meant by the Mystery Drink's "Ice cubes to fill flaming ice cone in center of bowl," but whatever it was, it was gone in the later years.

I'd have been happy to drink at the Kahiki in either era, of course, but the earlier drinks definitely had a closer connection to the original tiki flavor profile of dark, exotic and strong. The later drinks are much more in line with what the customers of that day would have desired, but I imagine they still seemed plenty exotic.

10

The Kahiki Legacy

Kahiki employees, 140 of them, are a miniature United Nations. They represent 15 different countries and their languages: China, Japan, Dutch New Guinea, Greece, the Dominican Republic, Cuba, Canada, Mexico, Nicaragua, Italy, Germany, Turkey, Puerto Rico, Korea, the Philippines, and Dutch Malaya. MOST OF THE cocktail waitresses are the wives of servicemen or ex-servicemen and all are from Japan or Korea. Although none of them had experience in this type of work, they were all trained rigidly for a two-month period prior to the Kahiki opening in February.[239]

—From an early advertisement for the Kahiki

There is a line—sometimes hard and fast, other times not—between cultural appreciation and cultural appropriation. Cultural appreciation occurs when the dominant culture—in this case, white European Americans—respectfully borrows elements from a nondominant culture, perhaps with the intent of blending them with other cultures to create a hybrid. Cultural appropriation, on the other hand, occurs when these elements are used without attribution and in a manner that is inconsistent with the beliefs, values and traditions of the culture in which they originated. The use of religious symbols and objects can be a particularly sensitive issue.

With respect to the tiki bar phenomenon, there are two major sticking points. First, it has its roots in America's colonial past. "America's presence in Polynesia," as John Birdsall put it, "is the result of military expansion.

We seized Hawaii in the 1890s for its geo-strategic value (same with Samoa, carved up by Western colonial powers in 1899), and we exerted control over various islands during and after World War II."[240]

Second is the very word *tiki*. It can be traced to New Zealand and the Marquesas Islands, where it refers to a carved image of a god, ancestor or even the first man. To transform such sacred artifacts into everything from necklaces to lamps to mugs is, understandably, viewed as offensive by some Pacific islanders. As a result, the *New York Times* has reported that a "recent movement aims to shift from the word 'tiki' to 'tropical.'"[241]

However, tikiphile C.W. Gross has argued that while "tiki culture and Polynesian Pop has pulled substantial influence from traditional Polynesian culture…it was never intended in any sense to represent it. Rather, tiki style was a reflection of the American experience of the South Pacific."[242] Furthermore, during the 1990s, "Tiki became associated strongly not with native South Sea Island culture, and not really with drinks either," according to Brooklyn bar owner St. John Frizell, "but with Midcentury Modern aesthetics."[243] It was fantasia composed of various forms and styles, part experience, part dream and part imagination run wild.

"I personally don't care if people want to drink mai tais," Stephanie Nohelani Teves, an assistant professor in women's studies and native Hawaiian, has asserted. "On some level it is just a drink, and I am not expecting bartenders to change minds. The nostalgia people express through tiki is offensive because it forgets that this colonialism and militarism is ongoing, not temporary. Not past. Not over."[244]

Nevertheless, the difference, today, is that more people are listening. Chicago bar owner Shelby Allison insists that modern tiki bars are "more conscientious and more considerate.…We're able to leave behind the old tropes that were problematic in tiki bars of yore."[245] Greater emphasis is being placed on hospitality and well-crafted cocktails and less on bamboo, hula girls and, yes, tikis.

If there had been more actual Polynesians in Columbus, the Kahiki would likely have hired them. But there weren't. So Lee and Bill turned to Cuban refugees, owing to their fondness for the people, and Asians—specifically Chinese, Japanese, Koreans and, later, Vietnamese. Think of it as the Ellis Island of Ohio restaurants.

The Chinese came first, but they didn't have an easy time of it. On August 28, 1886, just after midnight, Ong Q. Chung was found dead outside the door of his Columbus residence. Chung had arrived from Springfield, Ohio, about four weeks earlier and purchased the laundry

where he also lived. One or two white men—possibly drunk—had been seen quarreling with him earlier. And he had either died violently or of a heart attack. Newspaper accounts differed. The police and the reporters always had trouble getting the story straight when the witnesses didn't speak English.[246]

Chung was buried in Green Lawn Cemetery. However, the body would be "exhumed in five years and the bones shipped to Canton to be interred."[247] This was common practice in the early days because most Chinese nationals planned to return to China after they had accumulated enough wealth to live comfortably there.

Over the next decade, it became increasingly common for deceased Chinese immigrants to be interred in Green Lawn Cemetery. But as immigration laws became more restrictive, the likelihood that the immigrants would eventually return to China grew. And when they did, they would often take the bodies of their dead countrymen with them.

In September 1895, Ben Hope Lee and seven other Chinese gentlemen went to Green Lawn to disinter the remains of four of their deceased countrymen and ship them back to China.[248] According to the *Akron Beacon Journal*, "Nothing but the whitened bones of three of the Chinamen were found, and these were carefully place in zinc-lined boxes and carefully sealed."[249]

However, when the remains of the fourth—Mee Lung—were dug up, they were found to be in a "semi-petrified state," greatly frightening the men.[250] Mee Lung had been buried three years earlier. A short time before Mee Lung died, Reverend H.W. Bennett of Wesley Chapel had converted him to Christianity. Therefore, he was given a Christian burial in the presence of thousands of curiosity seekers. The Chinese men attributed Mee Lung's petrification to his religious conversion.

The newspaper account noted, "They were there to send the body home, however, and proceeded to break it into pieces, so as to be able to place it in the small box."[251] One of the men, however, fled from the cemetery while the others were mutilating the corpse. The remains were finally taken to the Wells Fargo office, where they were shipped to San Francisco and then forwarded on to China.

In 1943, Congress finally repealed the Chinese exclusion laws, replacing them with a quota of 105 visas from China per year. Three years later, exclusions laws were dropped against Filipino and Asian Indian immigrants as well. However, racial quotas were kept in place for all Asian immigrants until 1952. Congress finally abolished the National Origins quota system entirely when it passed the Immigration Act of 1965.

Frankie D. Chan (1927–2019) arrived in the United States in 1941 at the age of thirteen under the sponsorship of an uncle. His family described him as a "self-made man, living in a new land, fearlessly proud and independent."[252] He was one of the many Asians who worked at the Kahiki before opening a restaurant of his own.

Initially, Frankie operated a Chinese laundry but later gravitated toward cooking. Among the restaurants he worked at were Jong Mea, Wings, Miracle Bar and the Kahiki.[253] He later co-founded the Rice Bowl in 1980 with fellow Chinese immigrant Sze Chun Leung.[254] His specialties were homemade tofu, salted duck eggs, dim sum appetizers and egg rolls with a "secret ingredient," of course.

A naturalized citizen of the United States, Frankie was an avid fan of the Ohio State Buckeyes, Cincinnati Bengals and Cincinnati Reds sports teams. When he passed away at the age of ninety-one, he left behind a wife, Jean (Gin Sem Yee); three children; several grandchildren and great-grandchildren; and the respect of the Columbus Chinese community.

Although Chinese burials had become increasingly common, when Chan Woo passed on February 15, 1956, at Alum Crest Hospital, a problem arose. The Chinese New Year was approaching, which necessitated burying Chan on a Sunday. However, Green Lawn's rules did not permit Sunday burials. As a result, he was buried in Eastlawn Cemetery on Sunday, February 26, 1956. Chan Lem, owner of Lem's Restaurant, said a proposal would soon be made to purchase a large plot at Eastlawn for future Chinese burials. Woo had worked off and on at Lem's as a cashier.

"Most of the Chinese work every day but Sunday and holidays," Lem explained. "Sunday is about the only time we can go to services, but Green Lawn won't allow Sunday services."[255] The same year, representatives of the Chinese Benevolent Organization bought a number of lots to create a Chinese section in Eastlawn. Among those interred there are the Lee family, owners of the Hoy Toy restaurant, and Yee family, owners of the Ding Ho restaurant.

Gray Wong (1913–1975) was a waiter, then maître d' at the Kahiki, as well as a host at the Rice Bowl. A veteran of World War II having attained the rank of sergeant, Gray was survived by his wife, Helen (Woo); two daughters; and a son. Although he was also buried in the Chinese section, over time, the original plots were all occupied. Then in 1998, Andy Chan approached Thor Triplett, owner of the cemetery, about buying some additional land.

Andy, who started out with Columbus restaurateur Mark Pi, had become the purchasing agent and executive chef at Kahiki Foods. Michael Tsao

wanted to provide additional benefits to the employees of his frozen foods division, so they bought seventy-five spaces north of the existing Chinese section with an option to purchase more.

According to Triplett, the Chinese graves have red and black headstones. Red signifies "an evil-free condition"—in other words, "happiness, good fortune, and protection."[256]

Bing Kwok Ng and his five sons became naturalized citizens of the United States in November 1974.[257] They had left mainland China nine years earlier and had been in the United States for five years. They were among fifty-nine persons naturalized in U.S. District Court in Columbus on that day. Ng, age forty-eight, and his sons Tim Keith (twenty-three), Kin (nineteen), Chieu (twenty-four) and Ken (twenty-one) took the oath simultaneously. Four of the sons also added the letter "E" to their names to make it "Eng" so it would be easier for Americans to pronounce. The father, who spoke and understood little English, was a cook at the Kahiki. His sons Keith, Kin and Ken also worked there, while Chiu was a waiter at Jong Mea.

Dr. Yung-Chen Lu, professor emeritus of mathematics at Ohio State University, traces the birth of the Columbus Asian Festival to a meeting of thirty-eight businessmen and physicians in the basement of the Kahiki on December 17, 1993.[258] The purpose was to start a clinic catering to the needs of Asian Americans in Central Ohio, but a subsequent social event with over sixty Asian elders was such a success that John Seto from the Ohio Arts Council approached Dr. Lu about planning a fun event for the community. They were joined by Manju Sankarappa and Becki Krohm.

Dr. Lu felt that such an event should showcase Asian culture and heritage and also include a pavilion for health screenings. This would include various cultural exhibits and performances, as well as a large food court. From these humble beginnings, the Columbus Asian Festival has grown into a major event. Today, Columbus is the center of the state's largest and most diverse Asian community.

Given the continual turnover in employees, the Kahiki hired many non-Asians as well. But it took a special act of congress to enable one of them to immigrate to America. His name was George Louis Sauter (1942–2014). The son of Reverend Christon Makkas and his wife, Evgenia, Georgois (his original name) was born in Ilektra Messinis, a small village in southern Greece. His father was a priest in the Greek Orthodox Church. In 1956, Louis and Addie Sauter, a childless couple in Columbus, formally adopted fourteen-year-old George, who was Louis's great-nephew. From that time on, they contributed to his support.

For more than six years, the Sauters tried to bring George to the United States, but immigration barriers stood in his way. For one thing, he was too old to be admitted under the so-called orphan act, and for another, the quota for Greek refugees had been oversubscribed for years. So Louis and Addie turned to their local congressman, Samuel L. Devine, for help.

In 1960, Representative Sam Devine of Columbus offered a bill in congress to permit the Sauters to bring their now eighteen-year-old adopted son to the United States as a permanent resident. A year later, a measure passed conferring "non-quota immigrant status" on George. For immigration purposes, he would be considered the "natural-born alien child" of the Louis and Addie Sauter.[259] Without the special bill, George would have had to wait indefinitely—likely until 1965—before he could be admitted under the Greek quota.

Upon his arrival in Columbus in 1962, George did not speak a word of English, so he immediately enrolled in Central High School's immigration program to continue his education. He was already thinking of becoming a barber and eventually opening his own shop. However, Louis, his adoptive father, also had plans for him.

According to *Columbus Dispatch* columnist Johnny Jones, Louis was a "fine citizen" and "one of the original cooks at the New York Dairy Lunch at Broad and High."[260] When he came to Columbus, Louis didn't speak English either. Therefore, he immediately took George downtown to see where he had worked when he was first starting out. No doubt he also told him about his longtime employment as a chef at the QCB (Quickest-Cleanest-Best) Wagon Wheel Restaurant and the Jai Lai. After that, Louis got George a job at the Kahiki Supper Club as a busboy, where he had also worked at one time.

In 1965, George married Anastasia Kehagias at the Greek Orthodox Church. Along with Jim Barouxis, he opened Buckeye Donuts on North High Street in Columbus. It would become an Ohio State campus institution. In 1984, George and his son, Louis, opened a second Buckeye Donuts on South High Street. Thirty years later, he passed away at the age of seventy-two while vacationing in Greece.

On Buckeye Donuts' opening in 1961, Alice Taylor (1939–2014) was the first hostess. Twenty-two-year-old Alice was born Alexandra Lambropoulous in Columbus to Greek parents. She spoke Greek fluently and was skilled in Greek cooking. She was also one of the first staff members hired at the Muirfield Golf Club. Alice went on to work for thirty years at the law firm of Butler, Cincione and Dicuccio. A political activist, she was known as a perfectionist who had little patience for people with one-dimensional thinking.

Another Kahiki employee of Greek heritage was Stavros "Steve" Tsipas (1931–2019). Born in Corinth, Greece, Steve had been a sergeant in the Greek Police Department, serving in Sparti, Tripoli and Patra prior to immigrating to Canada and eventually the United States during the mid-1950s. Eventually settling in Columbus, Steve worked at various bakeries and commissaries and briefly owned a Jolly Roger Doughnuts franchise. After working for the Franklin County Court, he was hired as the maître d' for the Kahiki before taking a job at the Ohio Lottery Commission. Steve was said to be a skilled poker, gin and backgammon player and a lover of horse racing.

Alex V. Tsitouris (1935–2010) was a Greek immigrant who worked at the Kahiki, After becoming an American citizen in 1969, Alex found work at the Kahiki Supper Club. He was later co-owner of Zorba's Lounge and the adjoining Alex's Restaurant (formerly the Main & James) with his brother, Chris V. Tsitouris.

When he married Eleftheria Petropoylos in 1969, Chris Margetis was employed at the Kahiki, while his wife worked at F.&R. Lazarus & Company. Both newlyweds' parents were residents of Arcadia, Greece. Chris would later become the chef at the Blue Danube Restaurant, a once popular spot just north of campus on High Street. A family business, the 'Dube was owned at the time by George Margetis, a nephew of the founder, and managed by his son, Nick. By the early 1970s, there were so many young members of the local Greek Orthodox Church that they were referred to as the "Kahiki Boys."

Like many Kahiki employees, Dora Laswell (1931–2021) spoke English with an accent. But it wasn't Chinese, Japanese, Greek or any of the other ones commonly heard in the supper club. It was German. Born to Maria and Herman Hildebrandt in East Prussia, Dora lived in Germany throughout World War II. Afterward, she met and married Bill Laswell of Kings Mountain, Kentucky. They lived in Germany, Indiana, Kentucky and, finally, Columbus, Ohio, where they raised three children.

When her children grew older, Dora returned to the workforce, taking a job at the Kahiki Supper Club. She remained there several years while attending school to become a beautician. She passed away in Texas at the age of ninety.

There are countless stories similar to these of immigrants who got their start at the Kahiki Supper Club. But most will be lost or known only to a few as their days wind down. And soon all will be gone.

The Kahiki brand survives today as a leading manufacturer of Asian-themed frozen foods in the United States, Canada and Mexico. That it

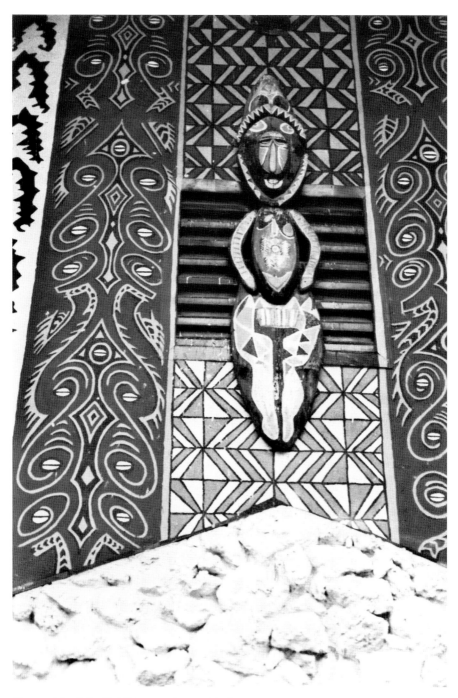

The outside of the Kahiki was as thoroughly decorated as the inside. *Courtesy of Bill Sapp.*

survives at all is something of a miracle. The brand has come a long way from Michael Tsao producing frozen egg rolls in the basement of the iconic restaurant to its state-of-the-art plant at 1100 Morrison Road, Gahanna, Ohio, a suburb of Columbus. Along the way, the company changed hands several times. Currently, it is wholly owned by businessman CJ CheilJedang of Seoul, South Korea.

The story of how the Kahiki got from where it was to where it is makes a good business case study. "In the mid-2000's, the company purchased a 25-year-old building that was five times larger than its prior manufacturing facility and built a frozen-food plant within its four walls."[261] Due to delays and cost overruns, Kahiki Foods found itself overextended, both financially and in terms of production capacity. Just ten weeks after the new facility was occupied, the company had lost $550,000 off the bottom line.

While attending a conference on continuous improvement, Kahiki president and chief operations officer Alan Hoover witnessed a presentation on the Miliken Performance System (MPS). He realized that MPS dealt with some of the challenges Kahiki was experiencing and quickly entered into a partnership with the company. Admittedly, Hoover and his team had not fully appreciated the problems attendant to scaling up from a 22,000-square-foot plant to a 119,000-square-foot one.

"The old facility, for example, had only one folding carton machine. It had one spiral freezer, which could take the cooked product and freeze it to a temperature of −70 degrees F in less than 15 minutes," Barry Rosenberg noted. "By contrast, the number of key pieces of machinery was more than double in the new facility. Some of the machines were new, though many were two-decades old."[262]

What the Kahiki executives discovered was having a larger facility and more machines alone did not make production more efficient. They had completely filled the new plant, but Hoover observed, "We were in fire-fighting mode daily."[263] Machines broke down, drains clogged, condensation built up and shipments were late.

This was the situation when Michael Tsao died unexpectedly. In that moment, there was a real possibility that the company might die with him. With Miliken's assistance, however, Hoover and his team began taking a closer look at what was happening. For example, they discovered that one of their key product lines required 105 steps from procuring the raw materials to shipping the finished product out the door. But "only 8 of those 105 steps created value in the eyes of the consumer," Hoover said.[264]

Then there was the ongoing problem with keeping the machines operational. That's when they discovered that the reason the carton folding machine was continually breaking down was that a glue nozzle was too large and the excess glue was literally gumming up the works. So Hoover instituted a program of daily machine maintenance, rather than waiting for something to break down.

Among the things the Kahiki management team learned was that they weren't out of capacity, but they had to do a better job of optimizing what they had. They had accepted a certain amount of waste as a cost of doing business, but MPS didn't. So they began to attack both waste, reducing it by 50 percent in key production areas, and efficiency, doubling the amount of finished pounds produced in an hour. This enabled Kahiki Foods to take market share from some of its major competitors in the Asian food market. It also made it a desirable addition to the CJ Corporation portfolio.

Although the food processing plant remains in central Ohio, the marketing arm of Kahiki Foods was relocated from Columbus to CJ Corporation offices in California. Meanwhile, the only member of the Tsao family to continue in food service is Jeff Tsao, general manager of Furkuryu Ramen USA in Columbus.

One thing that hasn't changed is the Kahiki's emphasis on attracting and nurturing a diverse workforce. The company continues to hire many immigrants. There are nearly two hundred "Kahikians"—as the employees call themselves—representing twenty-two different countries. Some have been Kahiki employees for over twenty years, having made the transition from the original restaurant.

When the Grass Skirt Tiki Room opened in 2012, the Fraternal Order of Moai arranged for George, the concrete monkey statue salvaged from the Kahiki, to be installed on the outside patio.[265] During the interim, it had been housed in the lobby of Kahiki frozen foods plant. But when the Grass Skirt closed seven years later, George was left without a home. And after spending five years outside in the elements, he needed a little loving care.

At the age of fifty-nine, George had outlived even the hardiest flesh-and-blood monkey. He had even "survived an overzealous fan who climbed in its mouth and thrust a foot right through to its base."[266] But at eight feet tall and 1,500 pounds, George couldn't find many places willing to take him in. Finally, Tony and Tracie Ball, owners of Tork Collaborative Arts, welcomed him into their South Side studio and set about the arduous task of restoring him to his former glory.

The peacock chairs were especially popular with customers. *Courtesy of Terry Darcangelo.*

The problems faced by the Balls in doing a complete overhaul of George is a microcosm of what it would have entailed to renovate the Kahiki itself. In some respects, such an undertaking might be comparable to the recent renovation of St. Mary's Church in German Village, which took two years and millions of dollars. Strictly from a business standpoint, it could never

151

have been justified. But from an artistic and cultural one, it would have been a sin not to do it.

Sculpted by Columbus artist Philip E. Kientz in 1961, George has "a rebar-and-iron-mesh shell…filled out with concrete and a stuccolike surface textured to look like lava rock."[267] Although it was well-made and built to last, in Tracie's opinion, George was not without problems, beginning with the broken base. Tony envisions replacing it with a steel platform. "You have this amazing sculpture, but it's sitting on a teeter-totter," he said.

Furthermore, George is riddled with cracks and stress fractures. As writer Bob Vitale explained, "The Balls plan to stay true to Kientz's vision—molds will be taken of his texturing so it's reproduced precisely—they do plan to upgrade materials for this job. Glass fiber-reinforced concrete, for example, weighs about 40 percent less than what was available in 1961."

Then there's George external appearance. Over the years, George was repainted several times, but Tracie believes she has identified the original colors and patterns. "A quarter-sized chip of paint missing from the bright orange helmet exposes metallic gold underneath," she noted. "Paint peeling off the brim reveals a palette of black, red and turquoise in a pattern of dots, bars and swirls."[268] For better or worse, the Balls will make George look just the way Kientz intended.

Once George is finally restored, the Fraternal Order of Moai hope to move him to an appropriate but as yet to be determined location. "To me, George is just as important as King Gambrinus," fraternity founder Matt Thatcher said, referring to the famous Columbus Brewery District statue. "They're both part of our history."[269]

Three other Kientz sculptures of similar construction to George were salvaged from the Kahiki—all of them much larger. They were the towering fireplace moai that dominated the inside of the restaurant and the two large Easter Island–like heads that stood outside, guarding the entrance. When the supper club was razed, the fireplace and one of the moai wound up in Vermont. The second moai was given to John "TikiSkip" Holt, providing he could arrange to haul it away. It was an offer he couldn't refuse.

A former restaurateur, John took it home with him. Ever since then, this particular moai has been moldering away in his backyard. Zoning laws had prohibited him from standing it upright as he originally intended. So the huge concrete sculpture lay flat on the ground for the next couple of decades, fully exposed to the extremes of Ohio weather. During that period, John began manufacturing and selling Polynesian-style lights of his own design.

Meanwhile, the Huli Huli Tiki Lounge & Grill opened in Powell, just north of Columbus, in 2019. At the time, owner Dustin Sun described this new venture as "a Hawaiian grill, with old-style drinks in classic mugs in a modern setting."[270] With its sleek appearance and tasteful tiki accents, it has proven to be quite popular, especially with a younger generation of tikiphiles.

Owing to Huli Huli's success, Dustin bought John's moai in 2022. He plans to completely restore it, although it will undoubtedly be an even bigger challenge than that presented by George. It will then likely find a new home at Huli Huli, providing a direct connection to the Kahiki. Although a time will come when no living person will have a firsthand memory of the Kahiki Supper Club, we hope that through our books the legacy of the greatest tiki palace of them all will continue to be kept alive.

KAHIKI CRAB RANGOON

When thirty-five central Ohio restaurants were brought together in March 1981 for A Taste of Columbus, it was just the twelfth time for such an event in the United States. Others had been staged in Washington, D.C.; Dallas; Louisville; New Orleans; Chicago; and New York. All sold out.

In Columbus, the site for the popular smorgasbord was Veterans Memorial Auditorium, since razed. Ticket sales were limited to 1,500. For its part, the Kahiki served up its ever-popular Crab Rangoon. The name, Rangoon, is taken from a city in the country of Burma, now known as Myanmar.

There is reason to believe that this faux Polynesian entrée was invented by Joe Young at Trader Vic's in San Francisco. However, it may have been in existence even earlier, possibly as far back as the 1904 St. Louis World's Fair. While Polynesians are consumers of crabs, there is nothing to indicate they wrapped the meat in wonton skins stuffed with cream cheese.

The coconut crab—*kaveu* in Tahitian—is the largest arthropod in the world, weighing up to nine pounds or more. It feeds on coconuts, which it is able to crack in its powerful pincers. In return, the claws, legs, eggs and grease of the abdomen are relished by Polynesians.

1 pound cream cheese, softened
1 pound crab meat
4 ounces (1 cup) breadcrumbs
Dash steak sauce

Dash hot pepper sauce
Dash Worcestershire sauce
Pinch garlic powder
Pinch salt and pepper
1 pound wonton skins

Combine cream cheese with remaining ingredients (except wonton skins) and blend well. Place a spoonful of mixture in center of each wonton skin and deep fry until golden brown. Note: February 13 is National Crab Rangoon Day.

• • •

Kahiki Almond Cookies

Melt-in-your-mouth almond cookies are a staple of every Asian restaurant. However, they were unknown prior to the early 1900s and appear to have been developed by Chinese immigrants to the United States, along with chop suey and fortune cookies. The recipe may have been adapted from the Chinese walnut cookie, which dates to the Ming Dynasty, but nobody really knows. National Chinese Almond Cookie Day is celebrated on April 9.

Kahiki's Executive Chef Philip C.W. Chin contributed this recipe to the Columbus Dispatch *at a reader's request.*

1 pound shortening
1 pound granulated sugar
1 teaspoon almond extract
6 eggs
2 pounds all-purpose flower (carefully sifted)
1 teaspoon baking soda (carefully sifted)
1 pounds whole roasted almonds

Mix shortening and sugar. Blend thoroughly with almond extract and eggs. Add sifted flour and baking soda. Mix well.

Roll into round balls. Place half almond on top—do not flatten. Heat oven to 300 degrees. Place cookies on greased baking sheets and bake for 50 minutes. (It's very important that the oven temperature be exactly 300 degrees.) Makes approximately 4 dozen cookies.

Notes

1. Arthur, "April 4, 1882."
2. Chenoweth, "They Put in the Fix."
3. Ibid.

1. Setting the Table

4. "Paradise Found: A Haven for Gourmets," *Columbus (OH) Dispatch*, September 24, 1961.
5. The term "Oriental" is no longer used in reference to people but remains acceptable when describing things such as rugs, restaurants and cuisine— although that could change tomorrow.
6. Although Won Koon was a dignified name in China, he officially changed it in 1882.
7. "Election Results and Notes," *Circleville (OH) Democrat and Watchman*, October 24, 1879. The word "Chinaman" is now considered offensive.
8. Ben Hope Lee did become a naturalized citizen in 1881.
9. Fay Courteney was sixteen when she made her debut in Columbus and was so small she could pass for a child on the streets. She was a favorite of local audiences for the next twenty-four years.
10. "Empire Stock Dines on Chop Suey," *Columbus (OH) Dispatch*, September 20, 1903.
11. Ibid.

12. Ibid.

13. Motz, "History Lesson: The Asian Festival."

14. Ibid.

15. "Grand Opening," *Columbus (OH) Dispatch*, July 17, 1905.

16. During this era, unescorted ladies were deemed prostitutes.

17. "His Stock of Dog Paws Wasn't Equal to Demand For 'Em," *Columbus (OH) Dispatch*, August 20, 1905.

18. "Bird's Nest Soup a Delicate Dish," *Columbus (OH) Dispatch*, July 25, 1905.

19. A *tong* was a secret society. Although some were strictly fraternal organizations, others engaged in criminal activity.

20. "Bird's Nest Soup."

21. Barney Kroger opened his first grocery store on Pearl Street in downtown Cincinnati in 1883. It would become the country's largest grocery chain and play a key role in changing the fortunes of the Kahiki brand.

22. Gibran, "Heyday of Hotel Dining."

23. "Band with Singer at Bamboo Inn," *Columbus (OH) Dispatch*, October 1, 1932.

24. Raper, "Shifting Scenes."

25. Olentangy Village had previously been the site of an amusement park and a zoo.

26. Jones, "Flavor of Historic Tea."

27. Just before the tavern closed in 1996, the bartender was a Greek man named Nick who "would serve Mexican margaritas, using a fake French accent in a Chinese restaurant with American Colonial décor" (Williams, "When Tavern Closes").

28. The couple had been separated for nineteen years due to the Chinese immigration quota and were only reunited in 1949.

29. "Chinese Food Is Booming Again," *Columbus (OH) Dispatch*, March 26, 1957.

30. Fraim, "Lee Henry."

31. Linda Sapp Long message.

32. Ibid.

33. Ibid.

2. The Kahiki Experience

34. "Paradise Found."

35. *Columbus (OH) Dispatch*, August 2, 1872.

36. Schenck, *Come unto These Yellow Sands*.

37. Oscar and Marion were married in 1899 by Reverend Washington Gladden.

38. "Nephew Weds Aunt," *Cincinnati (OH) Enquirer*, July 12, 1913.

39. Ibid.

40. Dr. Carr was the publicity agent for Peruna—one of the most notorious patent medicines of the era.

41. "Nephew Weds Aunt."

42. "Earl Schenck," Wikipedia, https://en.wikipedia.org.

43. *Columbus (OH) Dispatch*, May 8, 1939.

44 The title is a quote from Ariel's song in William Shakespeare's *The Tempest*.

45. "Two Daring Young Men," *Cornell Hotel*.

46. Ibid.

47. "Peter Drucker on Marketing," *Forbes*.

48. Sandro's older brother, Franco Conti, was vice president of Illonka's Provincial House, a popular eastside restaurant named after his wife, Helen "Illonka" (McClain). Illonka, which is Hungarian for Helen, was considered a good cook. She once said, "You can tell what kind of a cook a woman is by the way she uses her celery!"

49. Jones, "Spirit Seems Lacking."

50. Harden, "Making the Grate."

51. In 1951, a thirteen-by-fourteen-foot room from a New England log cabin was installed next to Lincoln's office on the seventh floor of the Nationwide Insurance building. It was a gift from his fellow executives in recognition of his love for his birthplace.

52. Martin was Harry W. Martin. When he left in 1977, the name was changed to S.E.M. Partners.

53. Ned Eller email.

54. Ibid.

55. Ibid.

56. Ibid.

57. Ibid.

58. Dave Timmons email.

59. Ibid.

60. Ned Eller email.

61. Ibid.

62. Ibid.

63. "Polynesian Restaurant to Be World's Biggest," *Columbus (OH) Dispatch*, August 14, 1960.

64. Lee Henry and Marilyn Mansfield had taken out a marriage license during the last few days of 1960.

65. Fraim, "The Kahiki."

66. Ibid.

67. His obituary listed him as Philip B. (Chin) Eng.

68. "Ancient Kettles to Radarange," *Columbus (OH) Dispatch*, September 24, 1961.

69. A friend of Lee's, William Kite also did some promotional work for the Kahiki.

70. "Ancient Kettles to Radarange."

71. Ibid.

72. The food was supplied by a central commissary.

73. "Food in French Polynesia," Yestahiti, https://www.yestahiti.com.

3. Something Different

74. "Paradise Found."
75. Slatzer was a member of a local by-invitation-only big game hunting club.
76. Wilson, "Stage and Screen."
77. Conspiracy theorist Mark Shaw would try to link the deaths of Monroe, Kilgallen and Robert Kennedy, while throwing some shade on former *Columbus Citizen-Journal* columnist Adam "Ron" Pataky (1935–2022). To say the least, it's a tangled web.
78. An avid chess player, Meiden spent his summers playing chess throughout Europe, North Africa and Russia. Perhaps that is how he got to know Vince.
79. Lease, "Obscure Artists Fill the Billboards."
80. We have used the word *tickler* because its purpose was to remind the reader to consider the Kahiki as an option. Advertisers probably have another word for it.
81. "L.M. Berry and Company," Reference for Business, https://www. referenceforbusiness.com.
82. Jones, "Trees Along New Routes Suggested."
83. McNulty, "The Sizzle."
84. Wilson, *Yesterday's Mashed Potatoes*.
85. Huddy, "Ames Talks of Song."
86. Slenske, "Art Awaking in Columbus."
87. Ibid.
88. Schmidt, "From the Editor."

4. No Evil Spirits May Enter

89. "Paradise Found."
90. Jones, "Progressive Meal Offers Variety."
91. The Sands Steak House closed in 1965. It then cycled through a succession of concepts: the Pub East, La Roc, Grand Ole Opry and Jim Otis's Time Out Steakhouse before becoming Dixie Jamboree, a popular country music venue.
92. After Presutti's closed, it reopened briefly in 1984 as Jo Ann's Chilli Bordello & Tartar.
93. There were a handful of Sandy's scattered around Columbus, but they seemed to close about 1967.
94. Casa Jose seems to have closed in 1963 and later became the El Toro and then Mr. Frankie's Bar (for owner Frankie Adams).
95. Plank's continues to thrive.
96. Referred to alternately as Vera's European or Vera's Hungarian Restaurant, it seems to have disappeared about 1966.

97. Planks Café on Parsons Avenue dates back to 1939.
98. A graduate of East High School, Reeves received the first degree in radio ever conferred by Ohio State University.
99. "Surprise Greets Radio Executive," *Columbus (OH) Dispatch*, January 19, 1964.
100. Ibid.
101. Although Galbreath was majority owner of the Pittsburgh Pirates, he lived in central Ohio.
102. When the Jai Lai closed in 1996, it was one of the nation's biggest restaurants. It had been losing money for two years because the Third Avenue exit off State Route 315 was closed for construction. Columbus has a history of doing things like that.
103. Chenoweth, "Like It or Not."
104. Ibid.
105. Berry, "Backgammon Booster Lucky Man."
106. Marcie seems to have been named after silent movie actress Marceline Day, who starred with Lon Chaney in *London After Midnight*.
107. Fisher, "Thanks Anyhow."
108. Morfit appeared on the television quiz show *To Tell the Truth* shortly after opening the Box Car.
109. Jim Rush interview.
110. Fraim, "The Kahiki."
111. According to the *Columbus Dispatch*, on March 9, 1962, Larry T. Grainger, age nineteen, was cut with a butcher knife by Clifford LeMasters, age twenty-four. LeMasters was not charged.
112. Fraim, "The Kahiki."
113. Ibid.
114. Ibid,
115. Ibid.
116. Ibid.
117. Ibid.
118. See Meyers et al., *Kahiki Supper Club*.
119. "Oldtimers Fondly Remember George Ono Who Died Dec. 25," *Morgan County (UT) News*, January 4, 1974.
120. Ibid.
121. George Ono Jr. email.
122. Grant, "Few Places Left."
123. Wen, "This History of Sweet and Sour."

5. Beyond Kahiki

124. "Paradise Found."
125. Ibid.

126. Lee once built a lavish home just outside Columbus, then built another exactly like it when he decided he preferred to live in the city.

127. Motz, "Two of Sweet."

128. In 1994, Wendy's Hamburgers added a small museum at its original location—known as "257"—in downtown Columbus. However, it was shuttered in 2007 due to poor sales and the memorabilia carted off to the Dublin headquarters.

129. Christopher Doerschlag interview.

130. "From Out of the Pages of History," *Columbus (OH) Dispatch*, September 10, 1972.

131. Lee and Bill indicated that Liberatore actually quit before the Kahiki was finished.

132. Jones, "Tone of Diamond Room."

133. Williams, "Local Insurance Firm."

134. Ibid.

135. Ibid.

136. "Thunderbird Restaurant Represents Indian Lore," *Lima (OH) News*, August 31, 1965.

137. Chenoweth, "Repasts—Venerable Yolanda's."

138. The Girves chain is not connected with famous Hollywood Brown Derby chain.

139. Mikal, "Old Market House Inn."

140. Hume, "Semiprivate Disco to Open."

141. Ransohoff, "Man That Skillet."

142. Blundo, "Poems Carry a Tiki Torch."

143. Santer, *Kahiki Redux*.

144. Bols is the name of the distillery in Curaçao.

6. Paradise Lost—and Stolen

145. "Paradise Found."

146. "Polynesian," PB Food History, http://foodhistory.pbworks.com.

147. Ibid.

148. Ibid.

149. Eber, "L.A. Restaurant Owners Reveal."

150. Yoon, "Enduring Appeal of Stealing Tiki."

151. Ibid.

152. Chenoweth, "Bear Stuck Its Paw."

153. Ibid.

154. "Great God Tiki Missing from Local Basement," *Columbus (OH) Dispatch*, March 31, 1968.

155. Ibid.

156. Jones, "Stolen Tiki God Returned."

157. *Columbus (OH) Dispatch*, August 1, 1968.

158. "Youths Find Marker of Wee Gee Wee, 1933," *Columbus (OH) Dispatch*, March 22, 1977.
159. Gapp, "Will to Live."
160. Jim Rush interview.
161. Ibid.
162. Ibid.
163. Meyers et al., *Kahiki Supper Club*.
164. Obituaries, *Columbus (OH) Dispatch*, March 11, 2014.
165. Moss, "From Trash to Treasure."

7. Women of the Kahiki

166. "Paradise Found."
167. Autumn Shah interview.
168. Focht, "Coed Blends Brains."
169. Ibid.
170. "The Many Roles of Carol Stanfield," *OSU Alumni Magazine*, September 1968.
171. Yamanaka, "Finding Aid for the Hipu-Huleia History."
172. Ibid.
173. Gibran, "Novel Features."
174. Chenoweth, "Mario's Internationale."
175. Thompson, "Kahiki Supper Club Connects Columbus."
176. Ibid.
177. Stout, "Ohio State Solon Weds."
178. Aja Miyamoto interview.
179. Ibid.
180. Ibid.
181. Thompson, "Kahiki Supper Club Connects Columbus."
182. Miyamoto interview.
183. Ibid.
184. Ibid.
185. Ibid.
186. Mike Rentz email.
187. Ibid.
188. Ibid.
189. Ibid.
190. Ibid.
191. Kay Oliver interview.
192. Even Lewis Oliver, Kay's husband, worked for Michael Tsao, but at the Sheraton Hotel.
193. Bracken, "Discover Tropical Columbus."

194. Shah, "Goddess of Sunday Brunch."
195. Ibid.
196. Ibid.
197. Ibid.
198. Ibid.
199. Ibid.
200. Ibid.

8. Pretty as a Picture

201. "2nd Annual Kahiki Photo Contest," *Columbus (OH) Dispatch*, October 1, 1963.
202. Terry Darcangelo interview.
203. Page, "Haunted by the Past."
204. Deborah William Diez message.
205. Josh Agle interview.
206. Ruth Pearl interview.
207. Hannah Tran interview.
208. Ibid.
209. Doug Horne interview.
210. Ibid.
211. Ibid.
212. Horne interview.
213. Ibid.
214. Dave Hansen interview.
215. Kohn, "Yea, Verily, Legions Seek Fairest in Land."
216. Blundo, "Restaurant Reflections."

9. Everything New Is Old Again

217. "Paradise Found."
218. Restaurant lifecycle data vary considerably.
219. "May Build a 'Rebellion Room,'" *Columbus (OH) Dispatch*, September 4, 1963.
220. Fulwider, "Designers Produce Warm, Graceful Spot."
221. Bridgman, "Mo'e's Mural Landscape History."
222. "Two Steubenville Men Purchase Kahiki Club," *Columbus (OH) Dispatch*, August 1, 1978.
223. Nall, "Hotel Sale Is Likely."
224. Wiley, "Guv to Conduct Musical Chairs."
225. Williams, "And Now, On Your Grocery Store Shelf."
226. Greenspan, "At Taste of Tiki."

227. Chenoweth, "AmeriFlora's Hawaii Kai."
228. Ibid.
229. Williams, "And Now, On Your Grocery Store Shelf."
230. Albrecht, "He Still Has Songs in His Heart."
231. Cervantes, "Tiki Tragedy."
232. Ibid.
233. Shah, "Goddess of Sunday Brunch."
234. The Santa Maria was removed, cut in ten pieces, and stowed by the city water treatment plant in 2014.
235. Veterans' Memorial was later demolished and replaced by the National Veterans Memorial and Museum, which opened in 2018.
236. Central High School had been renovated to house COSI, which was moved from the Old Memorial Hall building on West Broad Street.
237. Seagaloff, "Kahiki Food to Use."
238. Flavin, "Few Bad Times."

10. The Kahiki Legacy

239. "Paradise Found."
240. Birdsall, "Tiki Bars Are Built."
241. Katz and McGiff, "Reclaiming the Tiki Bar."
242. Birdsall, "Tiki Bars Are Built."
243. Ibid.
244. Ibid.
245. Newman, "New Golden Age."
246. Meyers and Meyers Walker, *Ohio's Back Hand Syndicate.*
247. "A Chinese Burial Service," *Columbus (OH) Dispatch*, August 31, 1886.
248. Despite a promising start, Ben Hope Lee would soon run afoul of the law for operating an opium den. After that, his life continued on a downward trajectory due to his own addiction, resulting in imprisonment and finally death in 1910.
249. "Frightened Chinamen," *Akron (OH) Beacon Journal*, September 25, 1895.
250. Ibid.
251. Ibid.
252. Frankie D. Chan Sr. obituary, *Columbus (OH) Dispatch*, February 4, 2019.
253. Started by Columbus orchestra leader Hugo Monaco, it was later rebranded Jong Mea Miracle Bar.
254. Leung came to the United States in 1974 at the age of thirty-nine.
255. "Chinese Colony May Buy Own Burial Plot," *Columbus (OH) Dispatch*, February 17, 1956.
256. "Caring for the Oldest Cemeteries in Columbus," Columbus Neighborhoods, WOSU Public Media, Facebook, January 24, 2021, https://www.facebook.com.

257. "Man, 5 Sons Naturalized," *Columbus (OH) Dispatch*, November 13, 1974.

258. Motz, "History Lesson."

259. "OK Bill to Let Greek Youth Live in U.S," *Columbus (OH) Dispatch*, May 3, 1961.

260. Jones, "Heated Mask Gets Test."

261. Rosenberg, "Case Study."

262. Ibid.

263. Ibid.

264. Ibid.

265. Bill Sapp and Lee Henry said they always called it "Pete, the Pig," but the name apparently didn't stick.

266. Ibid.

267. Ibid.

268. Vitale, "Saving the Kahiki's Iconic Tiki."

269. Ibid.

270. "Second Course," *Columbus (OH) Dispatch*, December 4, 2018.

Bibliography

Articles and Periodicals

Albrecht, Robert. "He Still Has Songs in His Heart." *Columbus (OH) Dispatch*, February 4, 1994.

Arthur, Chester A. "April 4, 1882: Veto of the Chinese Exclusion Act." UVA Miller Center, Presidential Speeches. https://millercenter.org.

Berry, Stephen. "Backgammon Booster Lucky Man." *Columbus (OH) Dispatch*, June 21, 1978.

Birdsall, John. "Tiki Bars Are Built on Cultural Appropriation and Colonial Nostalgia. Where's the Reckoning?" *Los Angeles (CA) Times*, November 27, 2019.

Blundo, Joe. "Poems Carry a Tiki Torch for Kahiki." *Columbus (OH) Dispatch*, June 17, 2012.

———. "Restaurant Reflections—Readers Share Fond Memories of Dining Destinations of Yore." *Columbus (OH) Dispatch*, March 28, 2021.

Bracken, Jim. "Discover Tropical Columbus at Kahiki." *Ohio State [University] Lantern*, February 14, 1986.

Bridgman, Mary. "Mo'e's Mural Landscape History." *Columbus (OH) Dispatch*, January 29, 1978.

Cervantes, Alice Thomas. "A Tiki Tragedy." *hunt&peck*. Accessed February 11, 2022. https://huntandpeckblog.com.

Chenoweth, Doral. "AmeriFlora's Hawaii Kai Good Enough To Stay." *Columbus (OH) Dispatch*, May 24, 1992.

———. "Bear Stuck Its Paw Where It Shouldn't." *Columbus (OH) Dispatch*, June 29, 2000.

———. "Like It or Not, Valet Parking Is Here to Stay." *Columbus (OH) Dispatch*, September 14, 1989.

———. "Mario's Internationale Best in Every Way." *Columbus (OH) Dispatch*, April 24, 1986.

———. "Repasts—Venerable Yolanda's Leave a Rich History." *Columbus (OH) Dispatch*, April 20, 1995.

———. "They Put in the Fix, So Dip Got the Nod." *Columbus (OH) Dispatch*, September 7, 2000.

Eber, Hailey. "L.A. Restaurant Owners Reveal What Customers Just Love to Steal." *Los Angeles Magazine*, February 3, 2020.

Egan-Ryan Funeral Home. "Frankie D. Chan, Sr." https://www.egan-ryan.com.

Fisher, Eddie. "Thanks Anyhow, Daddy." *Columbus (OH) Dispatch*, October 11, 1970.

Flavin, Daniel F. "A Few Bad Times, But Mostly a Ball." *Columbus (OH) Dispatch*, January 2, 1966.

Focht, Carolyn. "Coed Blends Brains, Judo and Good Time." *Columbus (OH) Dispatch*, May 2, 1965.

Forbes. "Peter Drucker on Marketing." July 3, 2006.

Fraim, John. "The Kahiki: Outline for a Story About a Legendary Polynesian Restaurant." *Greathouse Stories*. https://greathousestories.files.wordpress.com.

———. "Lee Henry." *Greathouse Stories*, September 28, 2015. https://greathousestories.com.

Fulwider, William. "Designers Produce Warm, Graceful Spot." *Columbus (OH) Dispatch*, September 7, 1963.

Gapp, Paul. "The Will to Live." *Columbus (OH) Dispatch*, June 17, 1951.

Gibran, Jay. "Heyday of Hotel Dining Service Is Remembered." *Columbus (OH) Dispatch*, May 17, 1966.

———. "Novel Features Used to Entertain Diners." *Columbus (OH) Dispatch*, May 19, 1966.

Grant, Herb. "Few Places Left to Spark a Memory." *Columbus (OH) Dispatch*, March 2, 2007.

Greenspan, Lorie. "At Taste of Tiki." *Industry Today*, July 26, 2016. https://industrytoday.com.

Harden, Mike. "Making the Grate." *Columbus (OH) Dispatch*, April 18, 1999.

Huddy, John. "Ames Talks of Song, Show." *Columbus (OH) Dispatch*, August 25, 1968.

Hume, Rose. "Semiprivate Disco to Open." *Columbus (OH) Dispatch*, February 23, 1979.

Jones, Johnny. "Flavor of Historic Tea Is Tested in Brew Prepared by Columnist." *Columbus (OH) Dispatch*, March 9, 1962.

———. "Heated Mask Gets Test in Bitter Cold Weather." *Columbus (OH) Dispatch*, January 20, 1965.

———. "Progressive Meal Offers Variety." *Columbus (OH) Dispatch*, May 27, 1962.

———. "Spirit Seems Lacking at OSU Appreciation Dinner." *Columbus (OH) Dispatch*, March 11, 1960.

————. "Stolen Tiki God Returned with Air of Mystery." *Columbus (OH) Dispatch*, July 16, 1968.

————. "Tone of Diamond Room Is Seen as Big League." *Columbus (OH) Dispatch*, October 24, 1963.

————. "Trees Along New Routes Suggested." *Columbus (OH) Dispatch*, July 12, 1963.

Katz, Sammi and Olivia McGiff. "Reclaiming the Tiki Bar." *New York Times*, December 27, 2020.

Kohn, Martin F. "Yea, Verily, Legions Seek Fairest in Land." *Colorado Springs (CO) Gazette-Telegraph*, April 27, 1978.

Lease, Carol Ann. "Obscure Artists Fill the Billboards." *Columbus (OH) Dispatch*, April 3, 1984.

McNulty, John. "The Sizzle." *New Yorker*, April 16, 1938.

Mikal, Deron. "Old Market House Inn Opens in City This Week." *Times Recorder* (Zanesville, OH), September 22, 1974.

Moss, Robert. "From Trash to Treasure: The History of Barbecued Ribs." *Serious Easts*. July 3, 2019. https://www.seriouseats.com/.

Motz, Doug. "History Lesson: The Asian Festival." *Columbus Underground*. May 25, 2013. https://columbusunderground.com.

————. "Two of Sweet—Uncovered Stories About the Kahiki Including a Museum and Blueprints for a Kahiki Franchise." *Columbus Underground*. August 6, 2019. https://www.columbusunderground.com.

Nall, Nancy. "Hotel Sale Is Likely." *Columbus (OH) Dispatch*, August 31, 1982.

Newman, Kara. "A New Golden Age for the Tiki Bar." *The Atlantic*, June 5, 2018.

Page, Meryll Levine. "Haunted by the Past; Family Pictures, Part II." *Jewish Luck*, June 11, 1917. http://www.morejewishluck.com.

Ransohoff, Jerry. "Man That Skillet." *Cincinnati (OH) Enquirer*, August 24, 1961.

Raper, Tod. "Shifting Scenes." *Columbus (OH) Dispatch*, January 27, 1931.

Rosenberg, Barry. "Case Study: Kahiki Foods." Performance Solutions by Miliken, 2008. https://www.plantservices.com/assets/wp_downloads/pdf/101112_Milliken.pdf.

Schmidt, Kristen. "From the Editor: Aloha, Kahiki." *Columbus Monthly*, December 2014.

Seagaloff, Miriam. "Kahiki Food to Use Former Restaurant Décor in New Plant." *Columbus (OH) Dispatch*, May 22, 2004.

Shah, Autumn. "The Goddess of Sunday Brunch." *Toasted Cheese*, September 1, 2016. https://tclj.toasted-cheese.com.

Slenske, Michael. "An Art Awaking in Columbus." *DuJour*. https://dujour.com.

Stout, Ned. "Ohio State Solon Weds with a Storybook Flair." *Columbus (OH) Dispatch*, June 17, 1973.

Thompson, Emily. "Kahiki Supper Club Connects Columbus, Family Histories." *Columbus Neighborhoods*. https://columbusneighborhoods.org.

"Two Daring Young Men on the Restaurant Trapeze!" *Cornell Hotel and Restaurant Administration Quarterly* 2, no. 1 (May 1961).

Vitale, Bob. "Saving the Kahiki's Iconic Tiki Statue." *Columbus (OH) Monthly*, February 2020.

Wen, Kristine. "This History of Sweet and Sour Sauce." *Chowhound*, November 26, 2018. https://www.chowhound.com.

Wiley, Jack. "Guv to Conduct Musical Chairs." *Columbus (OH) Dispatch*, November 5, 1982.

Williams, Brian. "And Now, On Your Grocery Store Shelf." *Columbus (OH) Dispatch*, November 27, 1995.

———. "When Tavern Closes, a Bit of Americana Will Fade Away." *Columbus (OH) Dispatch*, August 21, 1996.

Williams, Mardo. "Local Insurance Firm Has Distinctive Office." *Columbus (OH) Dispatch*, April 11, 1965.

Wilson, Samuel T. "Stage and Screen." *Columbus (OH) Dispatch*, July 27, 1952.

Yamanaka, William Kiyoshi. "Finding Aid for the Hipu-Huleia History." Kaua'i Historical Society, 2005. https://www.kauaihistoricalsociety.org.

Yoon, Tae. "The Enduring Appeal of Stealing Tiki Mugs." *Vice*, January 13, 2018. https://www.vice.com.

Books

Chenault, Jeff. *Ohio Tiki*. Charleston, SC: The History Press, 2019.

Meyers, David, and Elise Meyers Walker. *Ohio's Back Hand Syndicate: The Birth of Organized Crime in America*. Charleston, SC: The History Press, 2018.

Meyers, David, Elise Meyers Walker, Jeff Chenault and Doug Motz. *Kahiki Supper Club: A Polynesian Paradise in Columbus*. Charleston, SC: The History Press, 2014.

Santer, Rikki. *Kahiki Redux*. Self-published, 2012.

Schenck, Earl. *Come unto These Yellow Sands*. New York: Bobbs-Merrill Company, 1940.

Wilson, Patricia. *Yesterday's Mashed Potatoes*. Indianapolis, IN: Dog Ear Publishing, 2009.

Index

About the Authors

A graduate of Miami and Ohio State Universities, DAVID MEYERS has written numerous local histories, several novels and a handful of works for the stage, including two full-length musicals, *The Last Christmas Carol* and *The Last Oz Story*. For his contributions to local history, David was inducted into the Ohio Senior Citizens Hall of Fame.

ELISE MEYERS WALKER has earned degrees from Hofstra and Ohio Universities. While attending college in New York, she was a freelance writer for several national magazines and performed in a professional theater troupe. She has coauthored more than a dozen local histories with her father, including *The Reverse Underground Railroad in Ohio* and *A Murder in Amish Ohio*.

Tiki veteran JEFF CHENAULT is a music producer, author and musicologist. He is known throughout the United States for his expertise in exotica music and has written for various magazines, including *Tiki* and *Exotica Moderne*. Jeff is also the author of *Ohio Tiki* and continues to release rare exotica music on Dionysus Records.

DOUG MOTZ attended Ohio State University and writes "History Lesson," a regular feature for columbusunderground.com. He is the former president of the Columbus Historical Society. After joining David, Elise and Jeff on *Kahiki Supper Club*, Doug followed up with two books of his own: *Lost Restaurants of Columbus, Ohio* and *Lost Restaurants of Central Ohio & Columbus*.